IMAGES
of America

CHINCOTEAGUE AND ASSATEAGUE ISLANDS

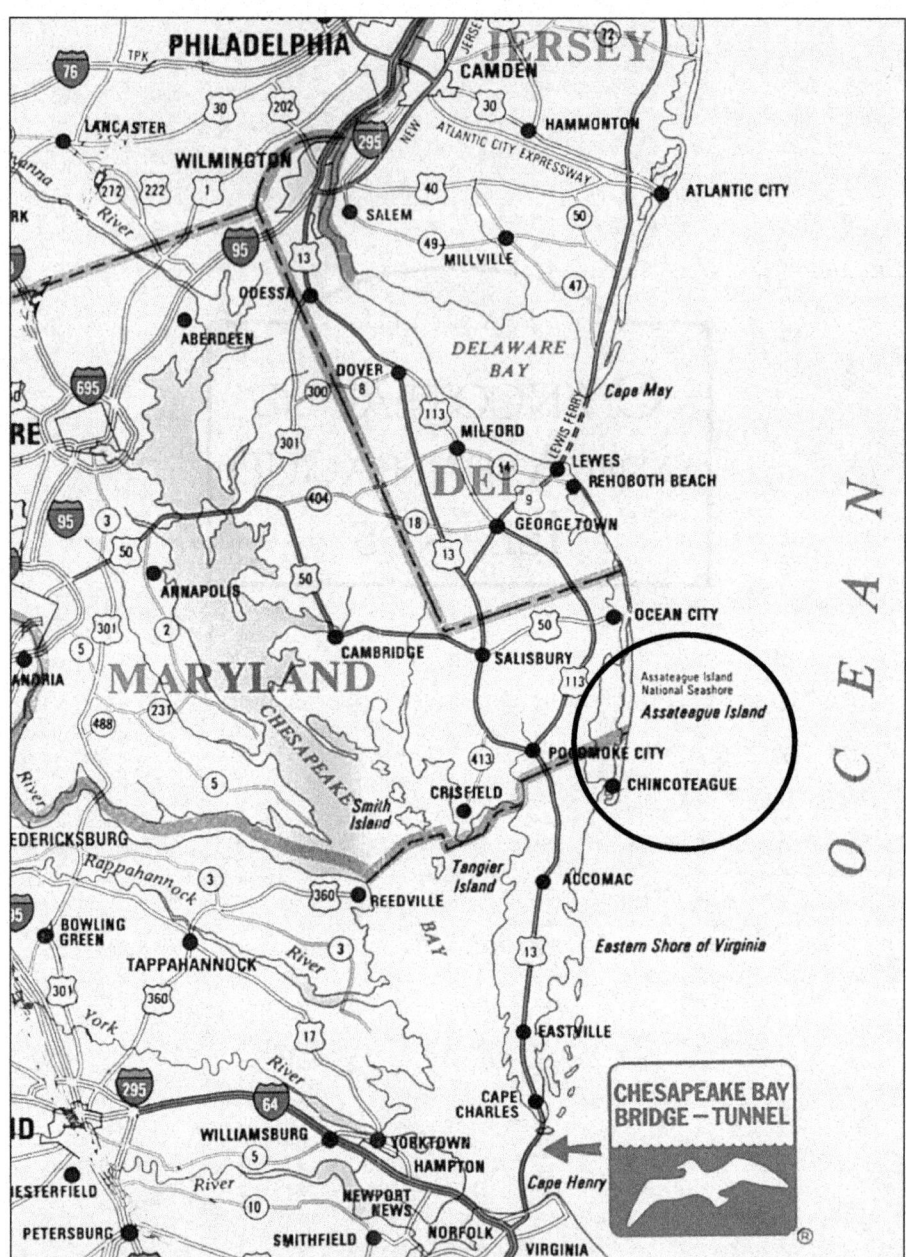

CHINCOTEAGUE AND ASSATEAGUE JUTTING OUT INTO THE ATLANTIC OCEAN. From the south, travelers can cross the Bay Tunnel Bridge from Cape Henry to Cape Charles to gain footing on the eastern shore of Virginia. Travel north about 50 miles up Route 13 (the Mainland) to Route 175 and then east 10 miles to Chincoteague. Once in the tiny town, you can easily make your way to Maddox Boulevard to enter Assateague. Coming from the north and the other side of the Chesapeake Bay, travelers take the Bay Bridge and then a scenic drive on Route 50 East to Salisbury—the major hub of the eastern shore of Delaware, Maryland, and Virginia (Delmarva). Then follow Route 13 South for about 30 miles to Route 175. In reaching Chincoteague and Assateague, you will be fortunate enough to pass NASA's Wallops Island facilities. (Courtesy of the Chesapeake Bay Bridge-Tunnel Authority.)

IMAGES *of America*

CHINCOTEAGUE AND ASSATEAGUE ISLANDS

Nan DeVincent-Hayes and Bo Bennett

Copyright © 2000 by Nan DeVincent-Hayes, Bo Bennett, and James R. Hayes
ISBN 978-1-5316-0360-1

Published by Arcadia Publishing
Charleston, South Carolina

Library of Congress Catalog Card Number: 00-100865

For all general information contact Arcadia Publishing at:
Telephone 843-853-2070
Fax 843-853-0044
E-mail sales@arcadiapublishing.com
For customer service and orders:
Toll-Free 1-888-313-2665

Visit us on the Internet at www.arcadiapublishing.com

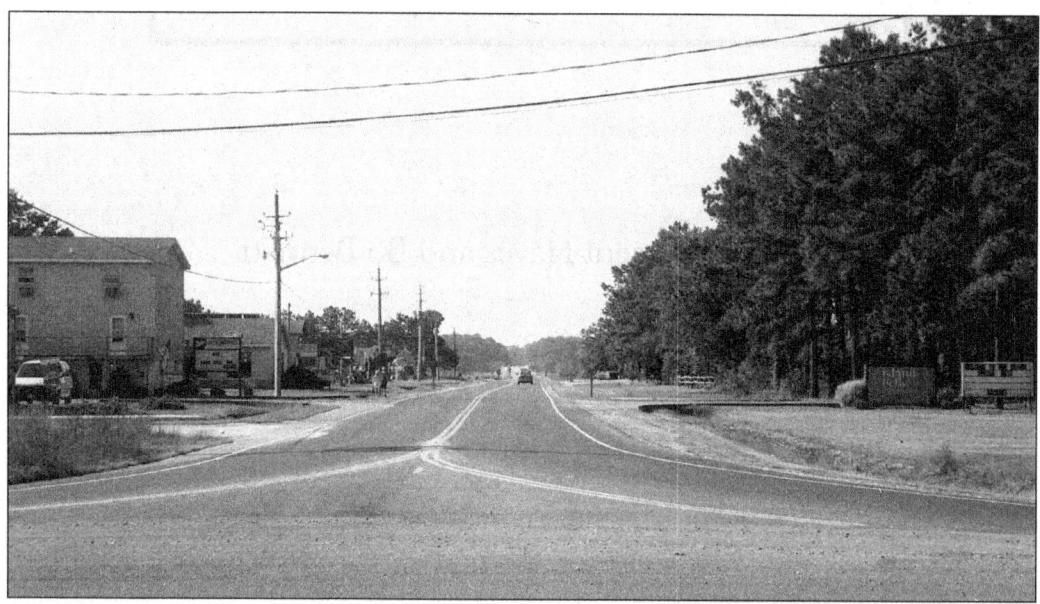

MADDOX BOULEVARD. This is the only road leading across the bridge. It was built in 1962 into Assateague from Chincoteague at Maddox Boulevard and named after Wyle Maddox, who was instrumental in erecting the bridge. When you cross the bridge on Piney Island, you enter the Virginia side of Assateague, which is overseen by the Chincoteague National Wildlife Refuge and the U.S. Fish and Wildlife Service. The toll to cross the bridge was $1. With the advent of McDonalds, numerous motels, and gift and retail shops lining the street into Assateague, many Chincoteague residents thought the beginning of the end for the once-quiet town was at hand. The chamber of commerce and visitors center is located at the corner of this road and is conveniently accessible from all directions.

Contents

Introduction: Two Thriving Barrier Islands — 7

Acknowledgments — 8

1. Assateague Island: A Pristine Beginning — 9
2. Chincoteague Island: Images of Town — 27
3. Transportation: Rivers, Rails, Roads, and Air — 37
4. People: Island Profiles — 51
5. Lodging: A Place to Call Home — 63
6. Education: Readin', 'Ritin', 'Rithmetic — 73
7. Occupations: Vocations and Vacations — 85
8. Pony Penning: Roundups and Giddy-ups — 99
9. Disasters: Row Your Boats Gently up the Street — 109
10. Churches and Cemeteries: Altar Stones and Tombstones — 121

Bibliography — 128

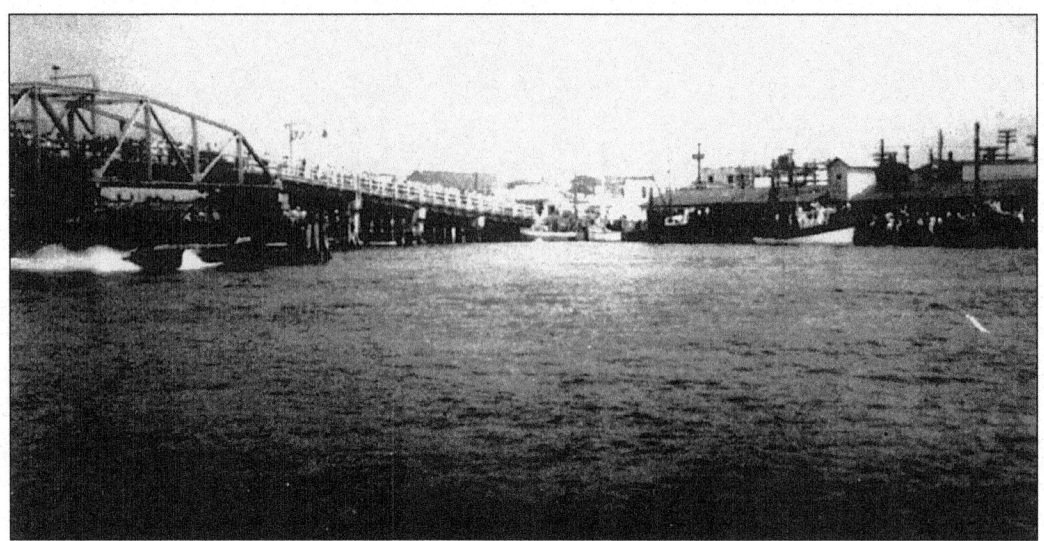

THE CAUSEWAY. This modern photo shows what the entrance into Chincoteague looks like now. In a sense, this is what the island is all about—a causeway that opened closed doors, breathed new life into an isolated town where "Teaguers" rarely saw non-natives and seldom cared if they did. With the causeway, the only Virginia route into Assateague, came a thriving existence—one that now includes millions of tourists a year. For the little island locked between Assateague and the mainland of Virginia, this road was its rebirth. Chincoteague would not be the Chincoteague it is today without this symbol, which infused a peaceful little village with a strong injection of vigor and power. Currently, plans are underway to build a new causeway, but a debate ranges as to where it should enter Chincoteague.

*To Nan's husband, Jimmy, for all his time, computer expertise,
and hard work in managing the graphics and the typing.*

*To Bo's fiance, Johnny Townsend, for running numerous errands
and putting us in contact with people who gave invaluable insight.
His understanding of the time we needed for writing the book is cherished.*

*To Nan's daughters, Marta and Brynne, and to Bo's son, Stephen,
for not making demands on us while we spent endless time away from them
in the creation of this year-long project.*

Introduction
Two Thriving Barrier Islands

Barrier islands, one of God's many wonders, move to a rhythm of their own. Many are isolated from the hustle and bustle of civilization; others encourage that very commercialized existence to survive. The islands of Assateague and Chincoteague are a mixture of both—each succeeds well in its individual endeavors, for each nourishes the other.

Lying adjacent to Assateague and accessible only by a bridge on the Virginia side, Chincoteague has a varied and interesting history arising not only from its pony-penning fame and Marguerite Henry's *Misty* book serials, but also from its unique and colorful lifestyle. Its citizenry and its proximity to the internationally known Assateague Reserve make it a hot and viable tourist attraction. And while Assateague is reminiscent of an almost antediluvian era, Chincoteague strives for modernization and tourism.

Assateague, a quiet, non-intrusive barrier island jutting out into the Atlantic Ocean, allows visitors to get lost in an ancient and primitive land filled with natural and undisturbed life. On the Maryland side the island offers a variety of outdoor activities including a gorgeous beach for surf fishing or swimming, camping, bird watching, canoeing, hiking trails, and hunting on certain days. On the Virginia side the ponies of Assateague can be seen meandering through the beautiful Chincoteague National Wildlife Refuge.

The two islands have, over time, formed a symbiotic relationship. Chincoteague needs Assateague to act as a barrier against gushing currents, ravaging winds, and eroding and amassing forces; Assateague needs Chincoteague for its pony auction and tourism.

Nestled in a part of the country that is neither easily accessible nor entirely secluded, the growth of the islands has been facilitated by the construction of the Bay Bridges and the Bay Tunnel Bridges. You can now enter and exit via either route.

We believe a visit to the islands is an experience worth tasting and savoring before fully digesting. We also believe you will leave here reluctantly, wanting second and third helpings, for this is a world of its own—a world of primal beauty intermingled with quaintness and an old town lifestyle.

You should visit these islands before the rest of the world beats you to it.

Enjoy!

Acknowledgments

We would like to thank everyone who helped us with this book, and appreciate the interviews, e-mails, phone calls, time, and photographs that have been extended to us. If any name is accidentally omitted, know that we thank you, too.

Our gratitude especially goes to the following: John E. Jacob, for his generosity in the use of his postcard collection; Curtis Badger, for his photos from his book on barrier islands; Kirk Mariner, for his photos and his book *Once Upon an Island*; the late Fred Breuckmann, for his postcards; William H. Wroten Jr,. for his photographs and time; Steve Cherry from the *Ocean City Times Press*; and the Virginia Bay Bridge Tunnel Authority for their map.

We also appreciate the help from the Chincoteague Public Library and their staff: Jay Cherrix, for his time and kayak tour; Robert Mears, for sharing his photographs and memories; Donna Mason, for her family pictures, time, and info; Wayne and Katherine Tolbert, for their photos and unlimited knowledge of the island; Robert and Nancy Conklin, for their photos and interview; Maury Enright, for his information and CHS where he has been teaching for over 30 years; Herman Whealton, for his images and interview; Donald Leonard, for his kindness and tour; David Snead, for sharing his time and pictures; Barbara Gehrm of the Chincoteague Chamber of Commerce, for answering our many questions; Todd Wantabe and Larry Beatty, QM1 of the U.S. Coast Guard Group Eastern Shore, for their info and efforts; Scott T. Price, USCG Historian and Public Info Officer; Assateague Chief Information Officer, Larry Points, for his time and patience; James R. Hayes, for high-tech assistance; and Robert McGee for the audio on Assateague.

We wish to thank the following for the use of their images: Richard L. Chenery III; HPS Pulling; Roland Bynaker of Trade Winds; the National Park Service; Eastern National Photos; Pony Penning Enterprises; Tingle and Breuckmann Publishing; H&H Pharmacy and E.C. Kropp; the Chincoteague Drug Company; Kaufman & Sons, Inc.; Maryland Visitor Center; Brook Barnes and Barry Truitt; Robert L. Krieger; the *Eastern Shore News*; *The Daily Times*; the Eastern National Park & Mon. Assoc.; Twilley, Co.; and Elsie Jones.

Additionally, we would like to thank the following "Teaguers," who provided us with much other needed materials and information: Pride Cottages, J&B Coldcuts, Nancy Sloan Payne, the Gatehouse, the Island Manor House, the Year of the Horse Inn, Waterside Motor Inn, H&H Pharmacy, Blue Dolphin Carry Out, Etta's Channel Side Restaurant, the Boulevard Beach and Surf Shop, and Nicholas Bay Band. And a special nod to Christine and Lauren Bailey, Michelle Manders, Effie Cox, and the attorneys and staff at the law offices of Seidel, Baker & Tilghman, P.A., for their support and understanding.

We are also grateful to our literary agent, Ivy Fischer Stone of the Fifi Oscar Literary and Talent Agency, as well as to our editor, Christine Riley of Arcadia Publishing.

One

ASSATEAGUE ISLAND
A PRISTINE BEGINNING

Unlike the traveler's oasis that Chincoteague has become, Assateague remains pristine and primitive, allowing visitors to close their eyes and transcend to a time thousands of years ago, when all living things existed undisturbed in their natural habitat. Evident to the daydreamer would be the feralness of the animals, the magnificence of the land, and the lack of human impact on the island. Nature would be seen unfolding in its all glory via the survival of the fittest.

Assateague, with the wild and primal permanence of its extensive wetlands, marshes, and native fauna and flora intact, currently overlaps both Maryland and Virginia and falls under the aegis of the National Park Service, which manages the 14,000-acre sanctuary of Assateague Island National Seashore (established in 1943). It is also under the shield of the U.S. Fish and Wildlife Refuge and Maryland's Department of Natural Resources, which control the 680 acres of Assateague State Park. As a state park, such leisure activities as surf fishing, swimming, sunbathing, clamming, crabbing, backpacking, biking, birdwatching, are permitted—all of which are non-disruptive to the land. Of world fame are the island ponies, truly small horses whose appearance on the coast is not well documented.

In the early 1900s, most of the land was owned by Samuel Fields, who made it difficult for the few hundred residents to make a living because he blocked their crossing his land to fish the rich oyster beds in Tom's Cove. By 1920, the village of Assateague no longer existed. It was not until the federal government bought the island in the early 1940s and turned it into a national refuge and recreational area, and a bridge was constructed in 1962 from Chincoteague into Assateague, that the natural wildlife felt any true human presence.

Today over 800,000 people visit the Maryland side of the refuge, while between 1.2 and 1.5 million tourists explore the Virginia side. The images in this chapter place you right on the sand dunes, inside the rising and falling ocean, and alongside the birds, ponies, and sea life.

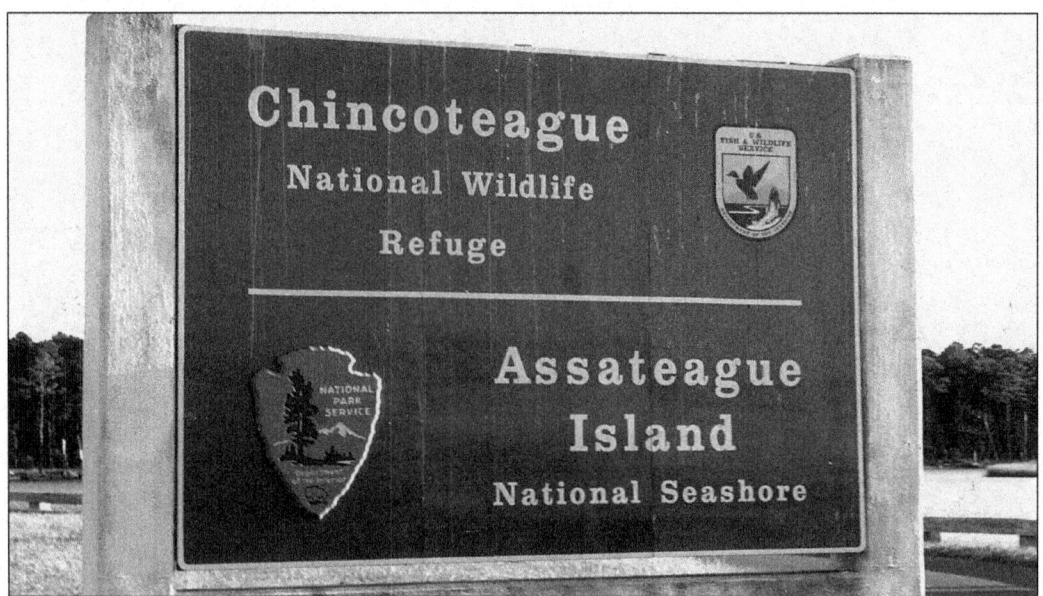

THE CHINCOTEAGUE-ASSATEAGUE ISLAND SIGN. This wooden sign stands between Assateague Island, VA, and Chincoteague, VA. The National Seashore symbol is attached to the Assateague part of the sign, showing that it comes under the supervision of the National Fish and Wildlife Service. The Chincoteague side, as the symbol indicates, falls under the National Wildlife Refuge. A narrow island, Assateague is about 37 miles long.

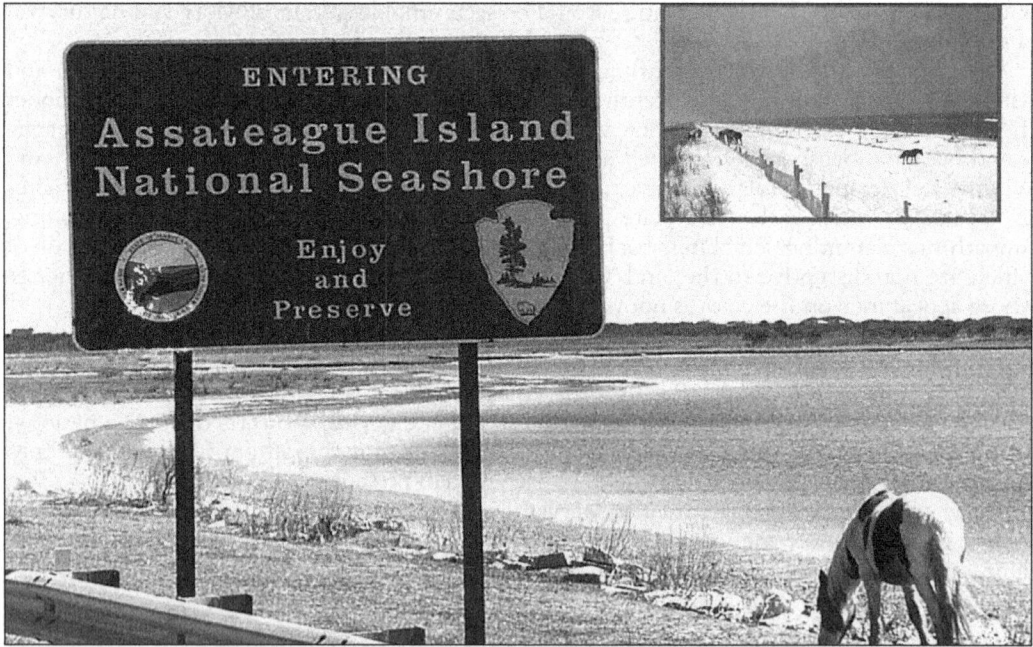

THE ASSATEAGUE ISLAND NATIONAL SEASHORE SIGN. This sign stands on the Maryland side of Assateague announcing it as a national seashore and refuge. Notice the pure white color of the sand in the inset, as well as how close the pony is to the side of the road—a common problem arising out of humans feeding the wild animals, which is not healthy for the horses and not safe for the humans. (Courtesy of R.C. Pulling.)

THE FENCE DIVIDING MARYLAND AND VIRGINIA. This fence serves as the divider on Assateague Island between the states of Maryland and Virginia, both of which share the national wildlife refuge. The Maryland side can be entered on Route 50 East leading from Ocean City, MD. The Virginia side offers entrance at Maddox Boulevard in Chincoteague, VA. Not only does the fence serve as a reminder of the two separate reserves, but it also prevents the Assateague herd of horses from intermingling with the Chincoteague herd, and visa versa. (Courtesy of Julie Bowers.)

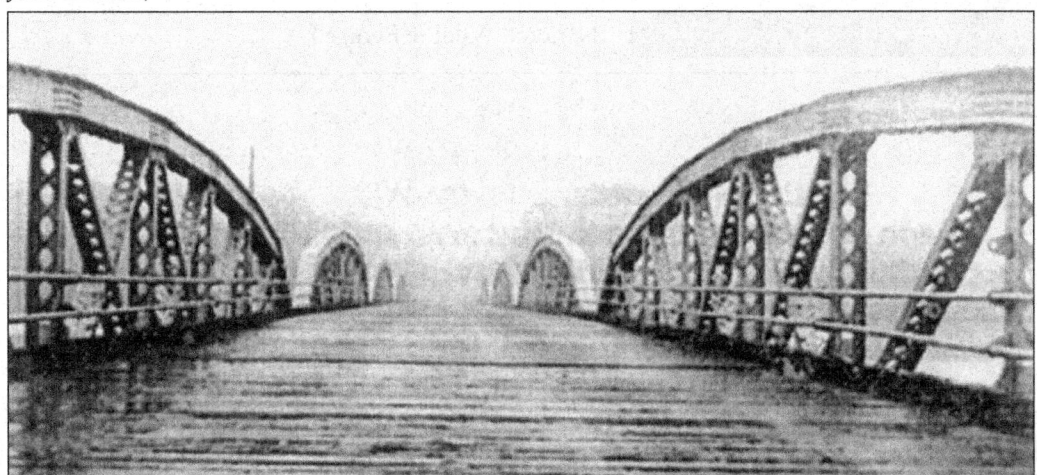

THE ASSATEAGUE BRIDGE. The 1962 storm delayed by a few months the much-awaited opening of the bridge from Chincoteague into Assateague—the only entrance to the barrier island on the Virginia side leading to the reserve and 10-mile beach. This marked the beginning of tourism for both. A $1.25 toll was charged to hear the clackety-clack of one's car tires roll over the wooden roadbed. The bridge came into existence when steel (which had served as a bridge in New York) was placed on a barge and sailed to Assateague, where it was reassembled. Over 4,000 cars crossed the bridge within its first 60 days. When President Johnson made Assateague a national seashore and the park came under the National Park Services, the toll bridge was removed, and a new bridge was built around 1978. Assateague's primitiveness did not prevent the rise in number of visitors. Today, millions cross this bridge to get a taste of nature in its prehistoric state. (Courtesy of Kirk Mariner.)

A "Cross" Skate. This specimen sits in the visitors center of Assateague, MD. As can be seen on the shell, a cross seems to be embedded in the middle of the carcass. Unlike the crucifix fish (where a persecuted figure is clearly etched on the animal's back), this specimen requires a second look to see such minute and distinguishing marks. This is a creature indigenous to the barrier island.

Assateague Village and Its Lighthouse. This early 1920s photo shows one of the small Assateague communities that was formed by the families of the men who worked on the island in such jobs as lifesaving rescuers and saltworks employees. Other residents set up services for the community, including Mr. Scott and Mr. Taylor, who ran stores; the sole teacher who presided over the one-room schoolhouse; and, of course, the lighthouse keeper. Homes consisted of cottages that were not well insulated and offered no conveniences. When the men were not working, they fished or trapped muskrats, and the women helped supplement the family income by tilling gardens. There were never more than 30 families living in the village; their life was simple, as were their expectations. (Courtesy of Chincoteague National Wildlife Refuge.)

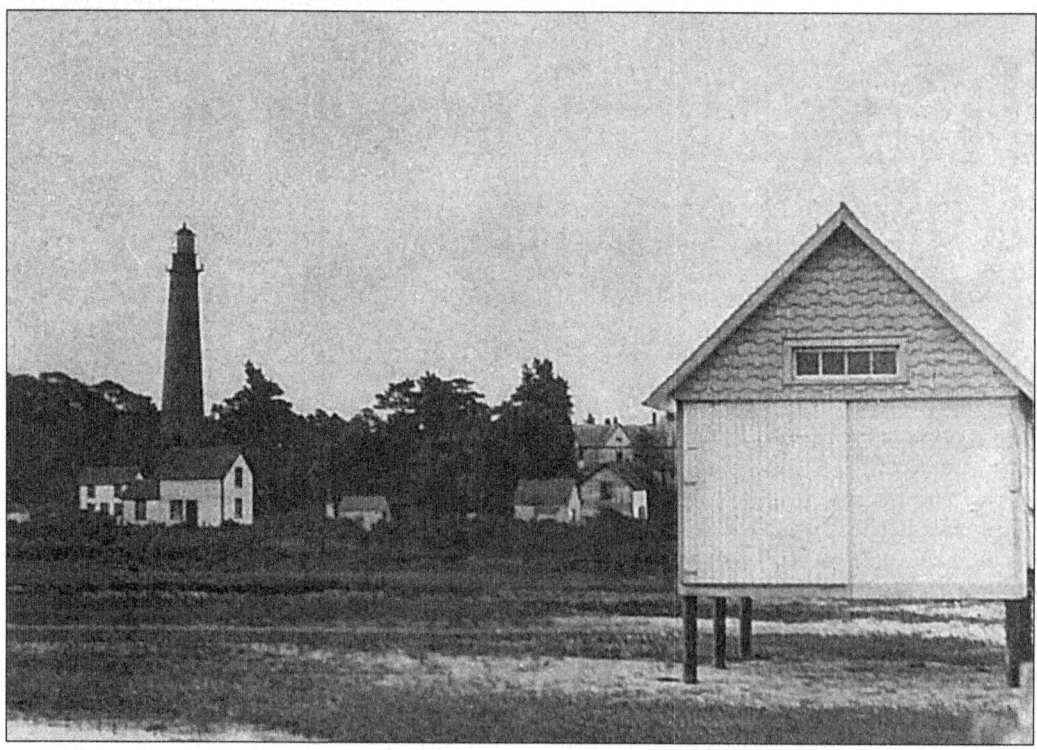

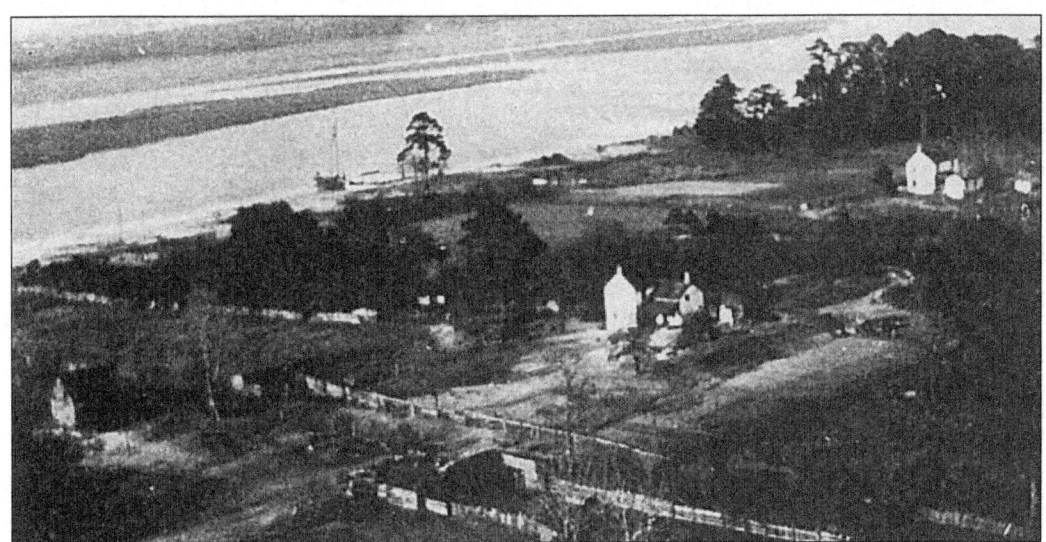

ASSATEAGUE VILLAGE (ABOVE) AND ASSATEAGUE VILLAGE AT WATER'S EDGE (BELOW). Although Native Americans ruled by Chief Kegatank and Emperor Waskawampe originally inhabited the shore, by the 17th century Assateague was home to a handful of hearty people who wrangled a lifestyle out of fishing, hunting, and farming. This settlement arose when Col. Daniel Jenifer hired caretakers for the land he had been granted. When Samuel Fields refused to allow residents to cross his acres to fish, most of them left the island. The top image, looking north from the lighthouse in the early 1920s, shows a village where homes dot the shoreline and very few roads shape the landscape. The bottom image ("Water's Edge") dates from 1915 and features Chincoteague across the bay and a lifesaving station at the water's edge. Early homes were made to protect occupants from the weather, and white sand served as the floor. Only some homes had windows, and fireplaces were of simple construction and vented through a hole in the roof. Although log fences may have physically separated the homes, nothing stood in the way of their inhabitants' hearts. Neighbors took care of one another, feeding the unemployed and caring for the sick. The villagers burned fish oil in clam shells for light and wood for heat. Sheep were raised for clothing, and hogs provided food and lard. The island was unfit for the cultivation of food and offered little in the way of other necessities. (Top image courtesy of Kirk Mariner/Elsie Jones; bottom image courtesy of William H. Wroten Jr.)

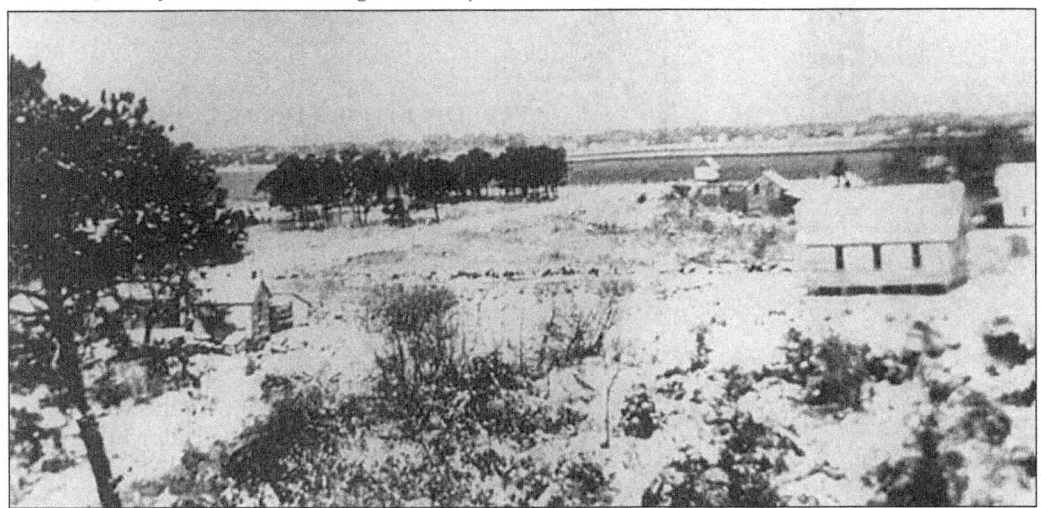

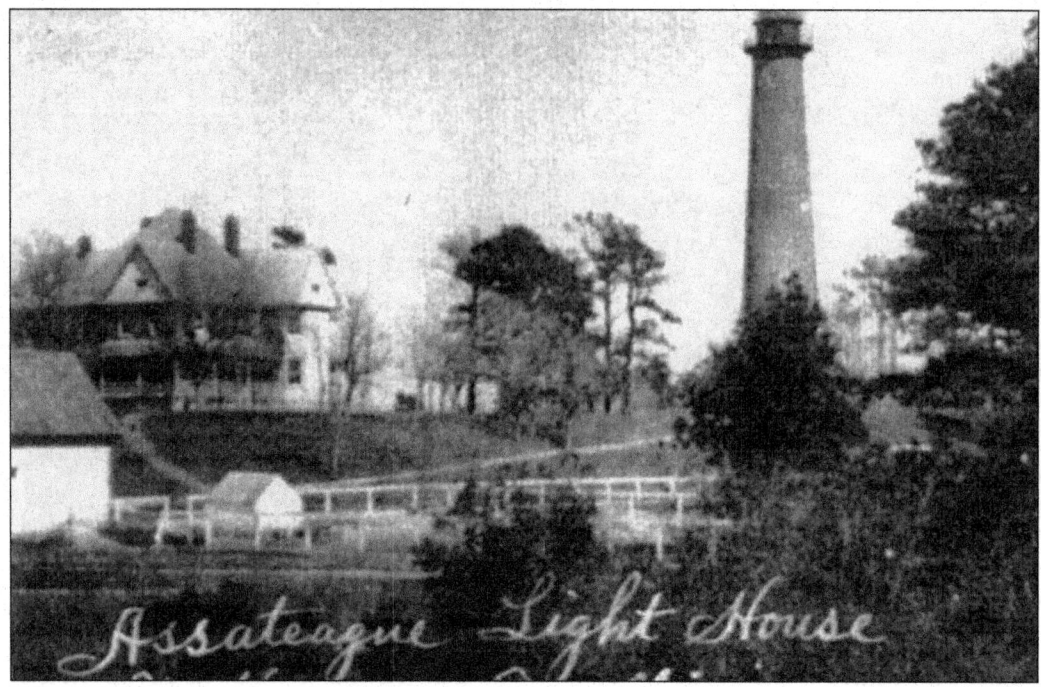

THE LIGHTHOUSE AND KEEPER'S HOUSE, C. EARLY 1900S. This is the lighthouse on Assateague Island, along with the lightkeeper's dwelling (built of wood in 1867) on a hill built with three large sections. Because the house was constructed as a three-family home, each section contained a foyer, living room, dining room, three bedrooms, a kitchen, pantry, bathroom, and a large closet. Compare this photo to the one below, which shows the house at a different angle. The grounds boasted trees, bushes, flowering plants, and colorful blooms of purple lilacs, yellow daffodils and forsythia, and holly and fruit trees. (Courtesy of Curtis Badger.)

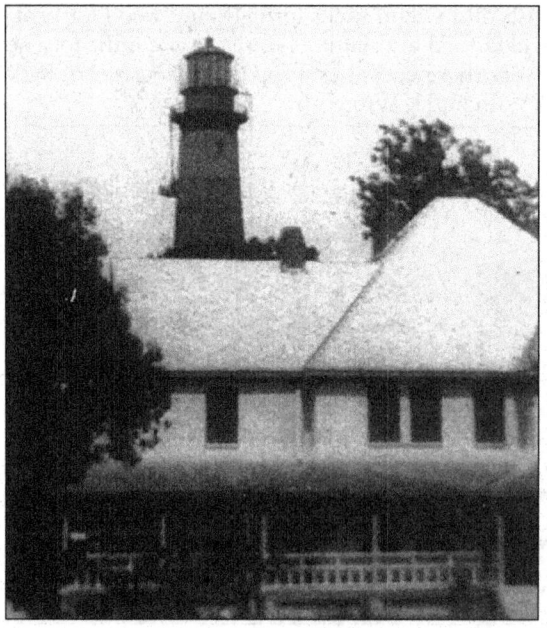

THE KEEPER'S HOUSE, C. 1930S. This photo depicts the lighthouse keeper's house on Assateague Hill. Behind the home is the lighthouse. It did not take long for the keeper to realize that the candlelight of the early lighthouse was not bright enough to prevent shipwrecks. Later, the light was replaced by electric illumination. David Watson was the first keeper, and William Collins is the last of record. Collins and his family, who chose not to live in the house, built a brick home 50 yards down the hill. (Courtesy of Curtis Badger.)

THE ASSATEAGUE LIGHTHOUSE. This 1905 postcard displays the lighthouse at the southern tip of Assateague. Construction on the $75,000 structure began in 1860 but was interrupted by the war and did not resume until 1866. The lime was made on site out of oyster shells, but the tons of stone for the foundation and the bricks were shipped in and dragged by oxen. Built on the sand ridge with a pine tree and salt marshes leading to it, the structure, from base to lantern, is about 139.5 feet tall and is reinforced with iron braces. A six-landing spiral staircase from France, rising 129 feet, leads to the lantern room. Whale oil served as fuel for the original 20,000-candlepower lantern. It was converted to electric in 1932. In 1869, the keeper had to install wire screens to prevent wildfowl from continuing to fly into the light. Notice that the lighthouse has no stripes in this picture. (Courtesy of John E. Jacob.)

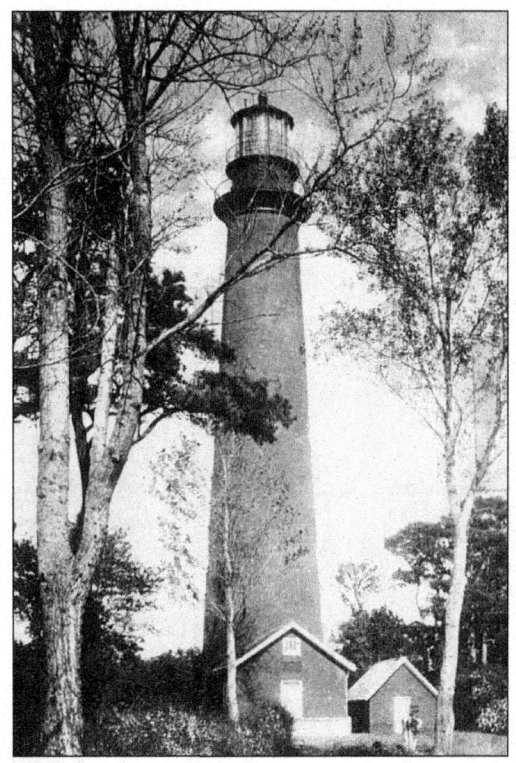

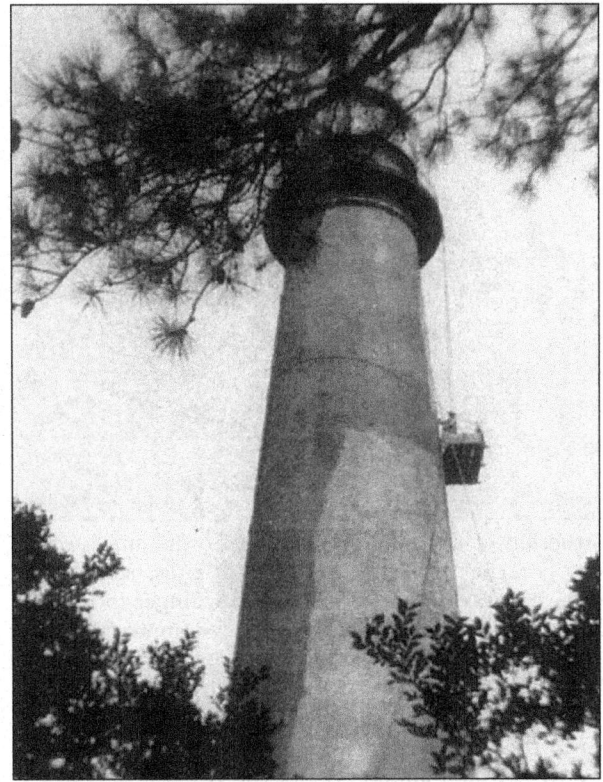

PAINTING THE "LIGHT." In this c. 1925 photo, two different shades of paint can be seen, the dark color coating the light one. Keeper William Collins is the painter on the suspended platform. Painting the tower was not only a laborious task but also a challenging and dangerous one. (Courtesy of Curtis Badger.)

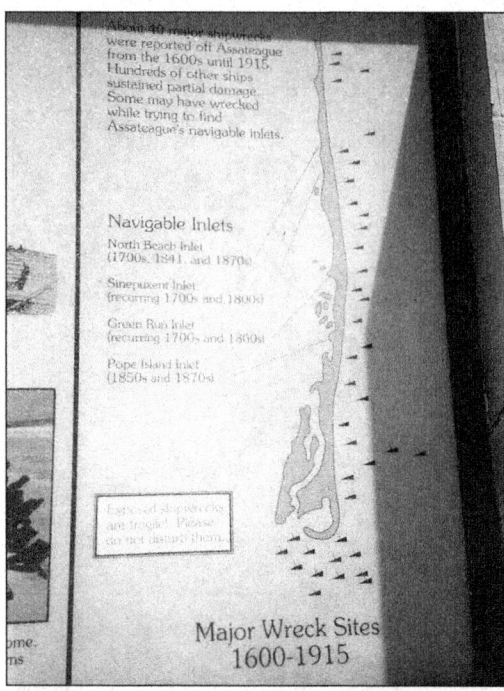

MAJOR WRECK SITES. This image illustrates the number of wrecks along the coast occurring between 1600 and 1915, a 315-year period. The majority happened prior to the construction of the lighthouse, which began in June 1860 and was completed around 1866. Most wrecks resulted from the difficulty of finding Assateague's navigable inlets without sophisticated equipment. Schooner cargo vessels in the 1800s were victims of reefs, poor navigation, and bad weather. The lighthouse was only a slight aid in spite of the money and time that went into building it. It was not until the emergence of the U.S. Lifesaving Station in 1874 that the number of wrecks diminished. This picture shows major accidents only; imagine how many smaller ones there were. Note the number of accidents occurring at the hook of Assateague.

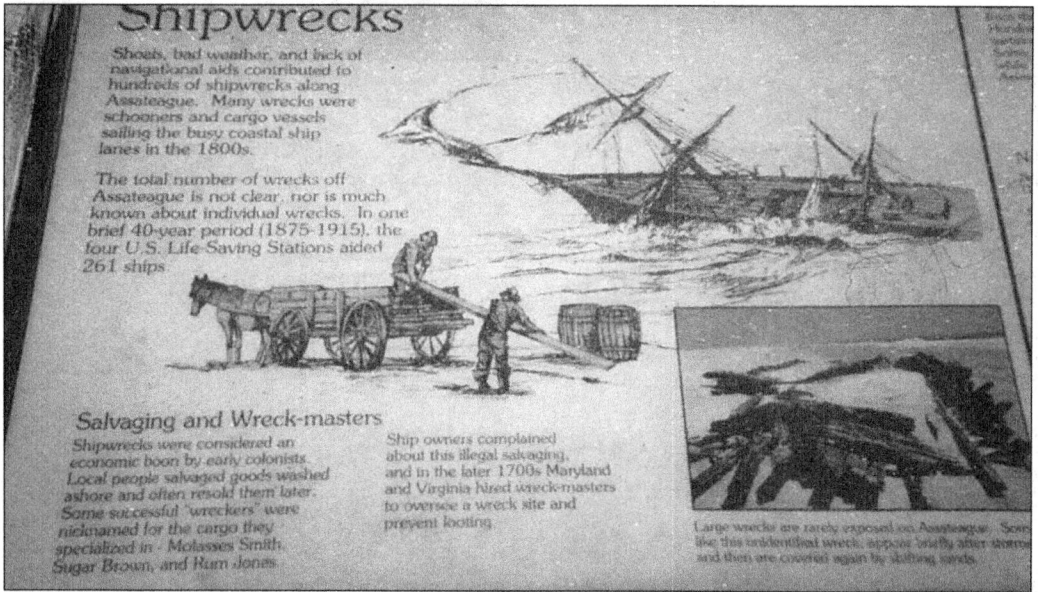

SHIPWRECKS. This image depicts the destruction of a sailing vessel from storms, unexpected shoals, and substandard navigational aids. For the residents of barrier islands, shipwrecks were gold mines because they provided booty for scavengers. People would scamper to recover treasures from downed ships to resell them for profit. Pilfering became such a common practice that Maryland and Virginia had to hire "wreckers" to guard downed ships. The wreck of the Spanish ship *Greyhound* in the 1700s prompted salvagers to strip the ship of everything, including its timbers. Wreckmasters became obsolete with the emergence of the lifesaving station. Blackbeard reputedly pirated ships in the Assateague area. Because of the number of wrecks and deaths, lighthouses were erected to provide illumination for the vessels.

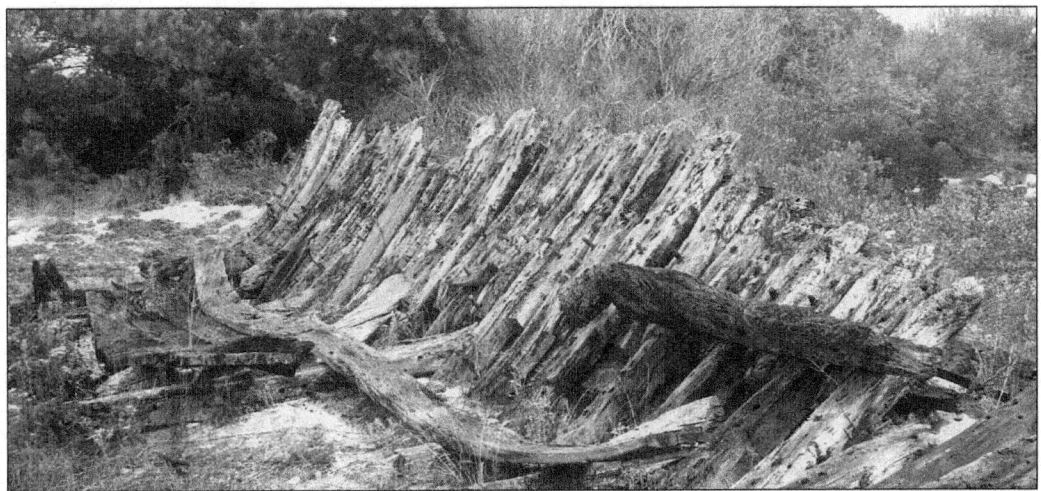

A WRECKED FREIGHTER. This damaged 1800s sailing freighter sits on the Maryland side of Assateague. Believed to have gone down by the mouth of the Chesapeake Bay in the 1900s, it washed up at Fort Story, VA. It was brought to Assateague by a noisy Hovercraft and its flying twin, unloaded over a beach dune down Campground Road, and set up as an exhibit to illustrate and promote the discussion of shipwrecks. The timbers of the ship are now decayed and fragmented.

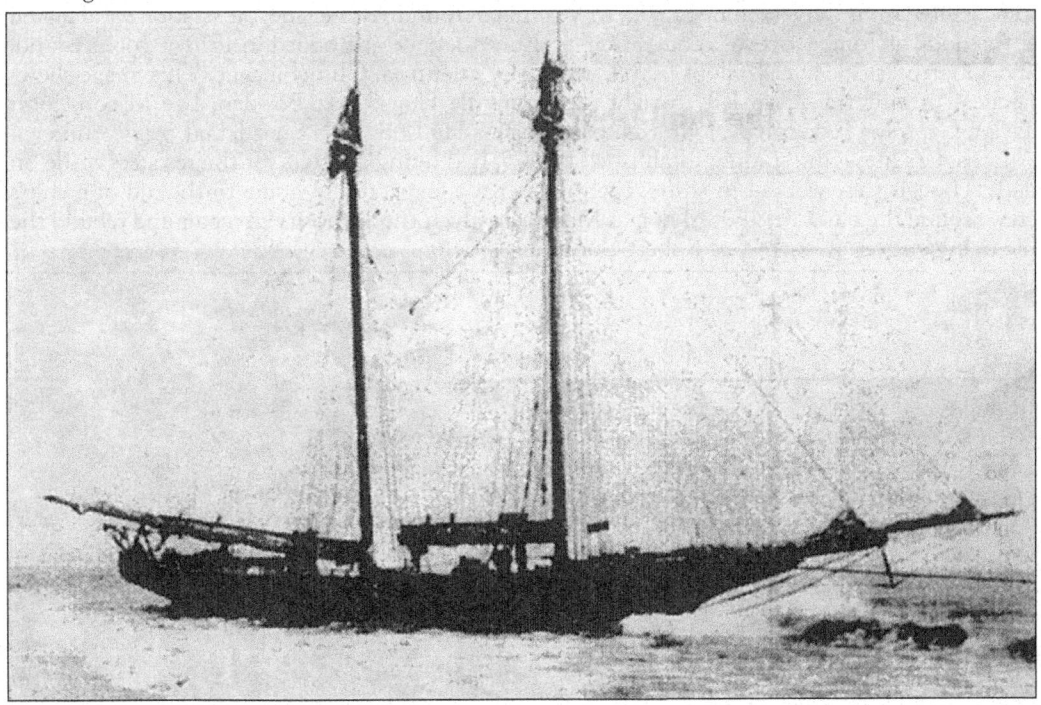

THE SCHOONER ALBERTA. This 1925 image shows the schooner *Alberta* grounded on Assateague from ice and frozen shores that deceived the captain as he sailed the ocean. The 1906 ship transported empty barrels to Norfolk, where it picked up and brought back coal for the Seafood Fish Oil and Guano Company. The *Alberta* was owned by "Squealer Dan," who was the brother of John B. Whealton, the builder of the causeway that crosses the mainland into Chincoteague. (Courtesy of Kirk Mariner.)

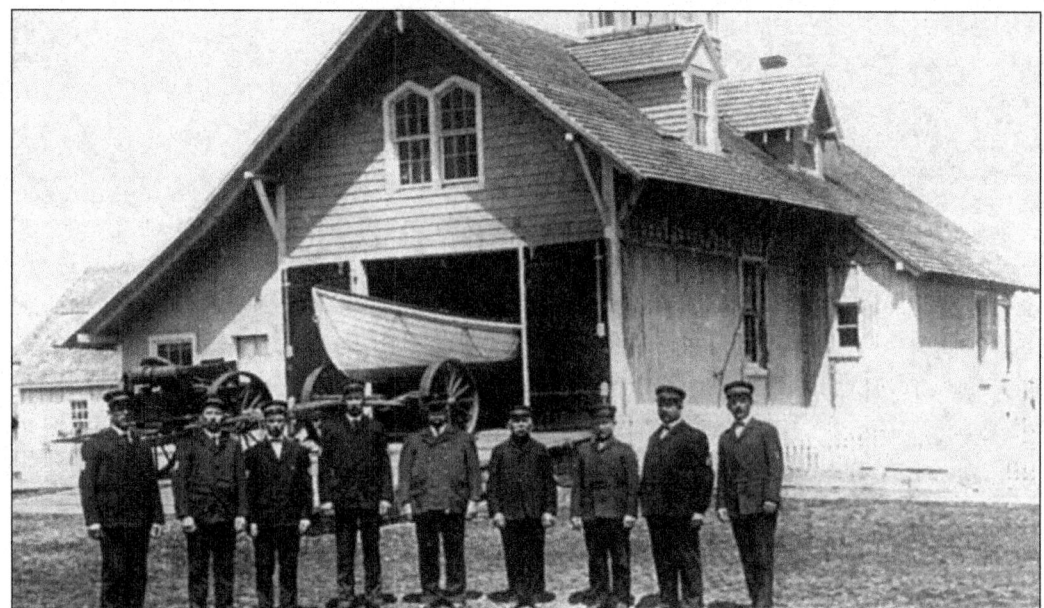

A U.S. LIFESAVING STATION, C. 1905. Law and order came to Assateague when Congress authorized the establishment of three types of lifesaving stations in 1871. Eight such stations were erected from Cape Henlopen, DE, to Virginia. Around Assateague, one station was located at the hook of Tom's Cove; a second at Green Run Inlet; a third, added in 1878 at Pope's Island; and a fourth, in 1884, at Wallops Island, across the inlet from Chincoteague. This image shows rescuers in uniform. From left to right are Granville Hogg, Bert Bowden, Lee Mason, John Taylor, Capt. Joe Fedderman, John Kambarn, Joshua Hudson, John Snead, and Selby Andrews. Assateague's lifesaving station, established c. 1875, had living quarters for the rescuers while on duty. Though they worked in shifts, each rescuer was expected to come to the aid of a ship's crew around the clock. In 1908, Thomas Mears was given the authority to repair and rebuild the lifesaving station. (Courtesy of Robert Conklin.)

A FORMER LIFEBOAT STATION. In 1915, the U.S. Coast Guard succeeded the lifesaving station. This 1991 photo shows an 1874 lifeboat station; it remained in such fine condition that the National Park Service used it for employee quarters. When the hook (Tom's Cove) at the end of the island began forming from an accumulation of sand, rescuers had to travel farther down the shore in boat, so a small boathouse was built to cut back on time and distance. (Courtesy of Richard Chenery III.)

A U.S. LIFESAVING STATION BOATHOUSE. This north beach auxiliary boathouse—not a full lifesaving or Coast Guard station—was a forerunner of the one on Pope Island. Boats were stored here until needed. In earlier times, rescuers had to travel farther down the cove by boat to get to the ocean, so a small boathouse was built to save time and distance. Though currently abandoned, this boathouse is situated at parking lot #1 on the National Seashore.

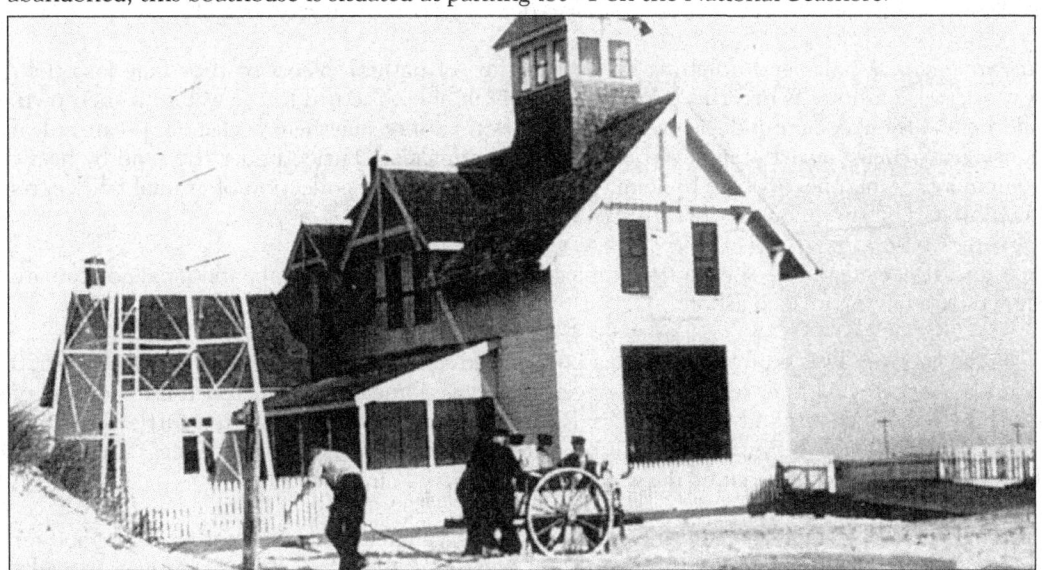

THE NORTH BEACH LIFESAVING STATION. Pictured here is a lifesaving station built in the early 1900s on the north beach of Assateague. Each station offered lodging for rescuers, as well as equipment such as life preservers and lines, life wagons, and boats. The station pictured here is the fourth on the National Seashore and was manned from 1883 to 1884. (Courtesy of Assateague Island National Seashore.)

A BEACH COLLAGE. This collection of images details life on the barrier island.

(top row, left) Whales and dolphins may be victims of natural events or they may lose their way and wash ashore. When this happens, they are unable to return to the water on their own, and hence, they die aground. If human intervention cannot put them back to sea—an ordeal considering their massive weight—then the dead animals are buried under the sand by heavy equipment. Sometimes a whale bone may wash ashore, but the collection of animal body parts is prohibited by law. (Courtesy of Ann Bell, NPS.)

(top row, right center) The shells of a long-legged spider crab, a blue crab, and a calico crab are shown here having washed ashore.

(top row, far right) This skull belonged to a Loggerhead sea turtle weighing between 400 and 500 pounds. As is true with all sea turtles, Loggerheads have joined the "threatened list" because of death by natural causes and mass killings. Ranger Larry Points offers that if a turtle is seen on shore, it was probably hit by a boat. This prehistoric species commonly lays her eggs under sand for a gestation period of about 60 days. (Courtesy of Larry Points, NPS.)

(bottom row, far left and left center) This image is of a valuable resource that provides food for hundreds of thousands of migratory birds and baby Loggerhead turtles. Watermen annually fish nearly 1 million pounds of horseshoe crabs. Although they are called crabs, they are really relatives of spiders and ticks. Their carcasses are often washed ashore, where they may be flipped

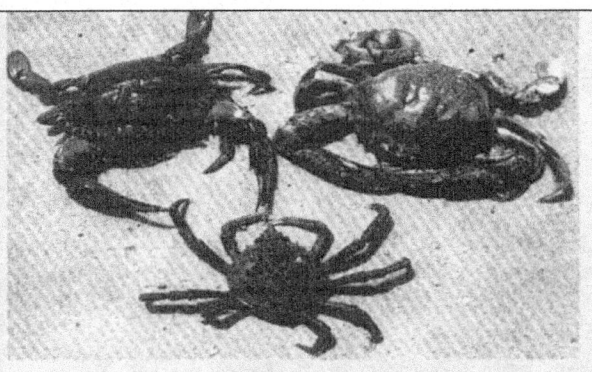
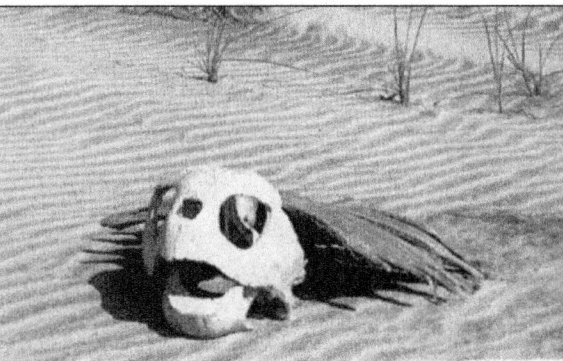
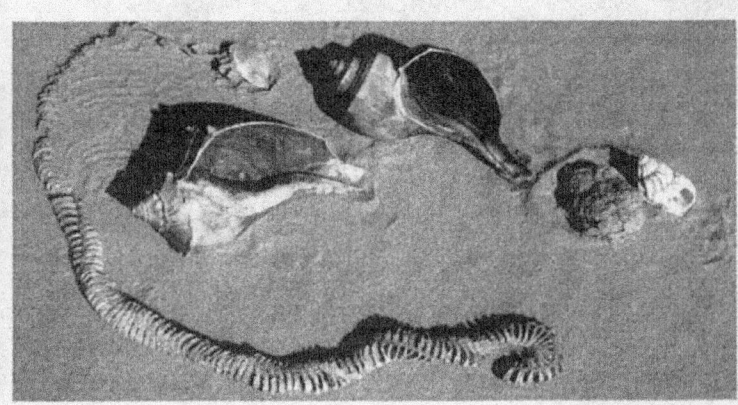
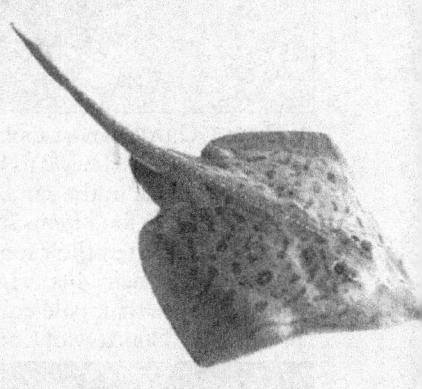

over by gulls and eviscerated. If the shell is completely empty but intact, it is likely the animal has molted so that it may continue to grow. Horseshoe crabs are throwbacks in history, having walked on the bottom of the sea for the last million years. Their gills allow them to move by walking or swimming, and once they find food, they crush it with their shoulders and suck it into its digestive system. Horseshoe crabs spend nearly an entire year offshore; in the spring, they crawl up on the sand into coves to lay thousands of eggs—most of which do not live because of birds preying on them or waves washing them back out to sea. The first image is of an eviscerated crab lying on its back showing its ventral gills, armor-styled plates, and spiked tail, while the next photo is of the specimen in its natural form. The black rectangular object is the egg case of a skate (see far right). (Courtesy of Len McKenzie, NPS, and Carol McNulty, NPS.)

(bottom row, right center) Seashells and snail shells frequently wash ashore. Whelks are a breed of marine snail whose reproduction involves snake-like strands that hold up to 100 egg cases. Shells with projections are "knobbed whelks"; "channeled whelks" have smooth spirals; "waved whelks" have ball-shaped cases. (Courtesy of NPS.)

(bottom row, far right) Skates look like stingrays but are actually fish, and they can be seen swimming near the shore. They hatch from black, rectangular, rubbery cases called "mermaids' purses" (see the image of the horseshoe crab in the bottom row, left center). When washed ashore, the ribbons of eggs are in a necklace arrangement. These egg cases are similar to those of sharks, which are relatives of the skate. (Courtesy of Doug Buehler, NPS.)

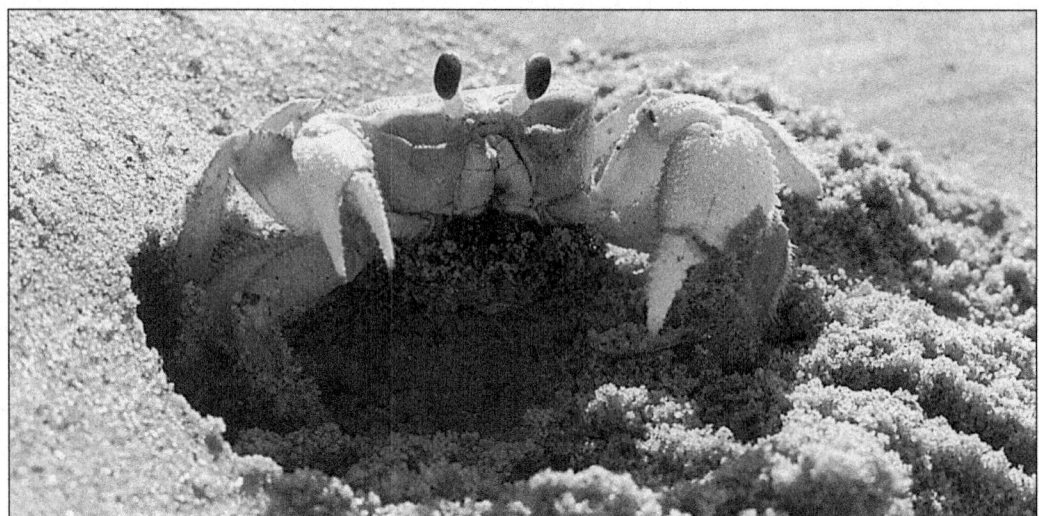

A GHOST CRAB. Ghost crabs are one of the swiftest, primarily land-dwelling members of the crustacean family. They can be seen at night, and their presence can be detected in the daytime by burrows made in the sand. Organic matter lying in the sand is their staple food. Often ghost crabs store large food items such as dead fish by burying them. The crabs' claws are so powerful that they can shred their food before eating it and cause damage to human flesh. Ghost crabs have retained their gills, which must be kept moist in order for them to breath. They are so named because their pale color allows them to easily blend into the sand, giving them a ghostly appearance. (Courtesy of Carol McNulty, Eastern National.)

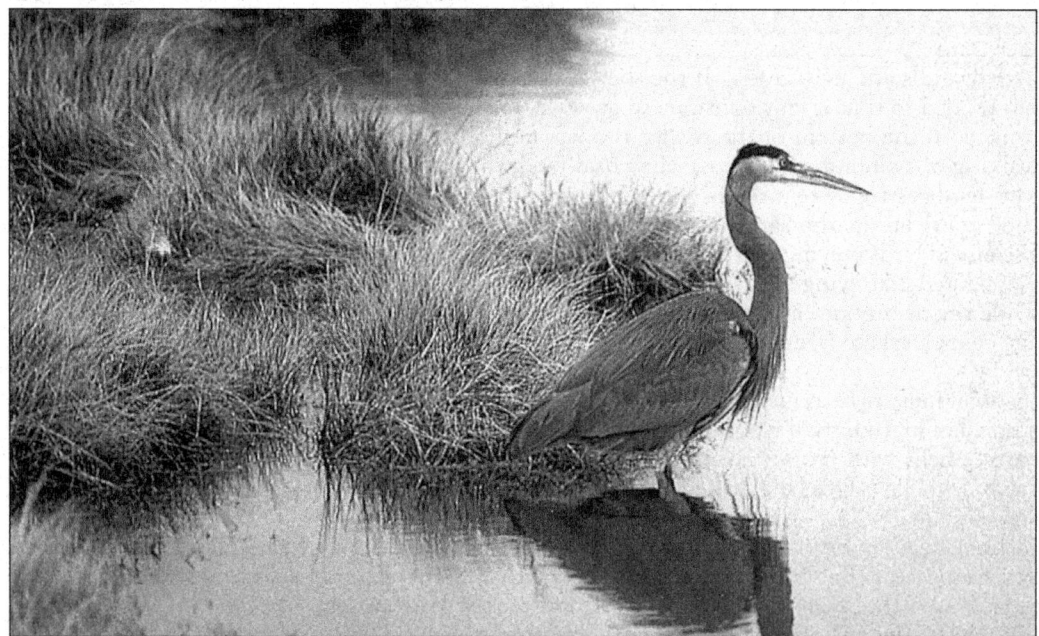

A BLUE HERON. Great Blue Herons (*Ardea herias*) can be seen from roadsides in wetlands hunting fish or in flight with their necks folded back on their shoulders and their large wings flapping majestically. Their average height is 48 inches, and when startled, they make a loud "craak" sound. Astute fishers, their sharp reflexes and long bills enable them to catch small game. (Courtesy of Eastern National Park & Mon. Assoc.)

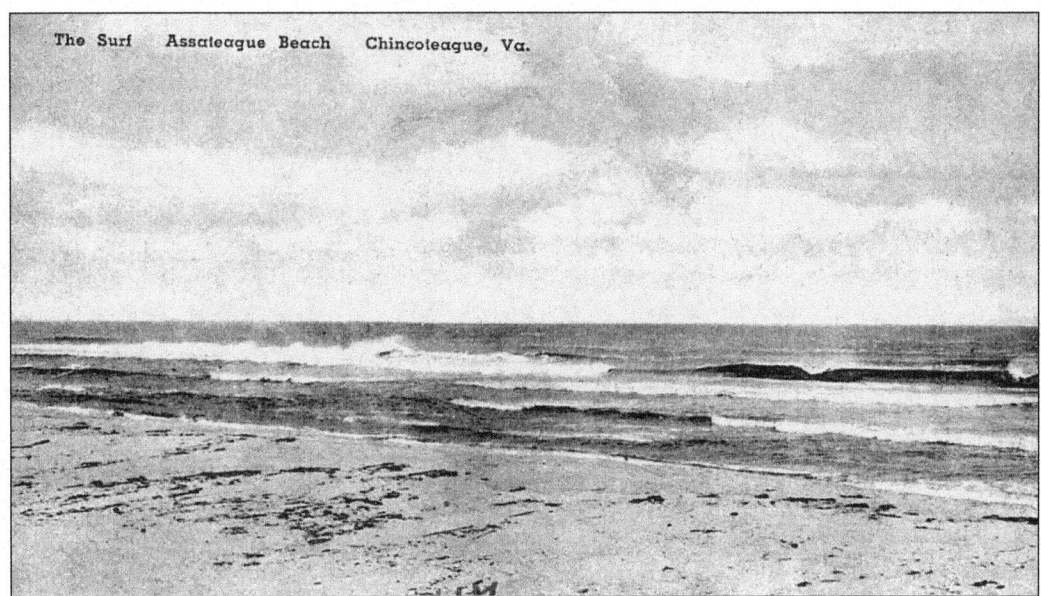

THE SURF. This 1947 photo gives a feel for the shore, back during a time when the island had few visitors. Notice the roughness of the sand and how expansive the water looks. Today, Assateague still does not permit commercialism of any type, and hence, it retains the primitive look offered in this image. Compare this image to the more recent one below. (Courtesy of H&H Pharmacy.)

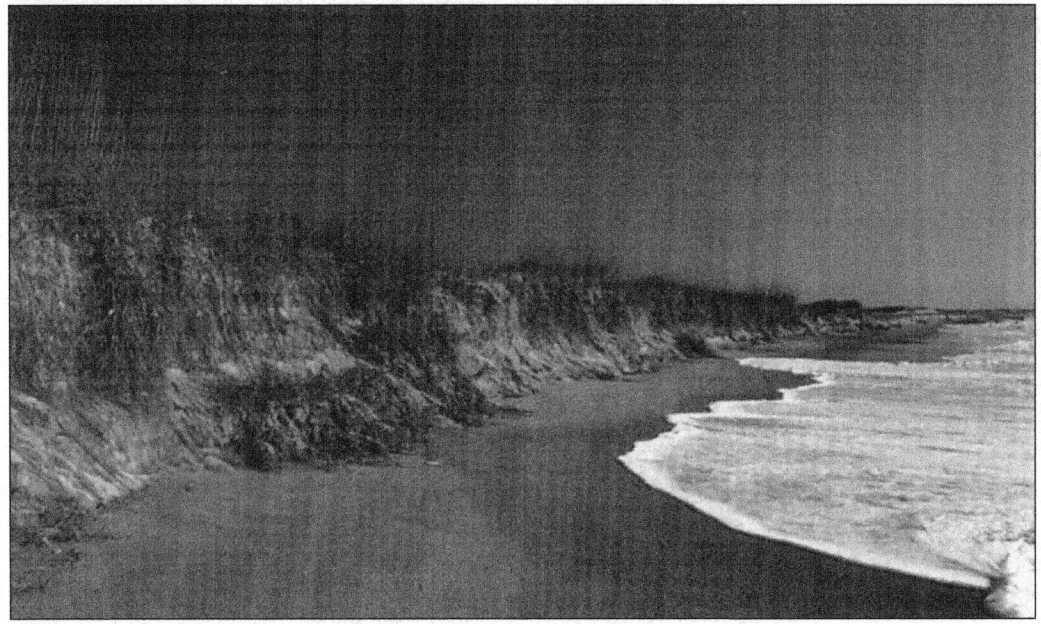

A SECLUDED BEACH, C. 1970S. Unspoiled shores are synonymous with Assateague, where activities are limited to communing with nature, swimming, sunbathing, hiking, backpacking, fishing, shell collecting, beachwalking, clamming, crabbing, birdwatching, and canoeing. You will not find one shop, restaurant, or fast-food service on the island. This is how Assateague has kept its charm and beauty. (Courtesy of National Park Service.)

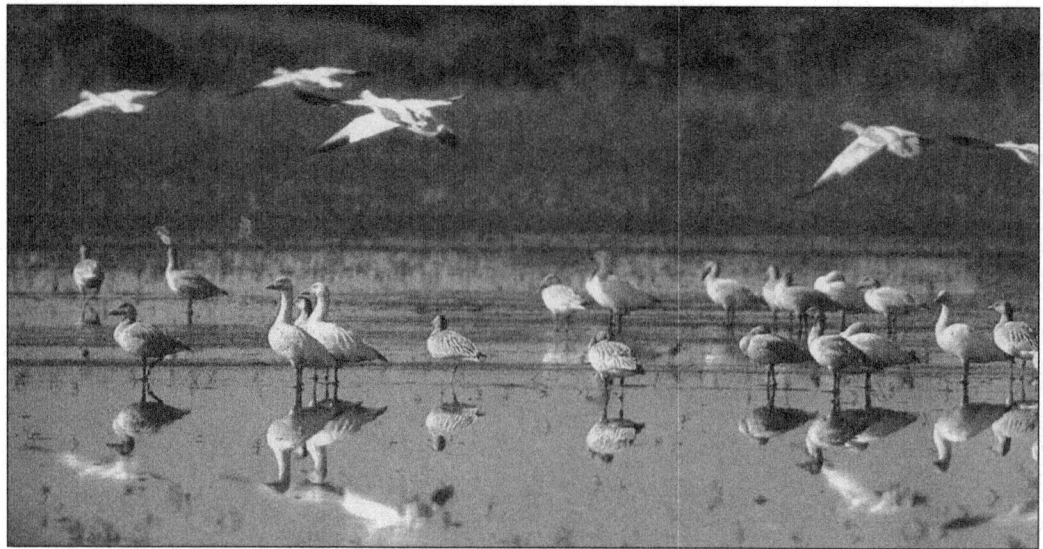

SNOW GEESE. Because these birds were nearly extinct due to hunting and egg collecting, the Chincoteague National Wildlife Refuge was established in 1943 on the south end of Assateague Island along the Atlantic Flyway. During the summers, these migratory birds nest in the Arctic only to return to Virginia in the winter months. (Courtesy of Eastern National Park & Mon. Assoc.)

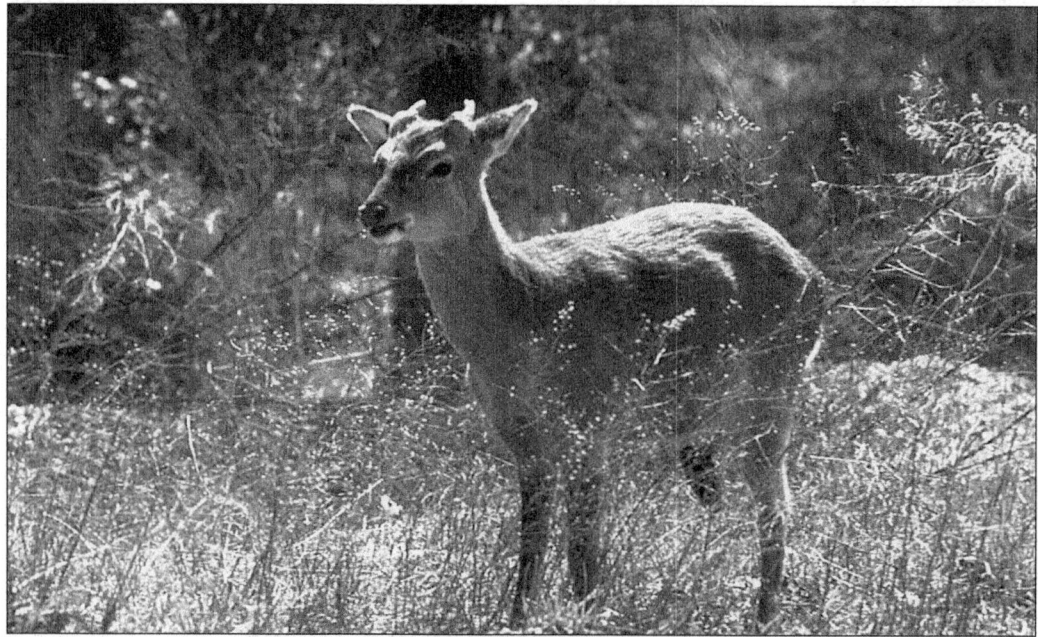

A SIKA DEER. About 12 of these spotted, "camouflaged" deer, a type of miniature elk from Japan, were introduced to Assateague Island in the 1920s by Boy Scouts during a National Jamboree. Over the years, the Sika have come to shy away from humans, and they easily blend into the background so that it is hard to detect them, even when they are close at hand. Sometimes the Sika deer can be spotted in the same roaming zones as the ponies. Having acclimated to Assateague's environment, there are currently as many as a thousand Sika deer living on the 38-mile island. (Courtesy of Eastern National Park & Mon. Assoc.)

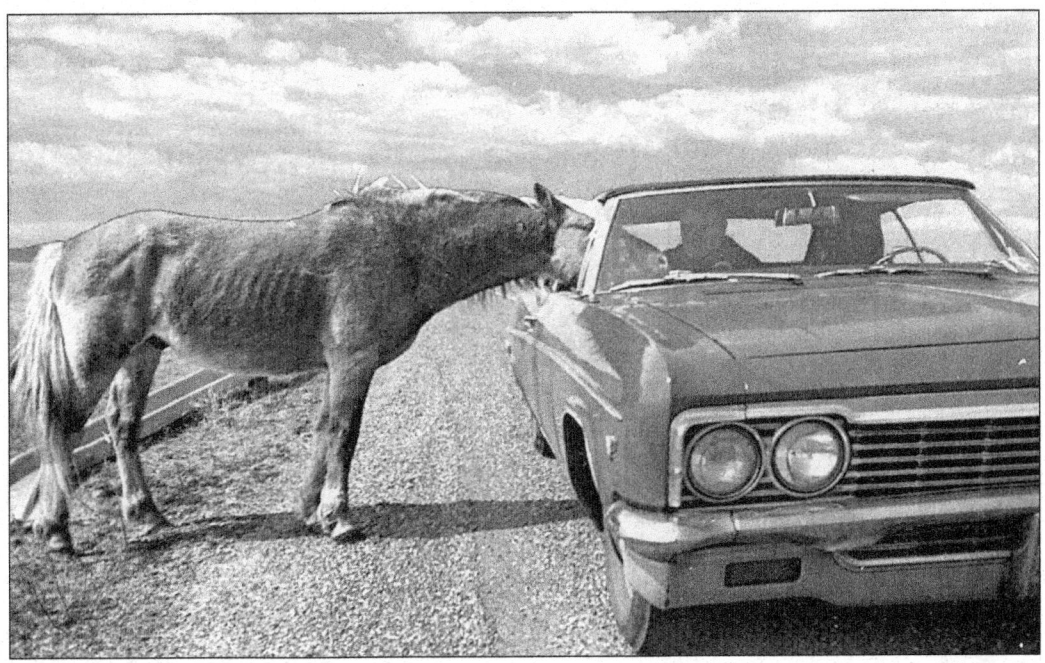

A CASUAL VISIT. Wild ponies are usually only seen on the beach during the summer, when the animals need relief from the hoards of biting insects and want to feel the cool ocean breeze. Occasionally the horses will enter the Atlantic waves to enjoy the crashing tide's refreshment, or they will greet visitors, even while in their cars. (Courtesy of Tingle Co.)

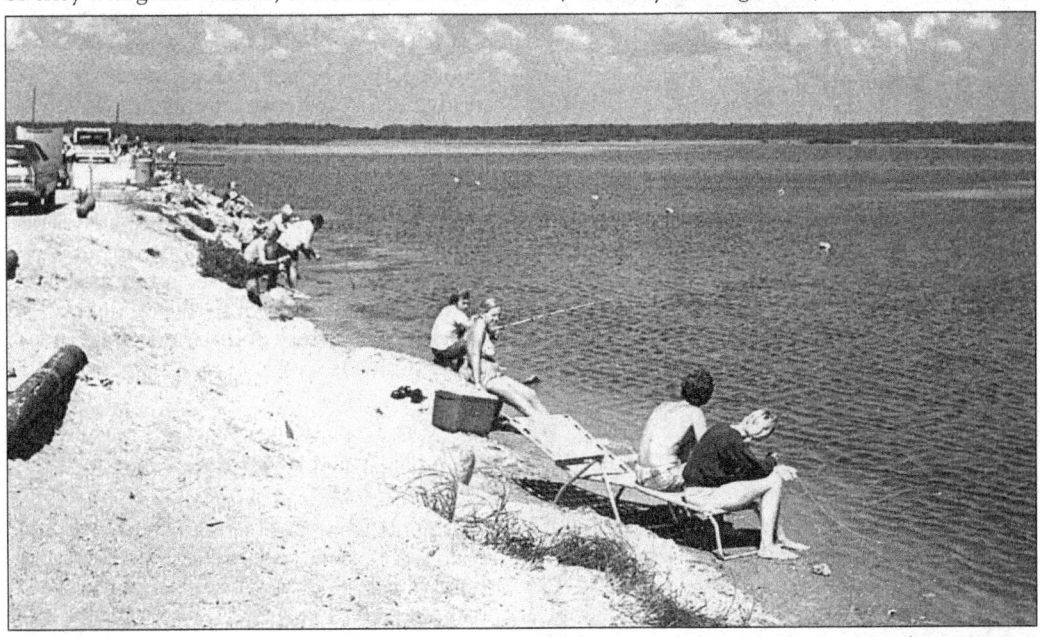

CRABBING AT ASSATEAGUE, C. 1980S. Fishing of all types and crabbing are popular activities among visitors. Note the pristine beach and the amateur crabbing techniques—professional crabbers use crab pots, nets, or baited lines placed in the water. Boats are employed as the crabbers go farther out in the water. (Courtesy of Paul and Helen Merritt, Pony Penning Enterprises.)

Official Bird of Assateague Island

THE MOSQUITO
(CULEX PIPIENS)

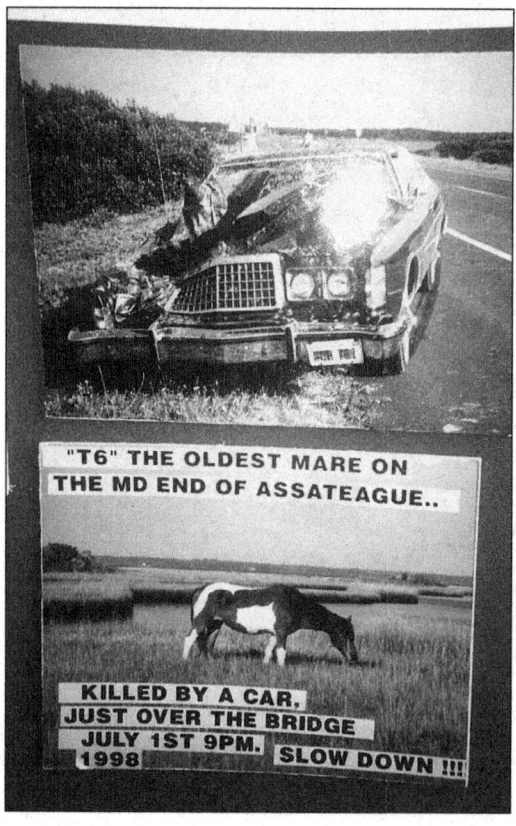

ASSATEAGUE'S OFFICIAL BIRD. With lush green grass, marsh lands reminiscent of a different time period, and the majesty of the island's natural life, Assateague's beauty cannot be equaled anywhere. It is an idyllic and awe-inspiring setting, save for the vampirish mosquitoes. Assateague appears to have an abundance of such pests because of its low-lying salt marshes and areas of stagnant water, which are a favorite of mosquitoes. Weeks and months that have no rain or humidity seem to breed the creatures because of the water at the shoreline. (Courtesy of Roland Bynaker of Trade Winds.)

THE MURDER OF "T6." This poster in the visitors center in Assateague, MD, documents what can happen when drivers speed in the slow zone of the park. "T6" was the oldest mare on the island until the day she came too near the Verrazano Bridge to graze and was struck by a car on July 1, 1998, at 9 p.m. Notice, also, the condition of the car. The accident proved to be a tragedy all around. (Courtesy of Maryland Visitors Center, Assateague Refuge.)

Two

CHINCOTEAGUE ISLAND
IMAGES OF TOWN

In 1650, Colonel Daniel Jenifer—the first to obtain a land grant on Chincoteague—was patented 1,500 acres on the island. The residents of that time lived primitively and simply, lucky to have roofs over their heads and sand below their feet as floors. The women made clothes by hand, food came from organic gardens, and the major mode of transportation were horse-drawn buggies or one's own feet. Illnesses and injuries were common and often resulted in death because of the lack of health care. Mothers were "Dr. Mom" back then and treated the sick based on their common sense and a fundamental knowledge of herbs. This led to the propagation of such "healers" as Ms. Reynolds, who was known for her ability to cure cancer, though she died with her secrets, never divulging what organic remedies she used.

The simple life was a tough one, but Chincoteaguers were an even tougher breed. Within two decades, the island was settled by such hardy families as the Bishops, Jesters, Bowdens, and others, who established large farms. Soon after came the Whealtons, Watsons, Thortons, Mears, Savages, and a number of other kin and their progeny, who are still represented on the island today. All these people have made numerous contributions to the welfare, improvement, and advancement of their community and its members.

Over time, various religions were welcomed and accepted on the island, bridges were built, roads were paved, and waterways were made navigable. Retail businesses opened, along with restaurants and lodging, and schools were established.

By the early to mid-1900s the seafood industry skyrocketed, hunting began taking a toll on wildfowl, and transportation a necessity for the conveyance of seafood products and the many tourists who wanted to visit the islands.

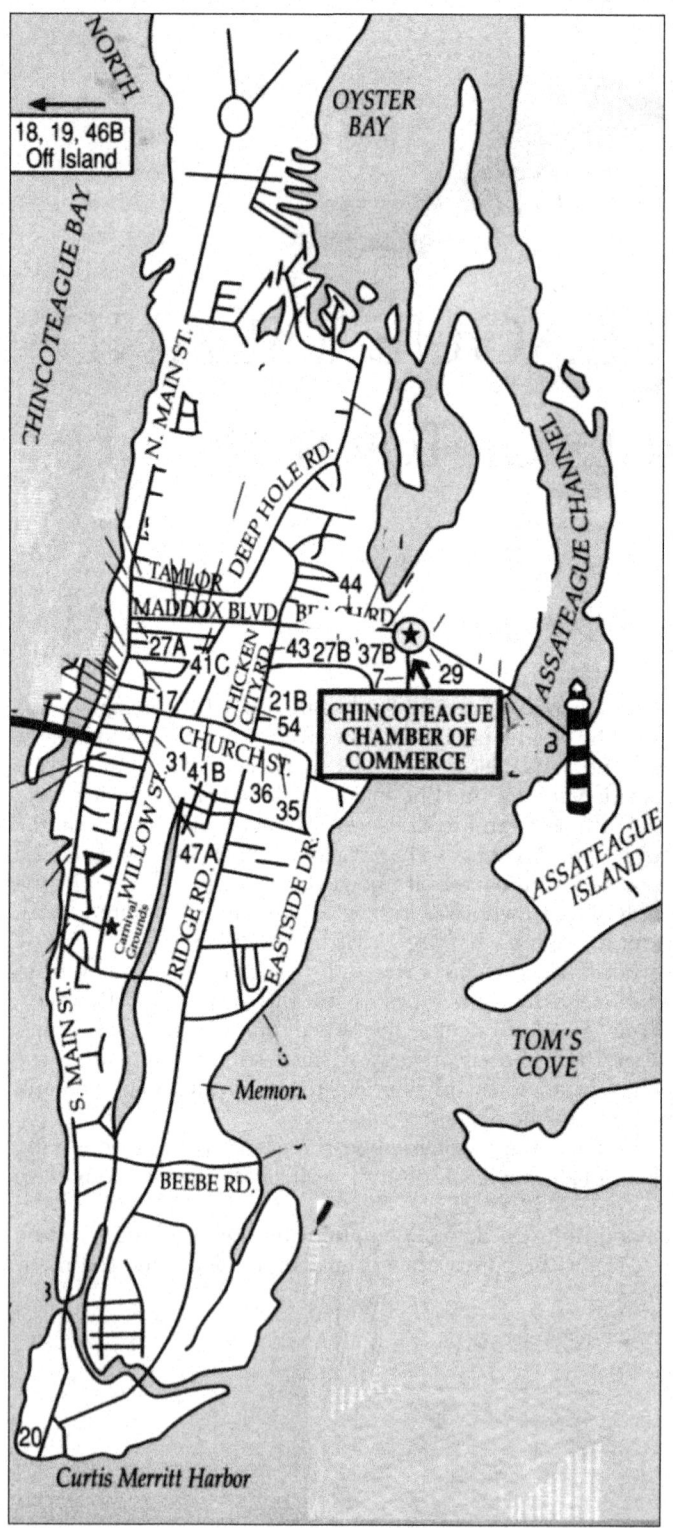

A CHINCOTEAGUE TOWN MAP. This map provides street names and the layout of the island. Clearly marked is the chamber of commerce, a great source of easily accessible information since it is on Maddox Boulevard—the main road into Assateague. There is a push for the construction of a major visitors complex (to be completed in 2003), which will offer exhibit halls, educational facilities, environmental education programs, and refuge administration. Notice that Chincoteague and Assateague are separated by Assateague Channel, that Tom's Cove is at the hook of the refuge, and that the causeway (the dark black line) crosses the Chincoteague Channel and enters the island at Main Street. North Main Street goes up to Oyster Bay, where it dead-ends in a cul-de-sac effect. South Main Street ends at Merritt Harbor. (Courtesy of Chincoteague Chamber of Commerce.)

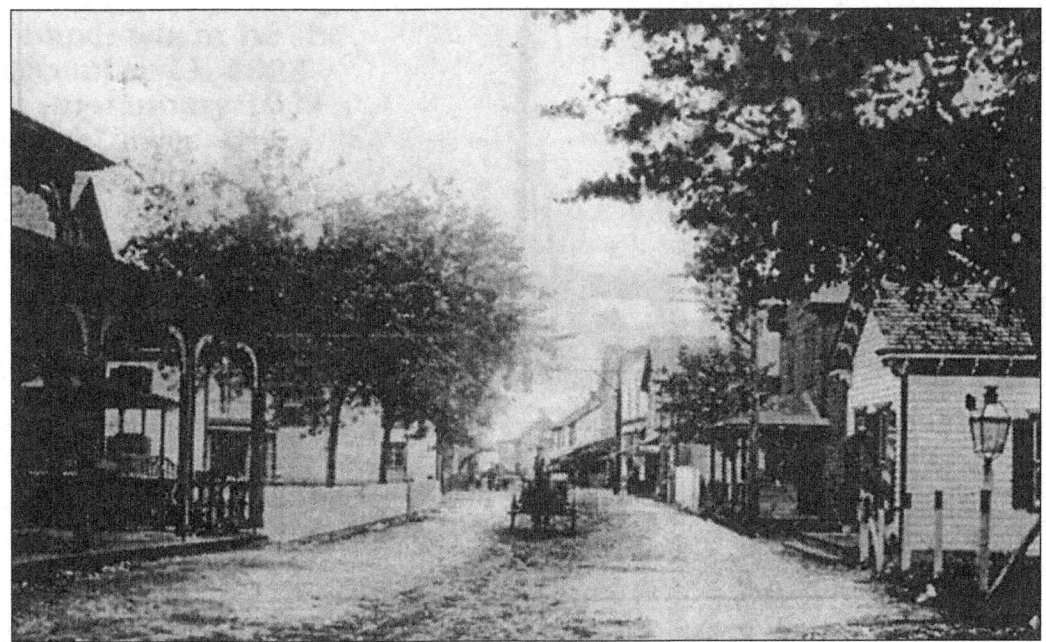

LOOKING SOUTH. This c. 1910 image shows a quaint-looking downtown, with tall, full trees and lanterns lining the road, which lacked any sort of pavement. In the middle of the street is a man riding in a one-horse wagon, probably to peddle his goods. The first structure on the left of the photo is the front porch of the old Atlantic Hotel. (Courtesy of Kirk Mariner.)

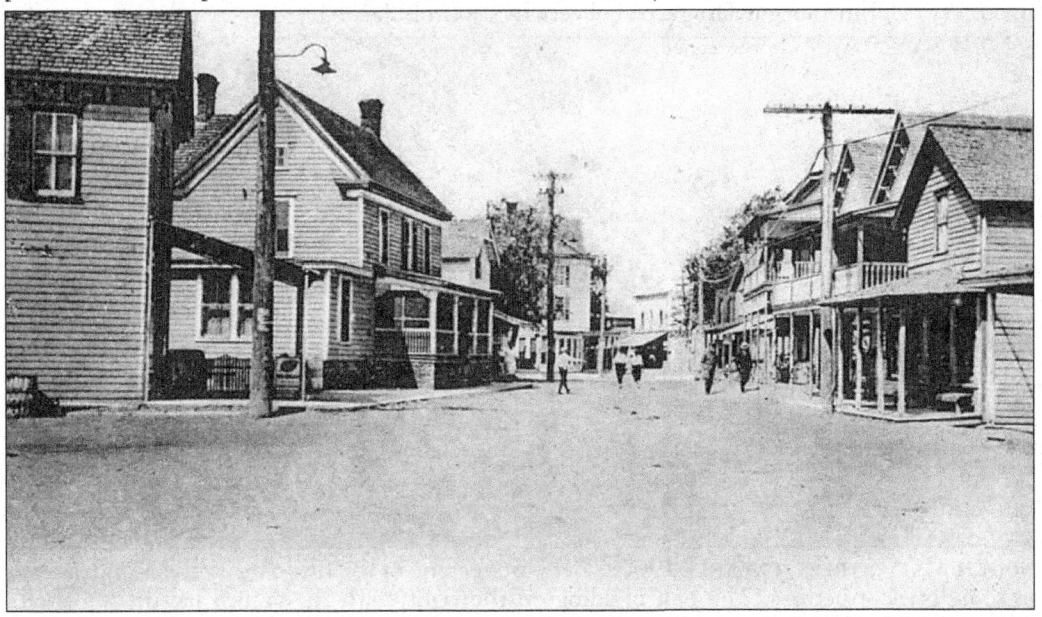

MAIN STREET, TURN OF THE 20TH CENTURY. This early 1900s postcard depicts Chincoteague over 90 years ago, when it was beginning to develop and had about 2,000 residents. The 3-mile-wide, 7-mile-long island offered few stores, inns, taverns, churches, and public buildings, but there was a post office, a notary public, and even a shoe store. The street was not paved—like all roads of the time, it was made of dirt and covered with seashells. (Courtesy of Louis Kaufman & Sons; collection of John E. Jacob.)

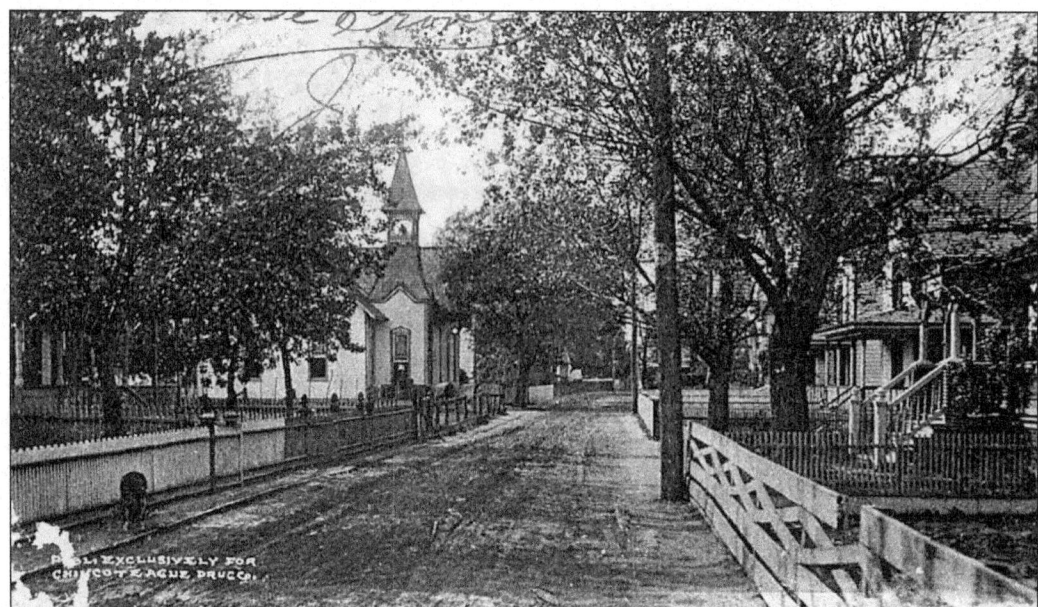

CHURCH STREET. Streets were made of oyster shells, and if a cemetery lay in the route of the roadway, as in the case of this image, the road went through it. Notice that the telephone pole in the right foreground appears to be situated in the path of cars. The first cars on the island were Fords and were brought over by auto salesman David Russell. Islanders enjoyed driving their new toys across the bridge to the mainland. The back of this card is dated January 14, 1909. (Courtesy of Chincoteague Drug Co.; collection of John E. Jacob.)

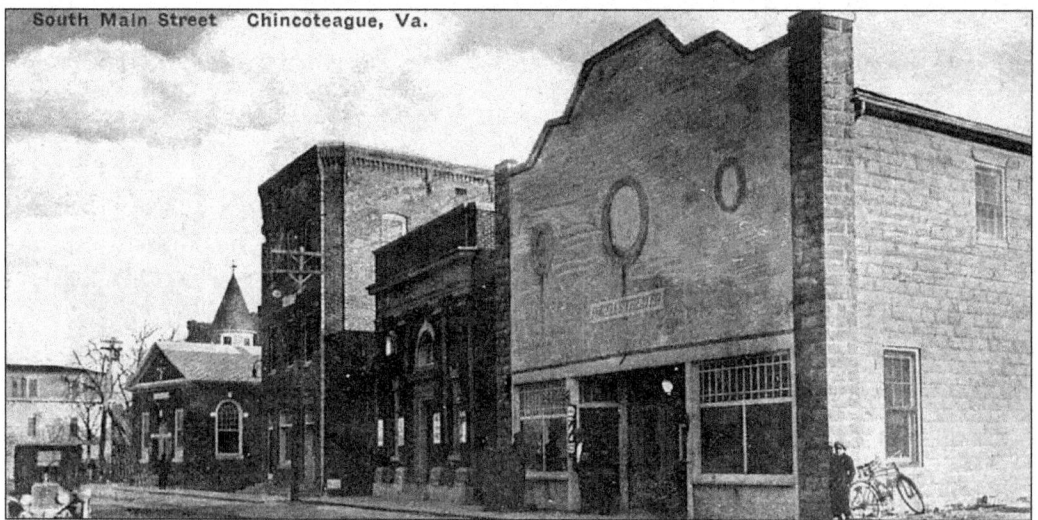

SOUTH MAIN STREET, C. EARLY 1900S. Here, we see one of the first cars on the island, as well as some brick structures. The first building on the right, with the arched facade, is Powell's Theater. Perhaps the sign running vertically in front of the building is a barbershop pole. The building next to the theater is the Bank of Chincoteague; the tallest and third structure is the Masonic Temple; and the last visible building is the Marine Bank. The structure with the spire behind the bank is the house of D.J.'s Whealton—the largest residence of the time and one belonging to a man considered to be the most powerful person in the town. (Courtesy of Twilley Co.)

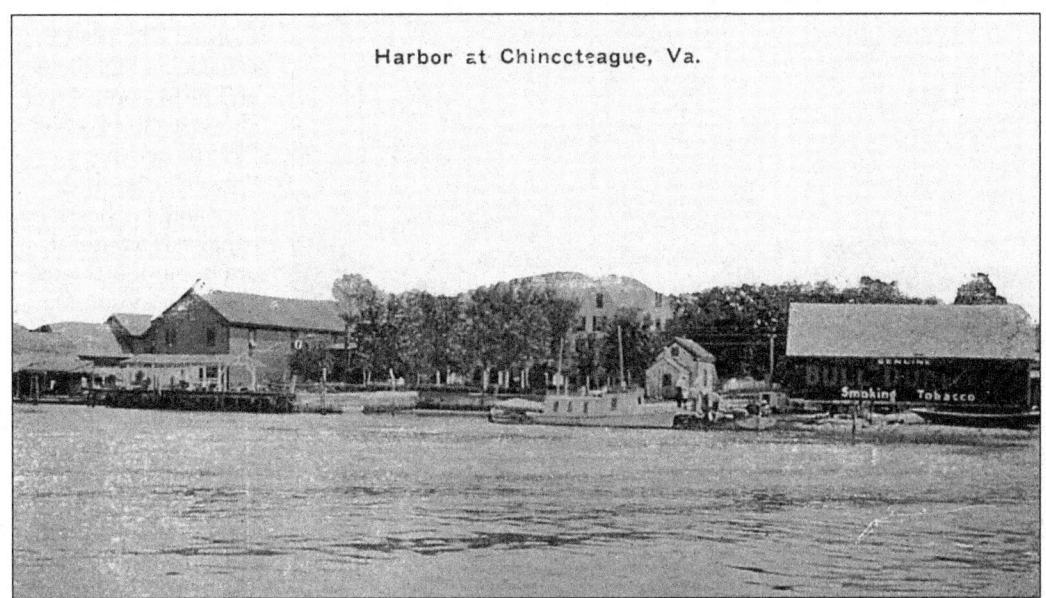

THE HARBOR AT CHINCOTEAGUE. This postcard, mailed from Chincoteague, is dated July 27, 1914, 1 p.m. The sender writes, in part, "A dandy breeze here. This is certainly a place no one could picture unless here Hope you are well and not so hot." On the right is a building with the writing, "Genuine. Bull Durham. Smoking Tobacco." The bridge was later built to the left of this structure. Work boats are moored out front, and the large dock to the left is the North Dock's pavilion, which undoubtedly was used for the ferry. The background buildings are across Main Street. (Courtesy of Louis Kaufmann & Sons; collection of John E. Jacob.)

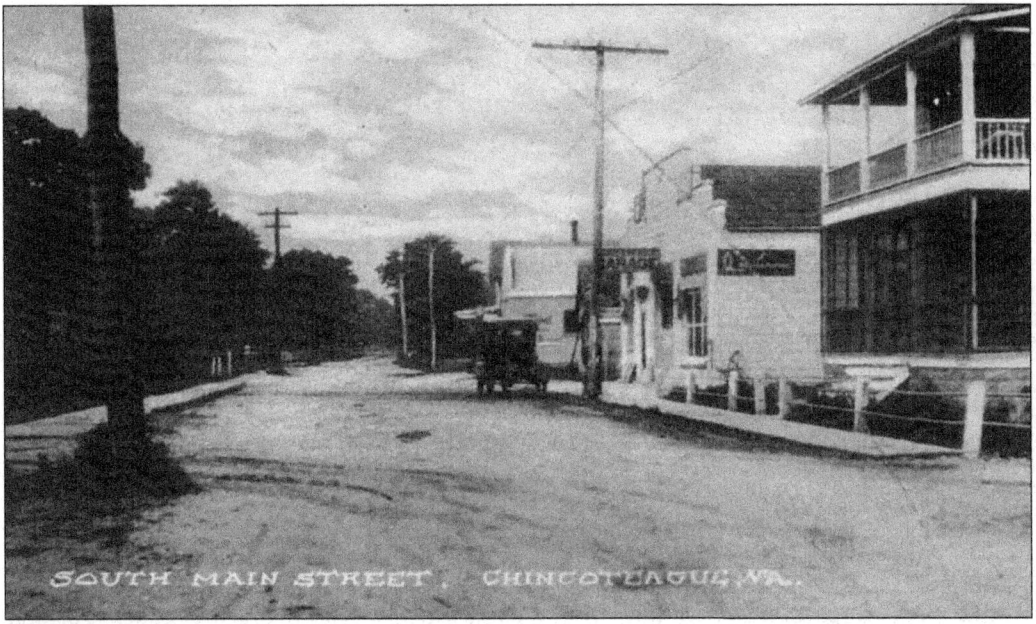

SOUTH MAIN STREET. This is likely a postcard of the town around 1918. Although there are sidewalks, telephone poles seem to be implanted in them in some places. Take note of the bend in the street past the parked car; this bend has since been eliminated. (Courtesy of Louis Kaufmann & Sons; Collection of John E. Jacob.)

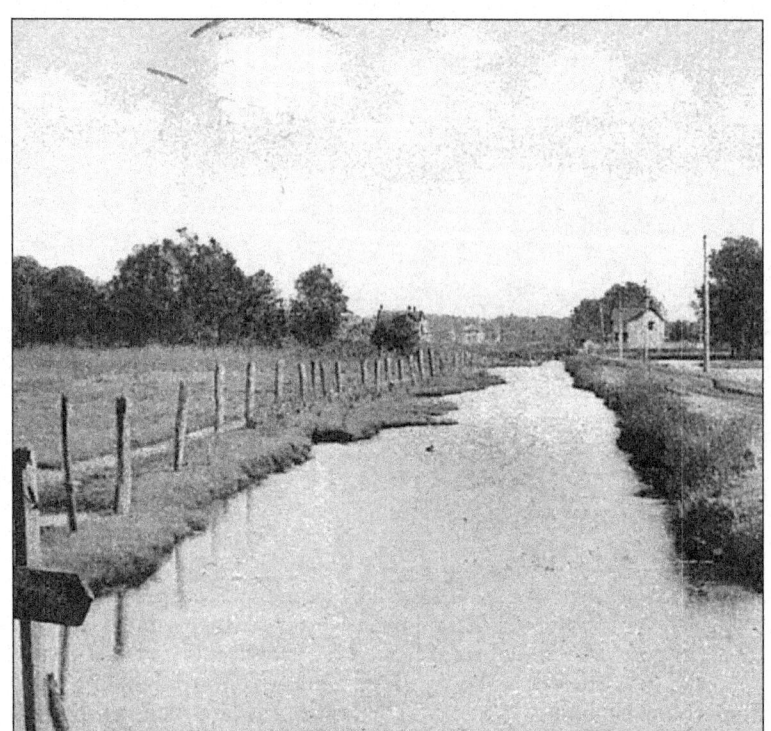

CANAL. The island is made up of valleys and hills—only 4 feet above sea level—and, like the ocean bottom, it has little rises and gulches. The canal was a natural drain, but it attracted hordes of mosquitoes, so in the 1950s, Wyle Maddox had the canal dug deeper to improve drainage and control the pesky insects. This card is postmarked 1909. (Courtesy of Baltimore Stationery Co.; collection of John E. Jacob.)

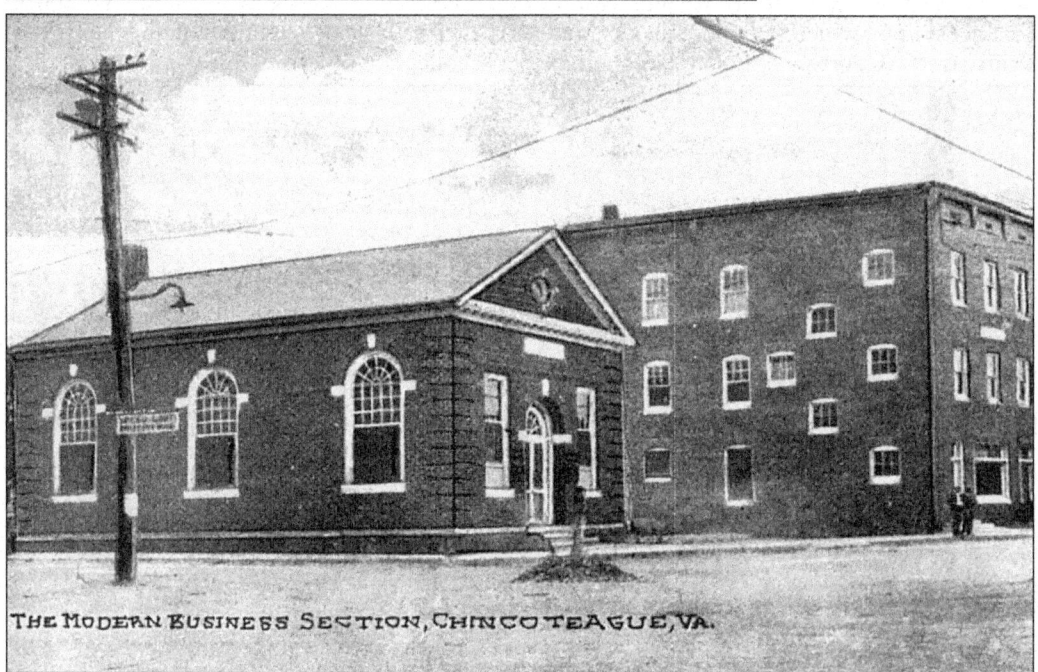

THE MODERN BUSINESS SECTION. In this postcard, which was postmarked October 1927 and mailed from Chincoteague to Cranford, NJ, we see the Marine Bank. The downtown appears a bit different from a previous postcard titled "South Main Street," because this image was taken after the fires of 1920 and 1924, which is likely why it is labeled "The Modern Business Section." (Courtesy of Louis Kaufmann & Sons; collection of John E. Jacob.)

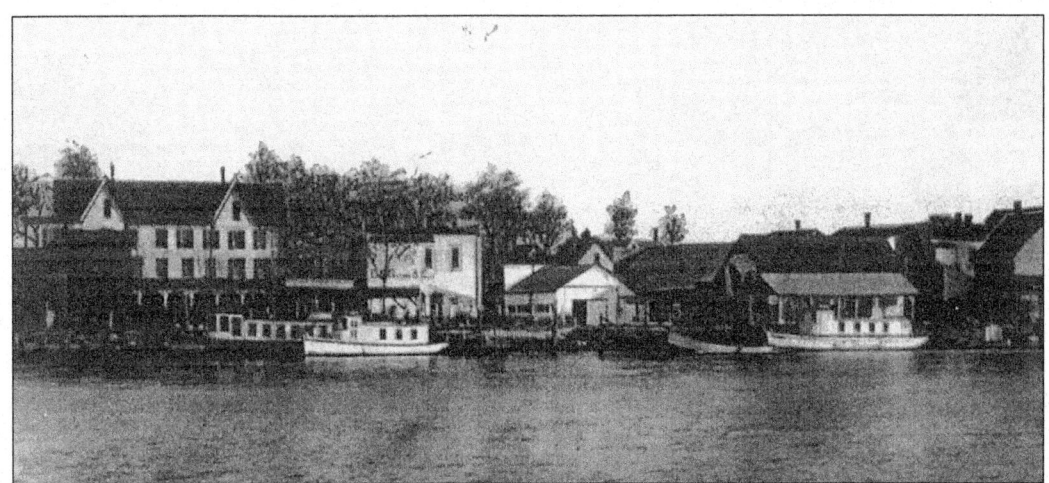

THE WATERFRONT. Similar to the photo marked "Harbor at Chincoteague," this image shows the docks, the Atlantic Hotel boat landing (at left), and the various boats moored but ready to go out at their owners' whims. The towering Atlantic Hotel is across the street from the landing. The fluid bay, seen here, occasionally froze over, as in the case of the winter of 1917–1918, during which boats were prevented from going out and people could walk across the ice to get to the other side. This wharf area prompted growth with the construction of hotels, liveries, storage sheds, a freight house, and, of course, the railroad office. (Courtesy of Donna Mason.)

THE END OF TOWN, 1930S. This image, looking away from the Curtis Merritt Harbor of Refuge, shows the end of South Street. Notice that there are no businesses in this section, and that the residential neighborhood remains sleepy and tranquil. The bay is behind the structure on the left side of the street—a dirt street with no sidewalks. The 1930s brought not only prosperity in the form of a new firehouse on the corner of Main and Cropper Streets, but also destruction with the arrival of the Storm of 1933. (Courtesy of Donna Mason.)

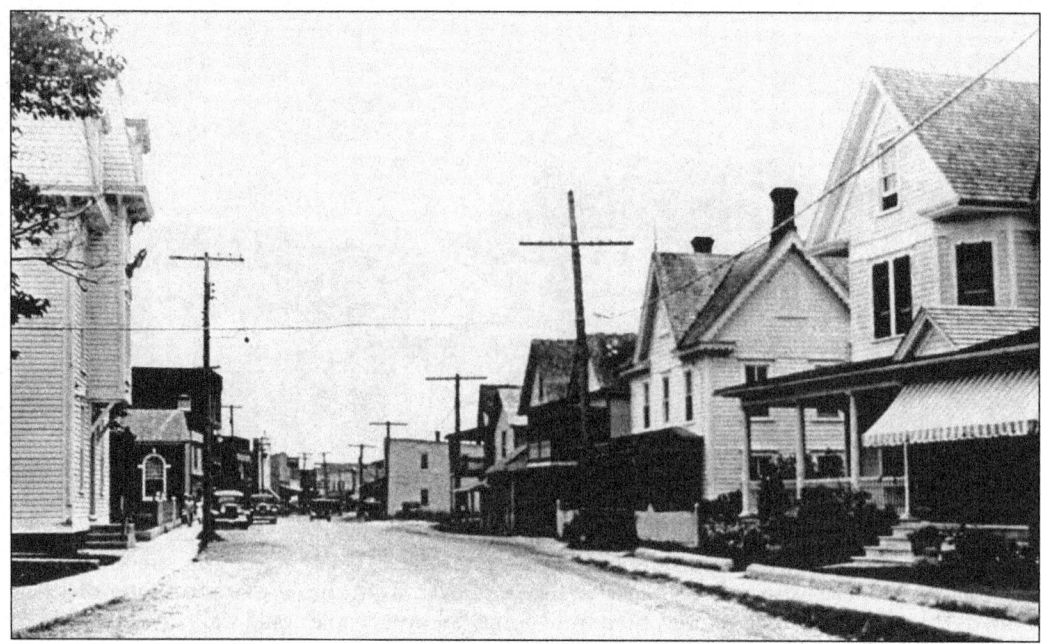

DOWNTOWN, 1930s. This interesting image shows the busier side of town during the same era as the previous image. Homes can still be seen, as well as automobiles, but the sedateness of the prior image seems gone; instead, this photo instills a sense of a town ready to boom at a moment's notice. Sidewalks are visible, as are telephone poles planted in them or so close to them that it is a wonder any pedestrian can get by. During this time, the three oldest people living in the town were Myra and Jack Daisey, and Ben Scott. (Courtesy of Donna Mason.)

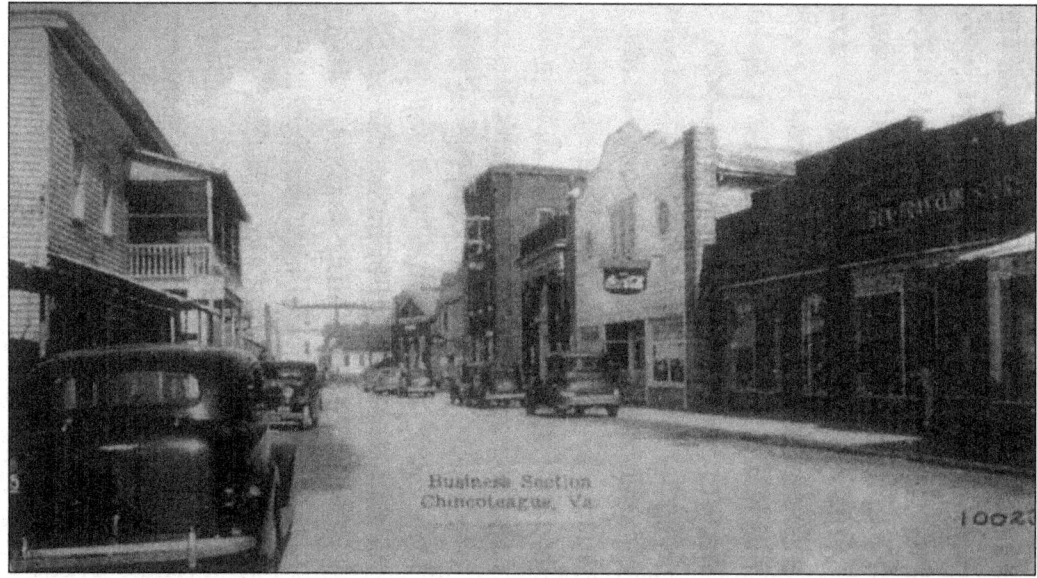

MAIN STREET, 1940s. In this photo, we see a 1937 or 1938 General Motors vehicle parked on the wide Main Street—residents realized how important and accessible transportation was to them. The car sits in front of a building with a sign reading "Garage." Chincoteague was a lively town during this decade, when the war ended and education began to take the forefront. (Courtesy of Robert H. Mears.)

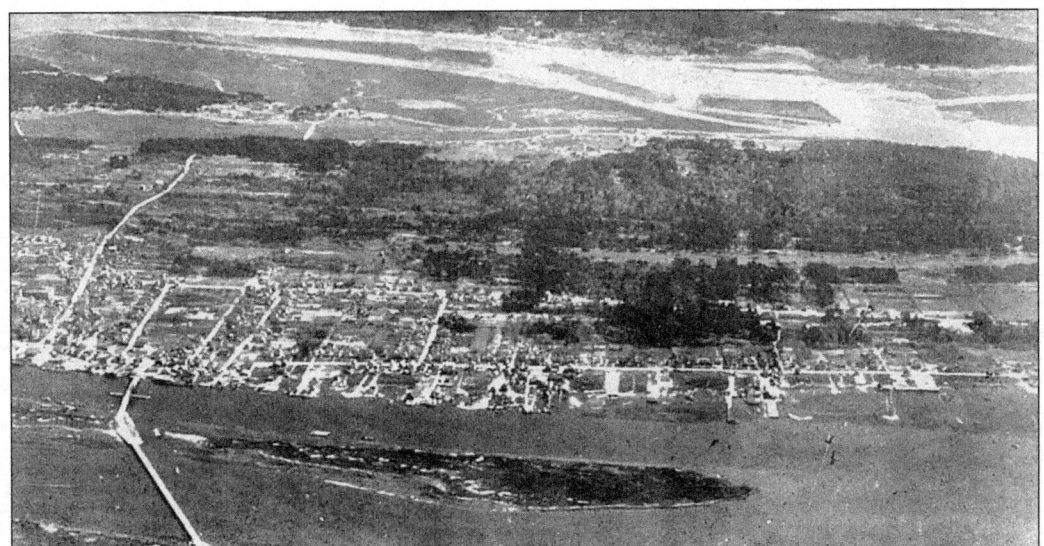

AN AERIAL OF THE BRIDGE. What a powerful picture this is of the causeway crossing the bay from Chincoteague to the mainland. Just by studying it, we can see what a feat this must have been in 1922. Today, townfolk are debating where the new bridge is to be constructed. Some want it to touch where it currently does; others want it to connect to Maddox Boulevard, which is the direct route to Assateague. Wherever it ends up, the bridge will continue to serve as the lifeline for the little island. (Courtesy of John E. Jacob.)

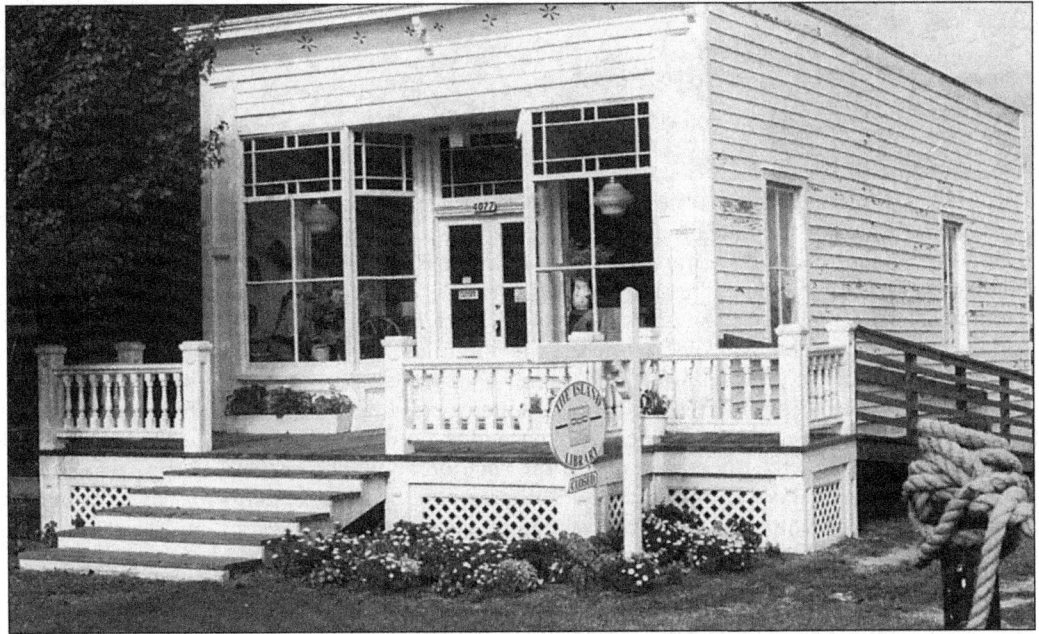

THE LIBRARY. The 1960s saw the establishment of the Eastern Shore Public Library. The branch pictured here is Chincoteague's library, which was initially located at the corner of Main Street, where the bridge entered, and served as the home of the Wallace Jester Barber Shop. The building is considered to be the oldest frame business structure on the island. In 1990, it was moved to its current site at 4077 Main Street, where it still serves as the island's main source of literature. (Courtesy of Conklin's Photo Service.)

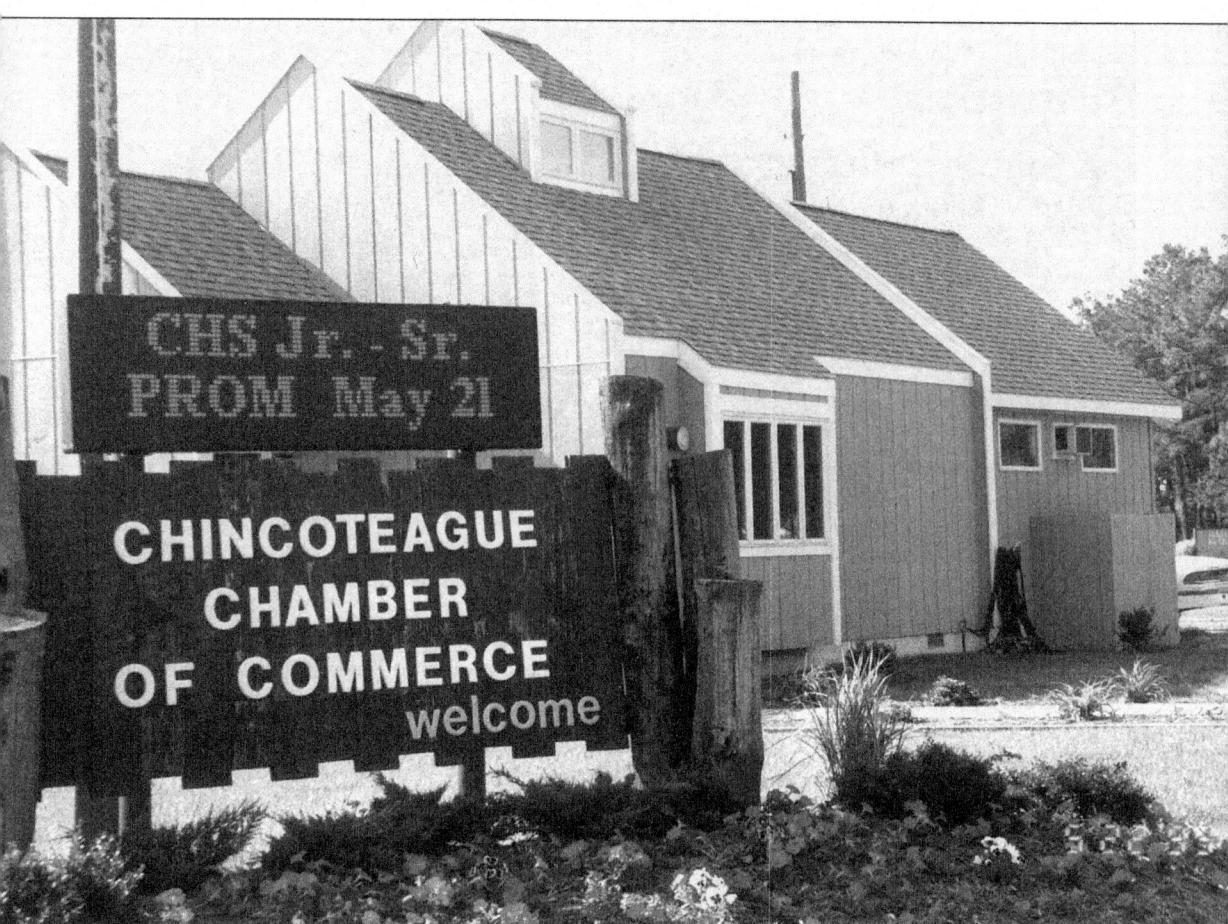

The Chincoteague Chamber of Commerce. Founded in 1954 by a group of businessmen, the chamber has grown from 66 members to well over 211. As a non-profit, volunteer organization, the chamber works at improving commerce, developing the island's economy, uniting businesses for the benefit of the town, and addressing state legislative issues. Maintaining a high tourism profile is primary to the group since the island is predominantly tourist oriented. The organization is a member of the U.S. Chamber of Commerce, the Virginia Chamber of Commerce, the Eastern Shore Chamber of Commerce, and the Virginia Tourism Commission. The sign in this 1999 image of Chincoteague's modern chamber of commerce building advertises the high school's May prom. The building is easily accessible at 6733 Maddox Boulevard, en route to Assateague, and the chamber of commerce offers a wealth of information about the island and the surrounding areas through videos, books, brochures, and other sources. The attendants are also a valuable source of knowledge. Information on the island, its events, accommodations, and pony penning may also be gleaned from the chamber's website at www.chincoteaguechamber.com.

Three

TRANSPORTATION
RIVERS, RAILS, ROADS, AND AIR

Transportation did not develop quickly in Chincoteague, but by 1855, the Pennsylvania Railroad began running its steamboats between Chincoteague and Franklin City. The island had its share of engine-powered vehicles, from trains, cars, and carts, to boats and water work vessels.

Then came steam locomotives, steamboats, and ox-drawn covered wagons. By the 1900s, Model Ts, steam-powered ocean liners, and steam trains appeared. Railroads and steamboats became an integral part of the lives of islanders, who relied on the *Chincoteague* and the *Manzanita* to carry their goods from one port to another. The years from 1870 to 1900 witnessed fast trains from Chincoteague to New York City transporting Irish and sweet potatoes shipped in 3-bushel barrels made by Chincoteague's barrel factory (which later caught fire). The train also conveyed salespeople who sold their wares to islanders, especially those of financial means who could afford to buy what they needed rather than hand-make everything.

Just as barrel factories and liveries sprang up at railroad stations, so did hotels to accommodate sales representatives and other visitors. There was a new demand for good roads, and a "superintendent" was appointed to oversee the construction of roads and bridges. One of Chincoteague's first roads led from Jester's dock, next to the Atlantic Hotel, across the marsh—hence, the advent of the causeway.

At the end of the 19th century, vehicles on the islands consisted of double and single wagons, buggies, surreys, hacks, tumbrel and speed carts, and bicycles. World War I took its toll on transportation, and "Teaguers" found themselves having to give up their autos to authorities. Supply and demand made cars more difficult to obtain until the war was over. By 1941, new autos were replacing the old ones used during the Depression. Tractors, too, sold quickly. By the 1970s, Chincoteague, like all other towns, faced the trials of a decline in fuel and supplies.

As much as the island's population has increased over the years and as crowded as the place gets in the summer (especially during pony-penning time), Chincoteague still has no form of public transportation. Yet, no one gripes about it. In fact, the laid-back islanders can not even decide where to have the new bridge enter the town. While the rest of the world may be in fast-forward, "Teaguers" sit on their porches, enjoy a cup of coffee or a couple of oysters, and discuss the ways of the world and how happy they are about not being in the midst of it.

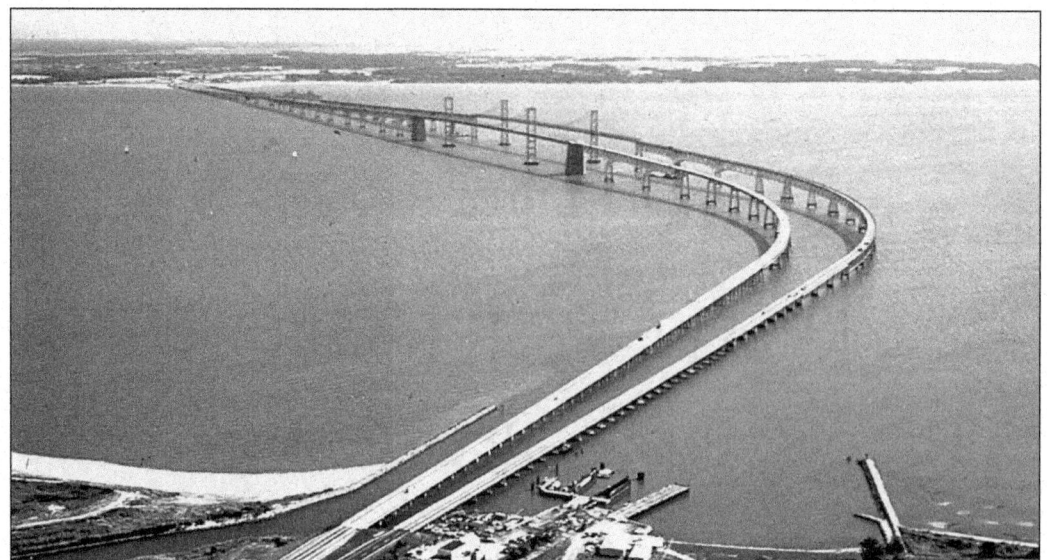

THE CHESAPEAKE BAY BRIDGE, C. EARLY 1960S. With the building of the Chesapeake Bay Bridge came the opening of the shore and a way into Chincoteague. Referred to by many as one of the "Seven Modern Wonders of the World" because of its construction and length, the first single span was built in 1952 to connect the Western Shore of Maryland to the Eastern Shore, called the Delmarva Peninsula. Traffic from the Western Shore to the peninsula's beaches and laid-back lifestyle prompted a second span to be built in 1973. The bridges are about 5 miles long and nearly 200 feet high. Many Delmarvans bear bumper stickers reading "Blow up the bridge" as a statement against the non-Shore people who "invade" the peninsula. (Courtesy of David E. Traub.)

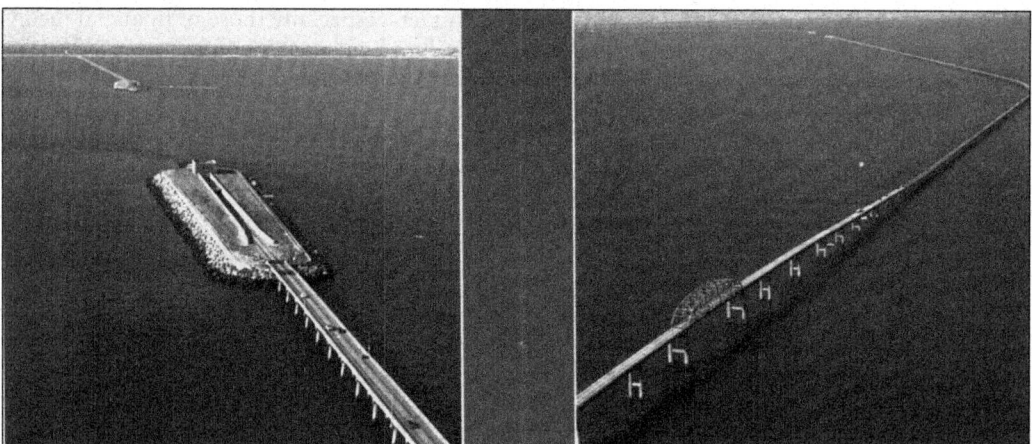

THE CHESAPEAKE BAY BRIDGE TUNNEL, C. 1970S. With the Chesapeake Bay Bridge at the north and this bridge-tunnel at the south end of the peninsula, entry and egress off the Eastern Shore has become very easy and, thus, brings even more traffic. The bridge-tunnel includes a two-bridge span of 17.6 miles, a tunnel measuring 5,738 feet, and another tunnel measuring 5,450 feet. There are four man-made islands, each of 8 acres and 12.2 miles of trestle. Construction of the bridge-tunnel required 110 million pounds of steel, 4 million cubic yards of sand, 34,000 carloads of rock, and 550,000 cubic yards of concrete. Forging began in 1960, and the bridge opened in 1964. Currently, another lane is being built. (Courtesy of Bay Bridge Tunnel Authority.)

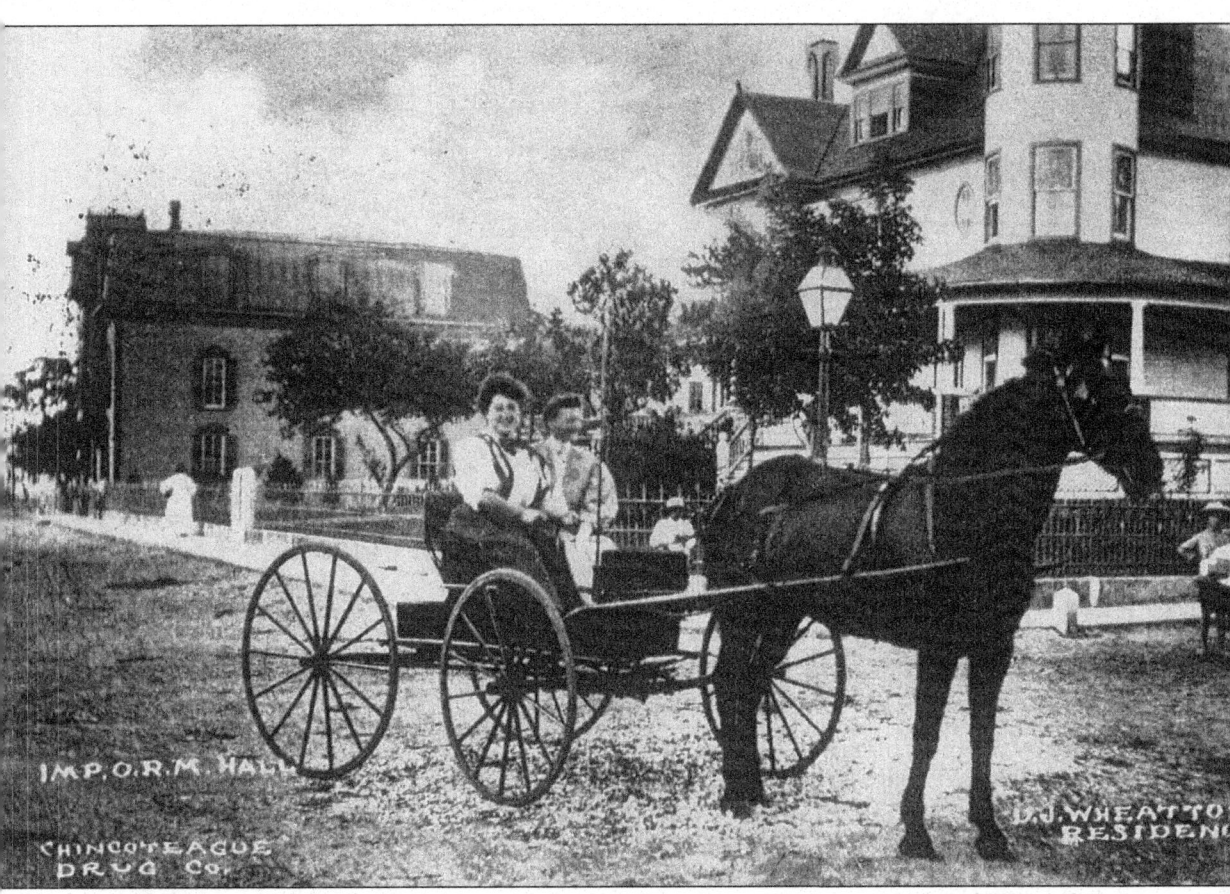

A HORSE-DRAWN BUGGY IN FRONT OF OF THE WHEALTON RESIDENCE, EARLY 1920S. Before super-highways and bridges were built, transportation was strictly limited to horse-drawn buggies. This image shows a standard carriage of the day: a two-passenger, one-horse surrey used for both business and leisure. The horses needed to pull such four-wheeled, hoodless buggies were about 12 to 14 hands. During this time, some carriages had only two wheels; often, four-wheeled carriages had two wheels of a larger size. (Courtesy of Katherine Tolbert.)

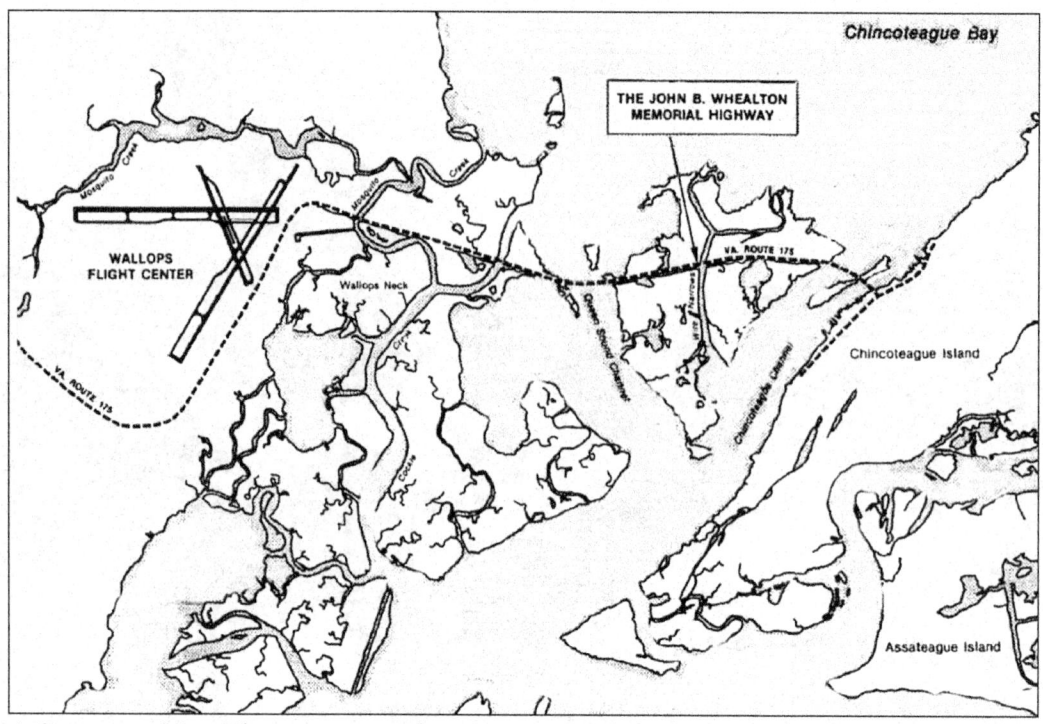

A CAUSEWAY MAP. This map gives a clear impression of how the causeway—if starting at Jester's Dock on Chincoteague Island—crosses the channel that is formed by the bay, goes over a small island, and then across the Narrows, which is Virginia Route 175. From here, the causeway spans Queen Sound Channel, runs through Wallops Neck and around Wallops Flight Center, where it ends at T's Corner on the mainland. The entire route is about 10 miles. (Courtesy of Robert Krieger.)

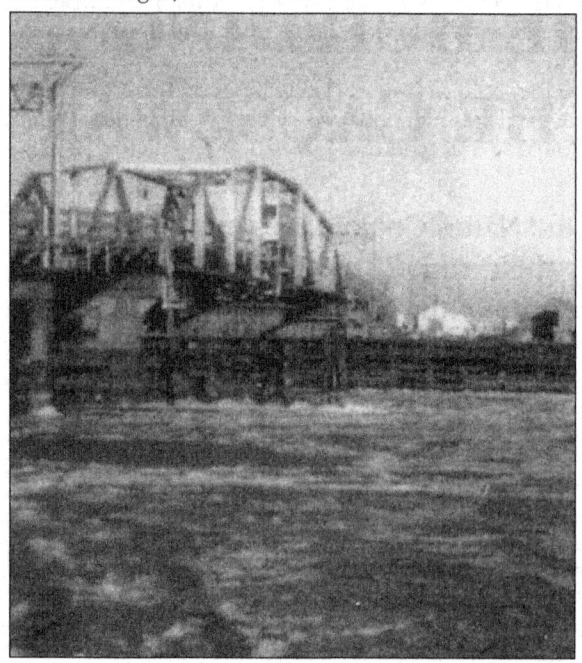

THE CAUSEWAY IN WINTER. This January 1922 photo shows the causeway frozen over from one of the worst winters on records. Even the Chesapeake Bay was covered in ice. Both played a vital role as major water routes for moving goods, mail, and passengers from Chincoteague to the Western Shore. The two-week, zero-temperature freeze permitted foot and sled traffic to cross the ice into Franklin City. Thus, not only were islanders inconvenienced, but their occupations were imperiled, as fishing, ferrying, and trading were prevented. During this same blizzard, about 55 feet of the Queen Sound Bridge was swept away by ice in 45-foot-deep waters, causing over $5,000 in damage. (Courtesy of Robert Mears.)

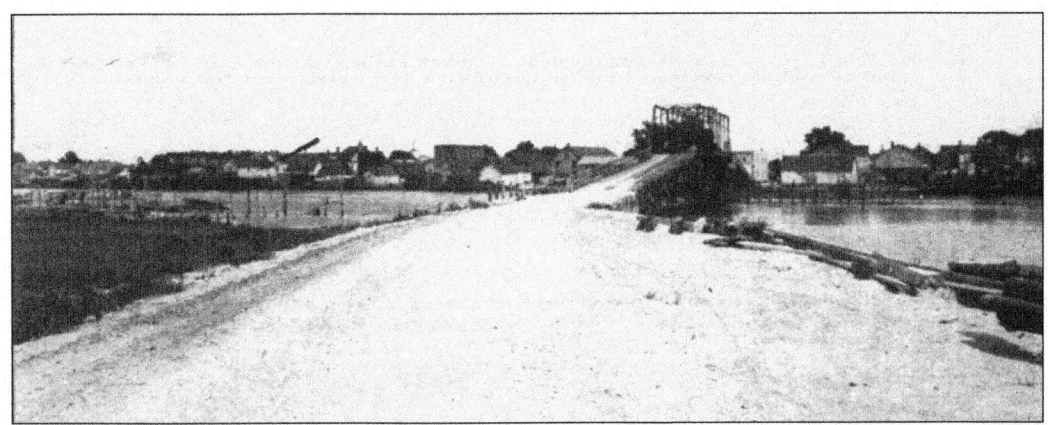

THE CAUSEWAY (ABOVE), C. 1922, AND A VIEW OF THE TOLL ROAD (BELOW), 1922. These pictures illustrate Chincoteague's famous drawbridge, built by John B. Whealton in 1921. Although scheduled for completion earlier than 1921, the bridge construction was hampered by blizzards, ice, and high winds, and freezing gales that swept the bridge away. The span, which originally came from New York, was 3.27 miles long. It crossed the channel from Jester's dock to the marsh, then across Black Narrows Channel and the marsh, through Wide Narrows to Queen Sound, then across Hickman's Farm in Wallop's Neck. The bridge was officially called the Chincoteague Toll Road and Bridge System. W.W. Wood was the first person to walk it in October 1922, while Wheaton, himself, drove the first auto—a Buick—across it. The base of the bridge was built from soil pumped up from the creeks and marshes the bridge crossed. A grand opening celebration, with dignitaries, festivities, food, a parade and marching band, was held. But it rained on the parade, and as the convoy of vehicles attempted to cross the bridge's muddy expanse of shells and stone, 96 cars sunk into the swamp-like surface and the roadbed collapsed. Independent boat owners, ferries, and the Coast Guard rescued as many motorists as they could, but several ended up enmired in their cars for the night. The next day, Whealton had his crew begin making repairs, and when the bridge's surface had been firmed up, the bridge became the island's main route of travel. Soon after, the State of Virginia purchased the bridge and dropped the toll fee. The top image is a view of the bridge at the horizon; the bottom photograph shows the bridge as it enters Main Street in downtown Chincoteague. (Top image courtesy of John E. Jacob; bottom image courtesy of Eastern Shore Historical Society.)

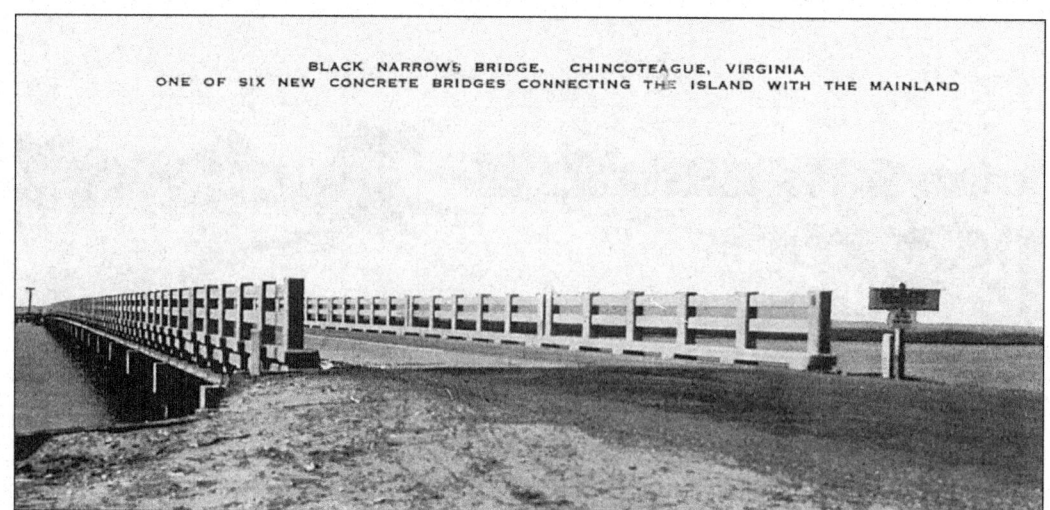

BLACK NARROWS BRIDGE, C. 1930S. The causeway started at this bridge on the Chincoteague end. Mud diggers kicked up heaps of dirt for use as the roadbed, then covered it with oyster shells. It took five months before the causeway reached Queen Sound from Black Narrows. In this photo, we see the bridge that crossed the Black Narrows Channel. The postcard informs readers that this bridge is one of six new concrete surfaces that connect Chincoteague to the mainland. Because of its increasingly rickety condition, it was replaced with a new structure in 1940. It consisted of 27 concrete-and-steel spans, with a vertical clearance of 9 feet above mean low water. The bridge had a boat passageway 33 feet wide. (Courtesy of H&H Pharmacy and E.C. Kropp; collection of John E. Jacob.)

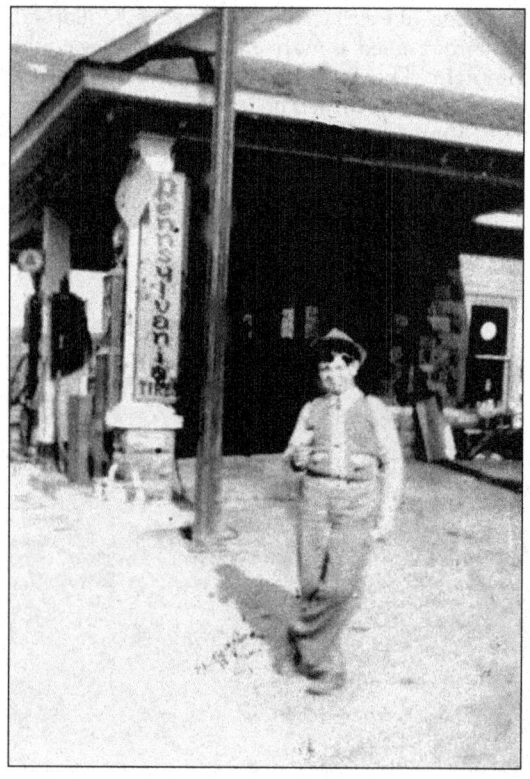

A GAS STATION. This is likely a 1920s or 1930s Texaco, Esso, or Sinclair filling station, based on its architecture and the outside signs. The front pillar on the left bears the words "Pennsylvania Tires," while behind it is the symbol of an old rotary phone, indicating that a telephone is on the premises; other types of services were available inside the building. This is one of two stations that were located at the end of the causeway—one on each side of the bridge. Some of these gas station structures are still in existence today, though they have been converted to junk stores, flea markets, or simply closed because none of the tanks abide by today's federal regulations. During their heyday, these filling stations did a wealth of business because of the growth of the automobile industry, the demand for fuel-operated machinery, and the profit mark-up on petroleum, though gasoline cost no more than a few cents per gallon at the time.

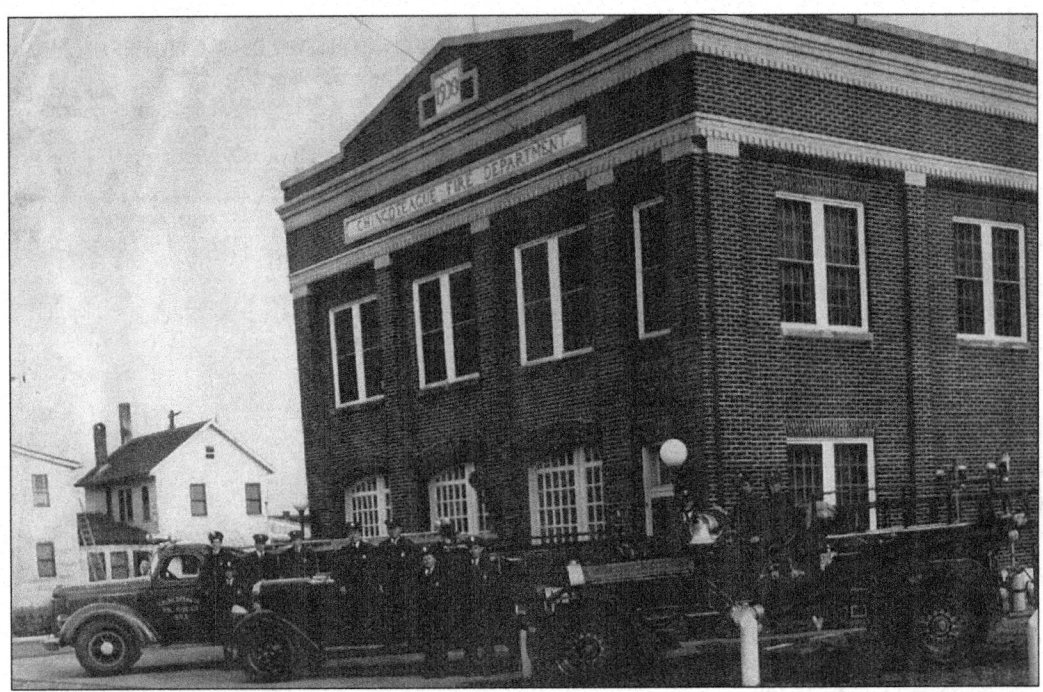

THE FIREHOUSE, C. 1942. After the fires of 1920 and 1924, the volunteer fire department decided to organize an official company and appointed their first chief, Ebe Jones. The company's Ladies Auxiliary was led by Victoria Pruitt, author of the Pruitt Papers and the group's first president. The first firehouse, with its horse-drawn pumper, was erected in the late 1800s on Cleveland Street, the site of today's Meatland Market. The fire bell was located across the street from the firehouse. Another building was constructed on Main Street in 1934 and was enlarged in 1957. During the Ash Wednesday Storm, many Chincoteaguers took refuge in the firehouse. (Courtesy of Katherine Tolbert.)

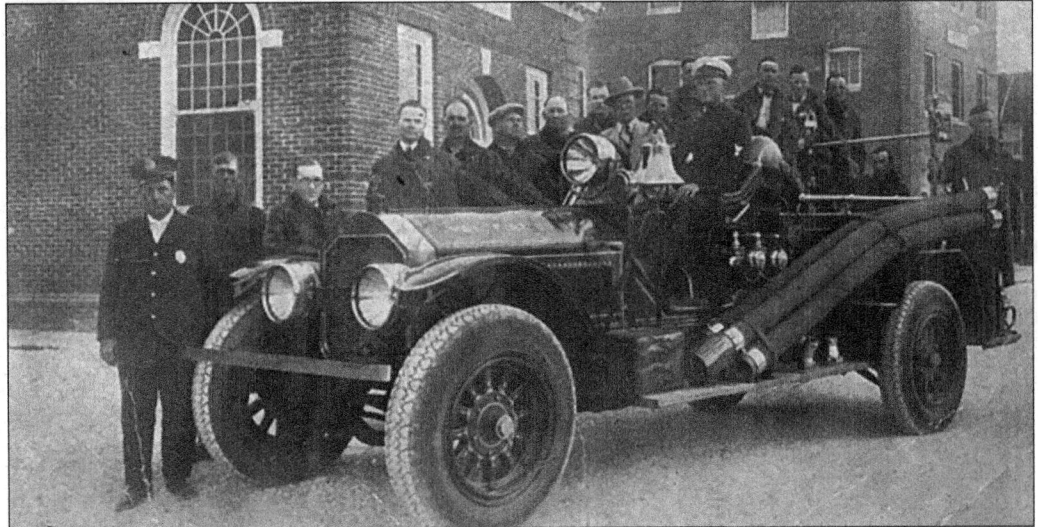

A CHINCOTEAGUE FIRE TRUCK. The driver (in the white hat) is E.B. Jones; standing behind him to the right is Alan Tolbert; and the man in the suit is Henry Leonard. The truck seen here may have been an American-LaFrance model. (Courtesy of Katherine Tolbert.)

	Make & Style of Car	Engine No.	Horse Power
	Title Number	Year	Weight—Tonnage

1936--VIRGINIA MOTOR VEHICLE REGISTRATION TRANSFER-DIVISION OF MOTOR VEHICLES--

Not valid unless signed in ink by addressee. This card must be carried with motor vehicle when in operation but does not permit holder to operate a motor vehicle. Registration valid for year ending March 31, 1937.

SIGN HERE:

Director Division of Motor Vehicles

TRANSFER License No. 34339

BUICK TRG SED 43168083 3
1113279 35-37 3519

C E SNEAD

CHINCOTEAGUE VA 6

THE FRONT (ABOVE) AND BACK (BELOW) OF A 1935 VEHICLE REGISTRATION. The card describes the registered car as a Buick-TRG SED (sedan), followed by the registration number and the weight of the vehicle—3 tons. The owner of the card is C.E. Snead of Chincoteague. (Courtesy of David Snead.)

This card to be carried at all times during the operation of Motor Vehicle described on reverse side.

The owner of the vehicle designated shall, within five days after the sale of said vehicle, furnish the Director Division of Motor Vehicles, Richmond, Va., with the name and address of the purchaser.

SOLD TO _____

ADDRESS _____

DATE _____

SOLD BY
 Signed _____

The law provides a penalty for using a fictitious name or address in applying for licenses. Your signature certifies the correctness of this transfer card.

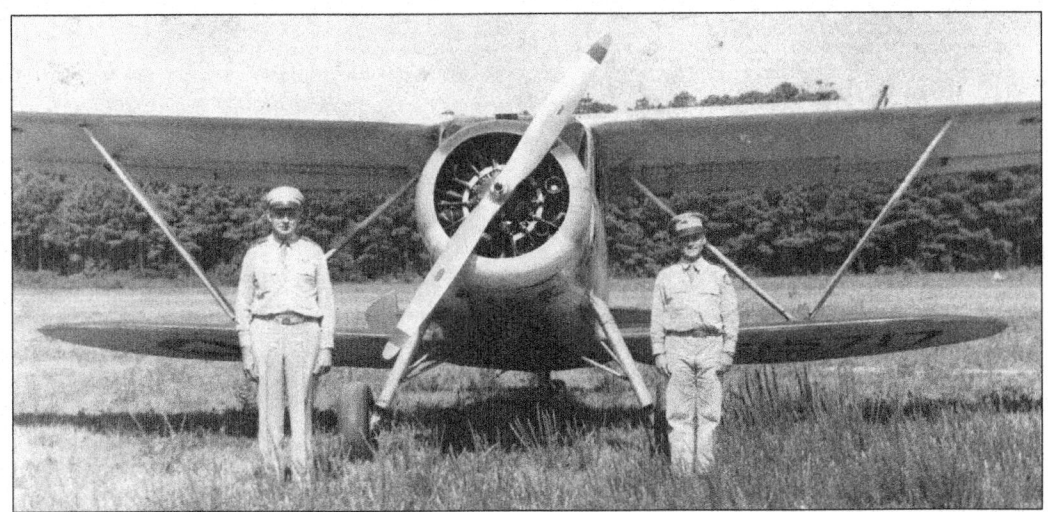

SAVAGES' PLANES. The late 1940s image above shows Lee Savage standing in front of his biplane; the image below shows his Cessna. Savage's transportation service was used for moving both goods and passengers, as well as for training veterans and others to become private pilots. Savage was also an instructor for spy and SAR (Search and Rescue) missions and trained Civil Air Patrol for SAR missions. Made of metal, the biplane was as a good training craft since it was easier for beginners to fly—because of its big engine and "four" wings—than most other types of planes. Savage says his service was "most useful and most wanted." The bottom photograph features Savage's wife, Wilma, and their two children, Clayton (standing) and Donna. Today, Donna Savage Mason owns the Waterside Inn. (Courtesy of Donna Mason.)

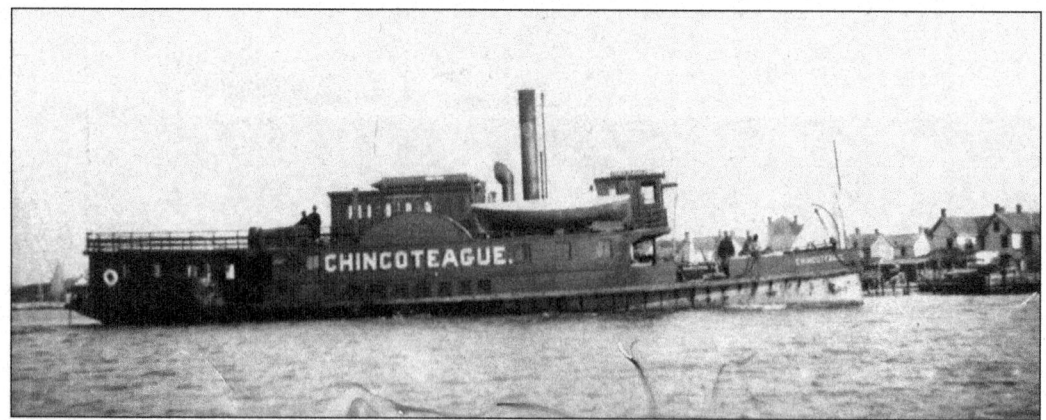

THE CHINCOTEAGUE, C. 1900. This 1893 side-paddle steamer was affectionately dubbed "Old Faithful" because it steadfastly plied the waters between Chincoteague and Franklin City, VA, daily and seldom broke down. It also served, for the islanders, as the chief means of contact with the rest of the world. At 100 feet long and 21 feet wide, the *Chincoteague* was the largest boat to ever run the route. The *Widgeon* and the *Lillie Agnes* ran the route prior to the *Chincoteague*. Because the railroad company saw that the ferry profited them, they maintained it by sending it to Wilmington for yearly repairs and remodeling. In 1902, they gave it a new paint job and added a "Jim Crow" room since segregation still existed. In 1907, the company rigged the steamer to carry 40 firemen and a fire engine with 500 feet of hose in case a fire broke out across the shore. Two years later, the steamer stopped ferrying passengers as a cost-cutting move. Soon after, the vessel was sold to a Midwest company to cruise the Mississippi River. The *Chincoteague* was retired in 1914 to Kansas City, MO, and converted to scrap metal in 1937. (Courtesy of Katherine Tolbert.)

THE CHINCOTEAGUE AT DOCK. In this photo, the steamer *Chincoteague* arrives at the railroad dock where people in their Sunday best await to greet it. Greeters did not care that many of the new arrivals were strangers, salesmen, or tourists. If the strangers remained in town for the next docking, they, too, went to meet the newcomers. Built in 1893 in Wilmington, the ferry was transferred to the Maryland, Delaware, and Virginia Railroad in 1905. It had 110 horsepower, weighed over 143 tons, and was 5.8 feet in depth. (Courtesy of Kirk Mariner.)

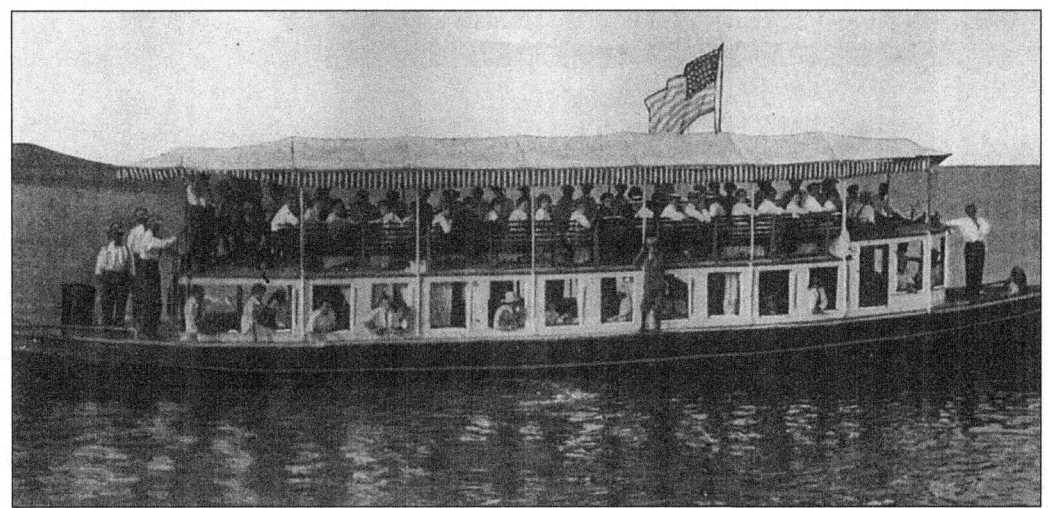

THE MANZANITA. This steamer was built in New York in 1900 and brought to Chincoteague around 1913. The 58-foot, gasoline-powered boat ferried passengers between the island and Franklin City. Remodeled in 1914, the *Manzanita* was the largest and fastest steamer of the time, completing its run in 25 minutes. (Courtesy of Curtis Badger.)

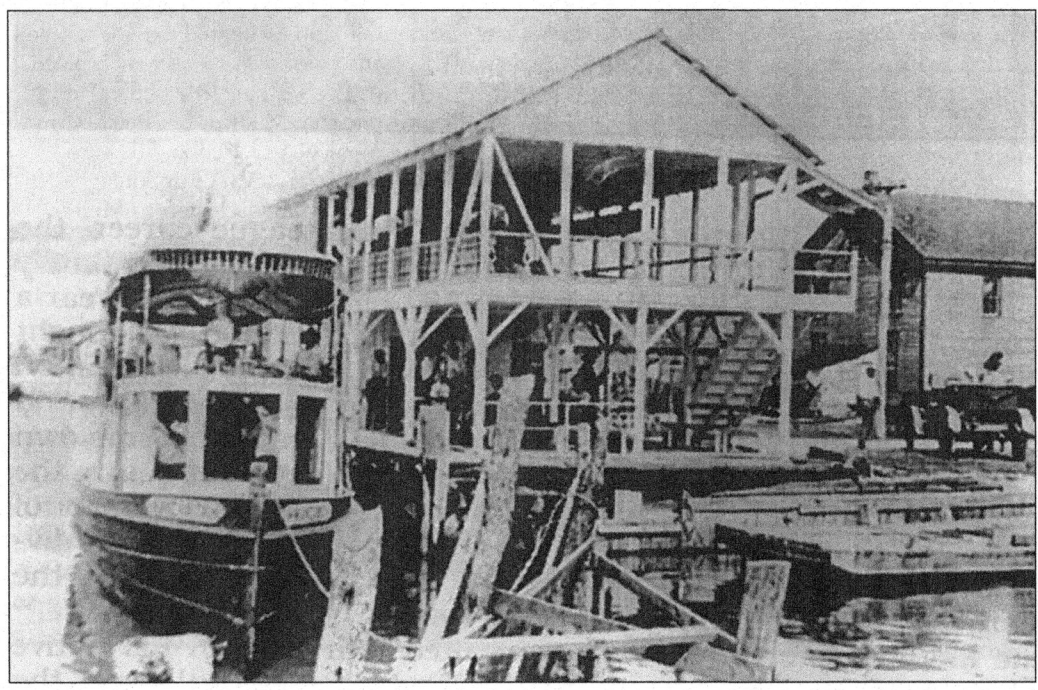

THE MANZANITA AT DOCK. The boat docked across from the Atlantic Hotel to board and unload passengers, and its presence caused so much excitement that many islanders would gather at the landing just to watch it arrive and depart. Many times, the residents crowding the docks would break out in spontaneous song, enjoying one another's company, smiling, and patting each other on the back. In 1921, the ferry came under new ownership and was moved to New Jersey. (Courtesy of Kirk Mariner.)

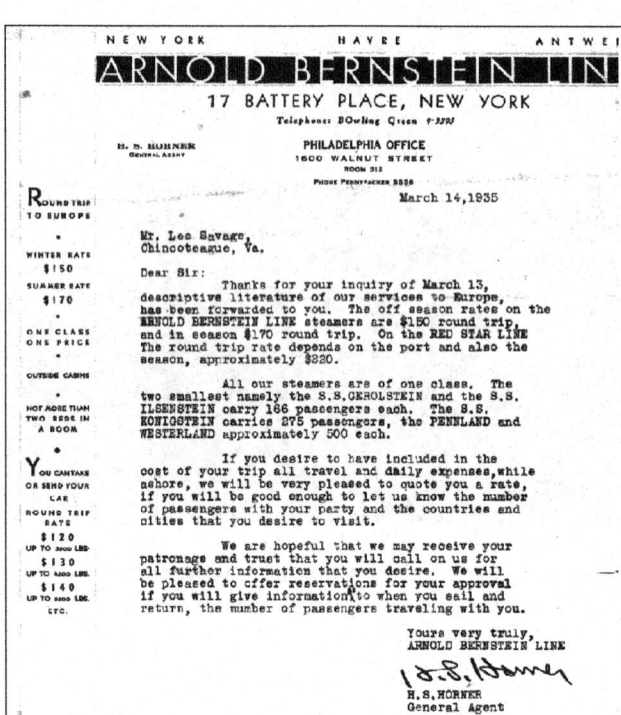

LEE SAVAGE'S ITINERARY. These two images represent Lee Savage's desire to travel overseas. On March 13, 1935 (top image), General Agent H.S. Horner informs Savage that the Bernstein Line round-trip rates are $150 off-season and $170 in-season and that the round-trip rate on the Red Star Line is $220, depending on the number of port stops. The itemized numerical list (bottom image) shows Savage's ports-of-call and estimated expenses. Lee's intention was to visit such places as Paris, Rome, Marseille, Berlin, Vienna, Madrid, Brussels, Bern, Venice, and Genoa. His plan was to go from Chincoteague to Norfolk and then to Miami, where he would begin his overseas trip. Based on the list below, the trip was going to cost him a fortune. Savage's daughter, Donna Mason, said, "Dad decided against the trip because of the expense—the same reason he decided against pursuing a dental degree, even though he had already sent in the initial payment and took the first class." (Courtesy of Donna Mason.)

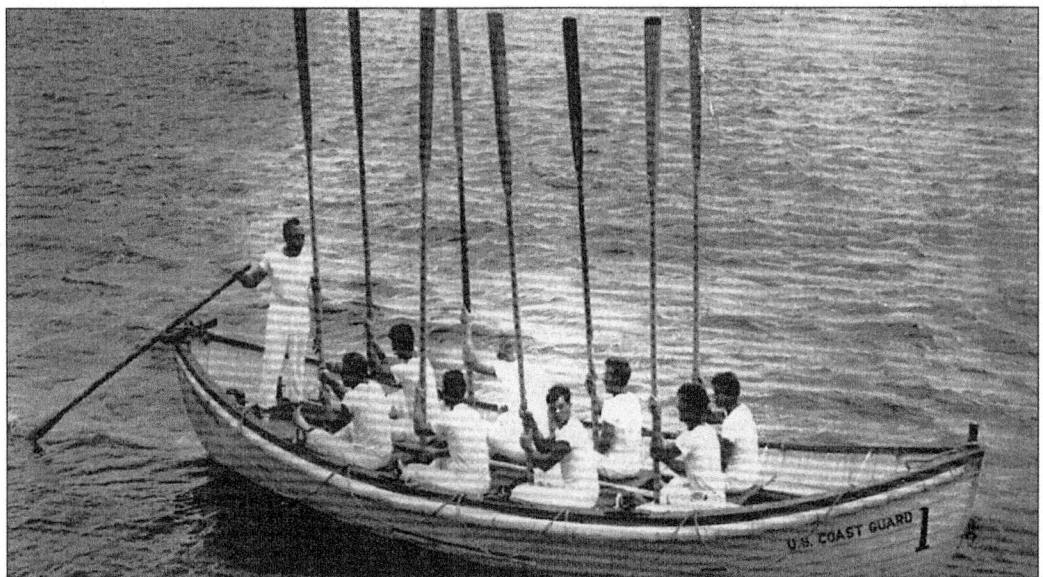

PULLING BOAT, 1947. Competitions between the crews of lifeboat stations were a regular event until the end of the 1940s. This race on August 4, 1947, in North Carolina, featured a 26-foot self-bailing surfboat. Richard L. Chenery III, in his book *Old Coast Guard Stations*, identifies the coxswain (left) as Ed Lewis of the Assateague Beach station. Others, from bow to stern, are as follows: (port side) ? O'Neil, Forest Purdy, ? McIntyre, and Foster Forbes; (starboard side) ? Snipes, Lee Burbage, ? Sapp, and Tom McHale. Crewman O'Neil was the "man who stayed in the boat and held all the oars when capsizing."(Courtesy of Richard L. Chenery III.)

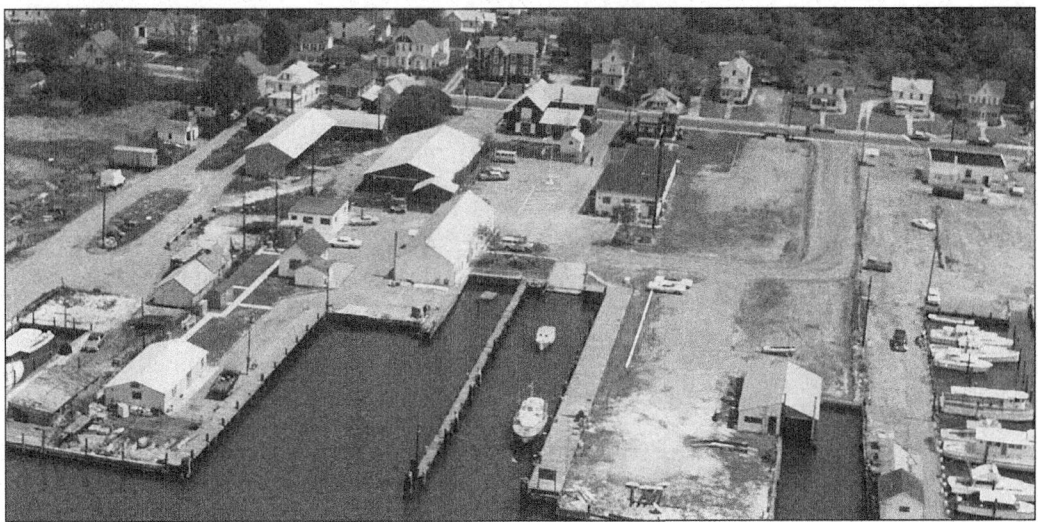

THE U.S. COAST GUARD CHINCOTEAGUE STATION, C. 1960S. The station's programs and services include search-and-rescues covering over 1,350 square miles, radio navigation, defense operations, marine environmental response, port safety and security, recreational boating safety, and enforcement of laws and treaties with aircraft support from the Virginia National Guard, for both small and large vessels. Chincoteague responds to well over 100 calls for assistance per year and conducts nearly that number of law enforcement boardings. (Courtesy of historian Scott Price, Public Information Office, United States Coast Guard; and Officer Pickerings of the Chincoteague Station.)

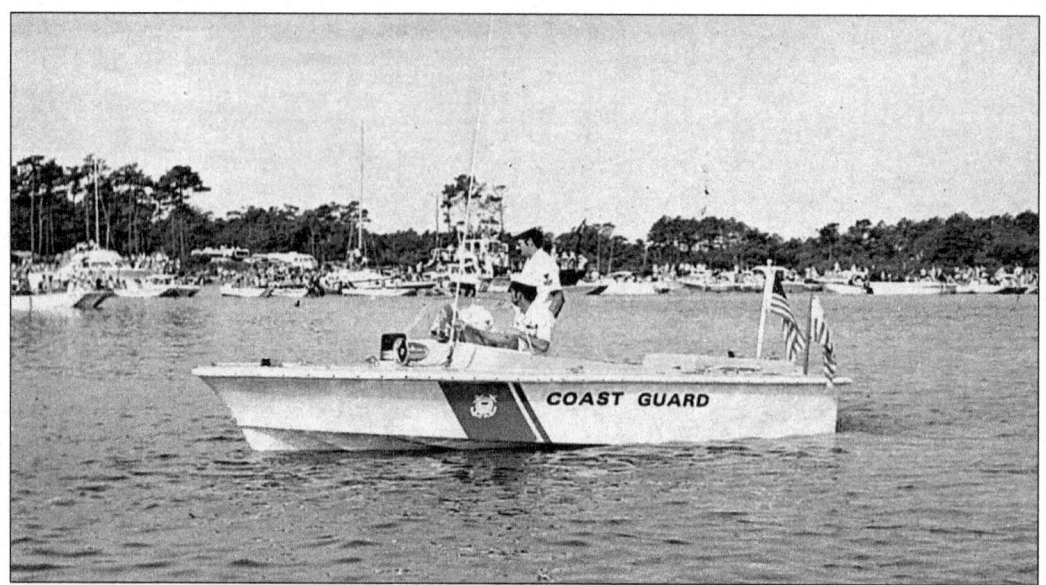

A COAST GUARD VESSEL, C. 1960. Although the actual date of this image can not be confirmed, it appears to be a mid-1960s postcard based on its color and presentation. This U.S. Coast Guard (USCG) boat patrolled the waters during one of Chincoteague's famous annual wild pony swims. It is the type of vessel that is used primarily for coast-side areas. Scott T. Price, historian and Coast Guard history webmaster, says that the red stripe on the boat's hull was the result of President Kennedy's recommendation that an industrial design firm make the USCG boats more visible to the public. (Courtesy of Ace Novelty Co.; collection of John E. Jacob.)

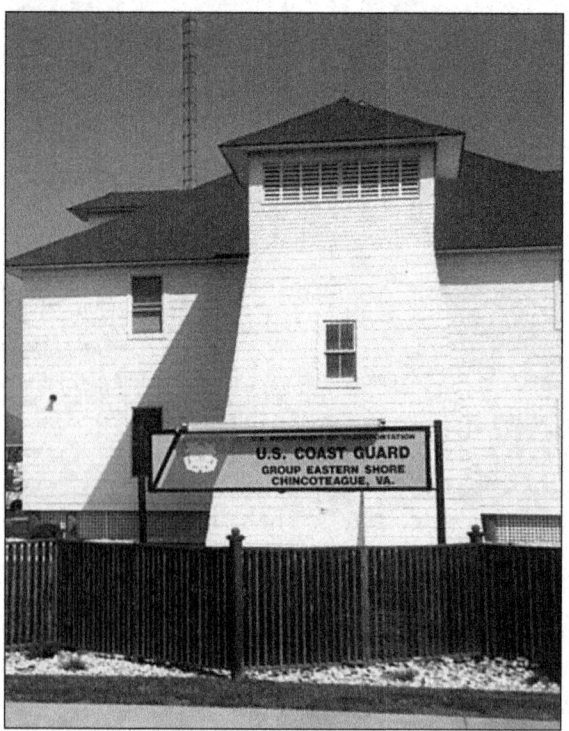

THE U.S. COAST GUARD CHINCOTEAGUE STATION (1999). The earliest USCG activity in the Chincoteague area goes back to 1833 with the lifestation, now a museum, on Assateague Island. In 1967, the USCG closed that station and moved its boats and personnel to the south end of Chincoteague's Main Street. Staffed by 16 active-duty personnel, this base is the operations center for three other groups: Indian River Inlet, Station Ocean City, and Station Parramore. These groups cover the area from Cape Henlopen to north of Cape Charles. Chincoteague's base has six buildings, including the Tarr Building, named for John Shields Tarr, who served from 1960 to 1992 and was accidentally killed while working on a buoy in St. Augustine Inlet. (Information courtesy of Officer Pickering of the Chincoteague Coast Station.)

Four

PEOPLE
ISLAND PROFILES

In the 1600s, the Chincoteague Indians, often known as Gingoteagues, were the first inhabitants to use the islands' resources. The Chincoteagues were part of a larger multi-tribe group known as the Assateagues, which included such tribes as the Pocomoke, Annamessex, Manokin, Assateague, and Kicotank. These tribes were living under the Emperor of Assateague. In 1742, a treaty was made with European settlers in the area and signed by the Assateague and Pocomoke chiefs following many years of battling over land with the newcomers. This treaty did not work well, and most of the Native-American inhabitants left the area by 1750.

The first European settlement on Assateague dates from the 17th century, when Ann and Daniel Jenifer obtained land grants for sections of Assateague and Chincoteague Islands. For the most part, these owners were absentee landlords. In the late 1800s, about 200 people were living on the island. Many of the family names from that time are still prevalent in the area today, including Cherrix, Hancock, Jester, Mumford, and Whealton. There were also three African-American families on the island.

In the 1920s, Assateague Village's population declined due, in large part, to Dr. Samuel B. Fields of Baltimore, MD, who owned much of the land on the Virginia side of Assateague. He would not let the locals pass over his property to fish, their primary livelihood. Dr. Fields went to the great lengths of hiring a cowboy to shoot at people who dared to defy his trespassing rules. This situation led to the demise of Assateague, as the residents slowly moved to Chincoteague, floating some of their homes to the mainland. These folks also had to hold the pony penning on Chincoteague (with the ponies swimming across the Assateague Channel) as well.

Once these families moved to the mainland, they joined the residents already living in the prosperous community. Many islanders played a part in shaping the island's future, and some of them are included in this chapter.

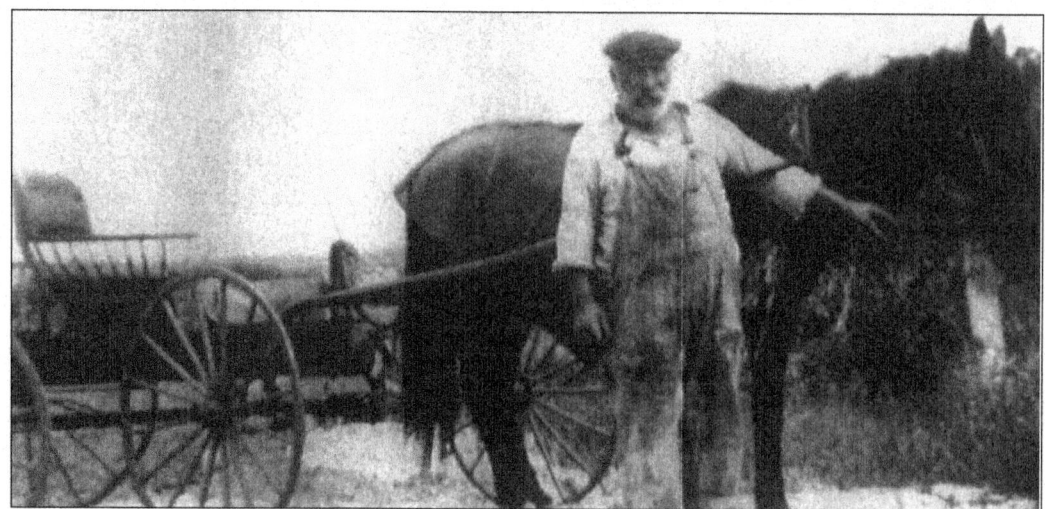

BILL SCOTT AND A BUGGY, 1920S. William Scott, known as "Big Bill," was perhaps the most noted figure on Assateague. Every morning, he rose early to make his way to Tom's Cove for his oyster breakfast; he picked the bivalves right out of the harvested oyster beds. As a storekeeper, he often bartered food for goods and sold geese to his customers. He finally left the island when all the other Assateague inhabitants headed for Chincoteague. He is shown here with his horse and country wagon buggy, which he used to deliver fresh vegetables to Assateague villagers. (Courtesy of Curtis Badger.)

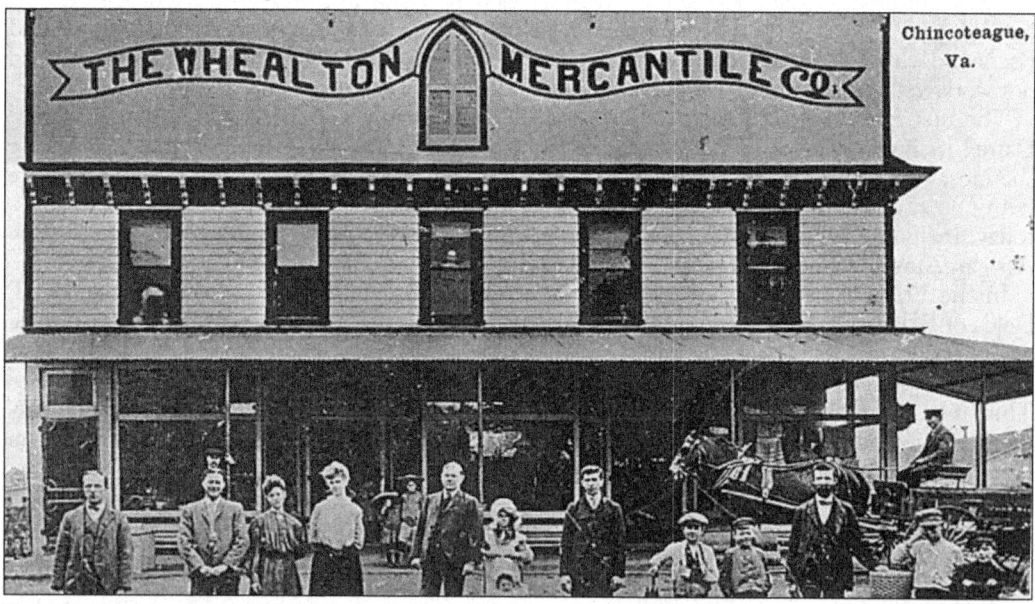

FACES FROM THE PAST. Perhaps the largest business on the Eastern Shore, the Big Store, owned by J.A. Whealton, is seen in the early 1900s. The building was three stories high and was located on Main Street. The town's men gathered in front of the store to find work on the water and to socialize. The parade of personalities shown here are, from left to right, John Anderton Jr., Edward Gillis, Harry White, Annie Timmons, Flossie Mesick, unidentified, Elizabeth Coulbourne, Clayton Richardson, unidentified, G. Wilbur Twilley, Dr. Turman, Robert Holston, one of the Hurdle boys, Joe Baker, Vincent Tolbert, William Munger, and Jay Smith. (Courtesy of John E. Jacob.)

ROBERT H. MEARS AND LEE SAVAGE. This high school picture of Lee Savage and Robert Mears was taken in the early 1900s. During high school, the boys became friends, having similar interests in a variety of sports. A year after graduation (after Robert attended William & Mary for a year), the pair went to Florida to work on a tugboat for John B. Whealton. Not soon after they went home to Chincoteague to work catching seed oysters for Lee's father. In 1927, they started a fish market in Pittson, PA. During their stay there, Lee became known as "the Savage" after punching out a big Polish boy in a neighborhood boxing match. This was not a surprise to locals, as Savage had won the local strong man contest by holding a boat anchor with one arm over his head. After selling their business and buying a truck in 1927, the two friends started "Savage & Mears," an oyster and clam company, and landed A&P supermarket as a customer. A&P purchased seafood from Savage & Mears for 43 years. (Courtesy of Robert Mears.)

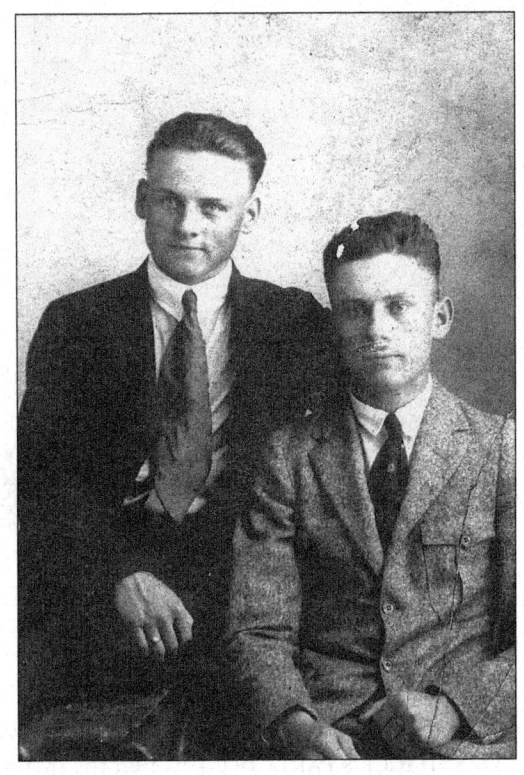

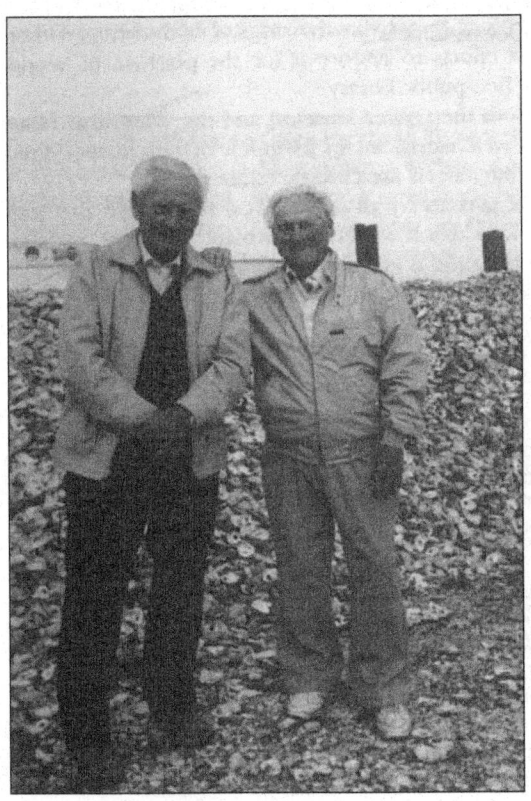

YEARS LATER. Here is a picture of the men years later, standing in front of a huge stack of shells from their shucking house. The oyster shells were used for a variety of things, including making roads, draining fields, and replenishing oysters. The shells, used to replenish the oyster beds, were washed and planted from March 20 to September 15. An acre of oysters brought between $300 and $500. (Courtesy of Donna Mason.)

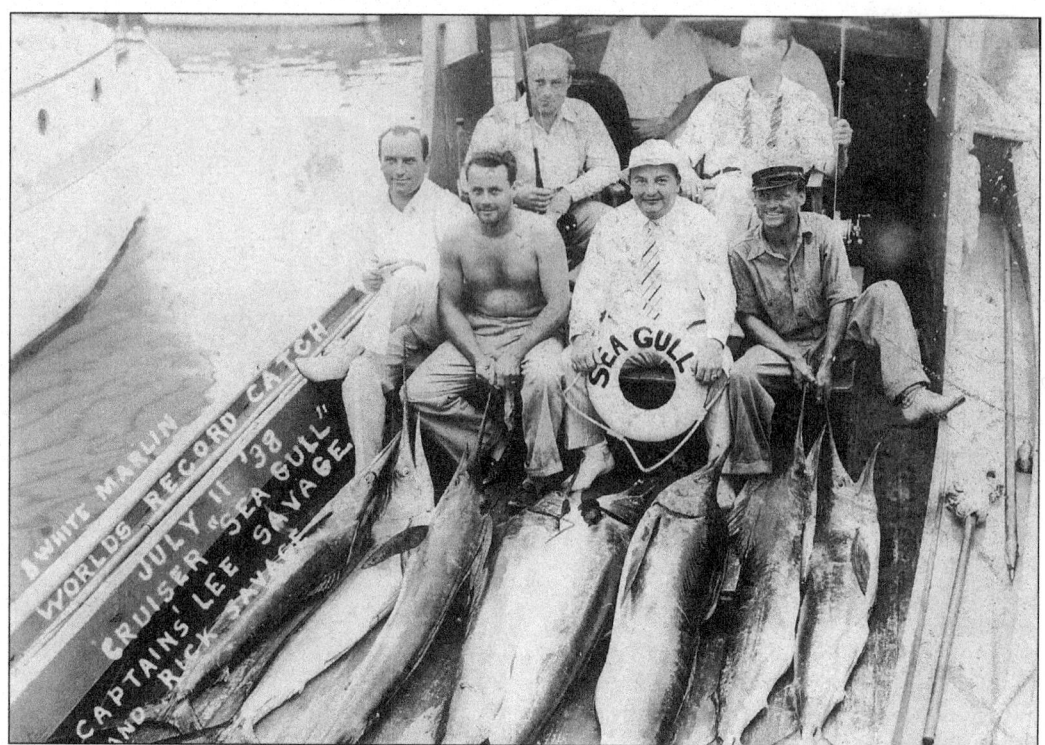

LEE AND RICK'S PARTY BOAT. When the oyster and clam business was slow, Lee Savage and his brother Rick took fishing parties out to sea at Ocean City in a party boat Lee and his brother had purchased. On July 11, 1938, a party from Lancaster, PA, caught eight marlin, the world record at the time. (Courtesy of Donna Mason.)

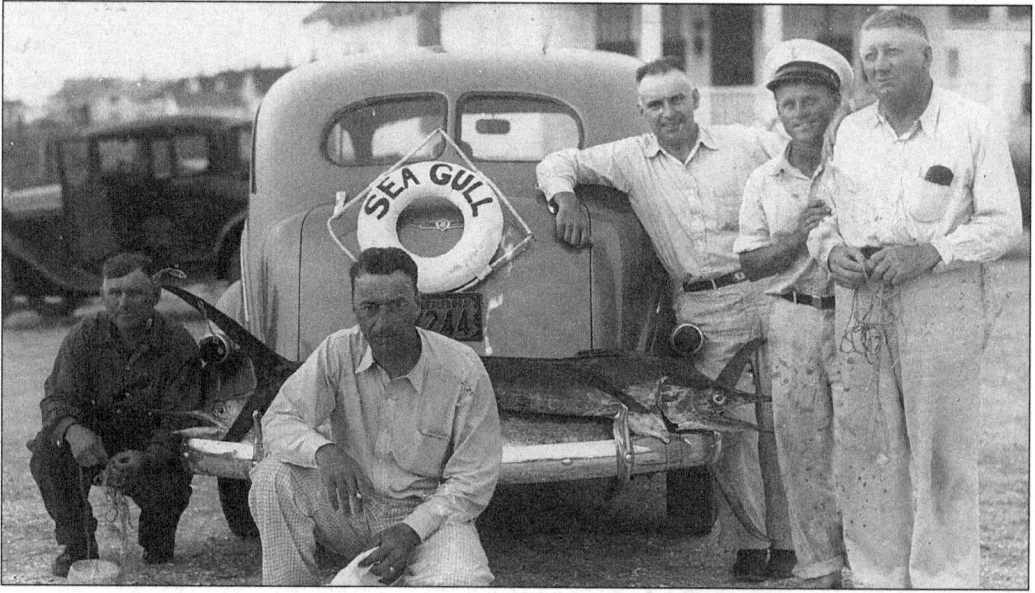

A FISH ON A TAILGATE. The bumper of this early 1930s car sports a large marlin the men brought back from Ocean City. The life ring on the bumper of the car lets everybody know this marlin was caught on the *Sea Gull*. (Courtesy of Donna Mason.)

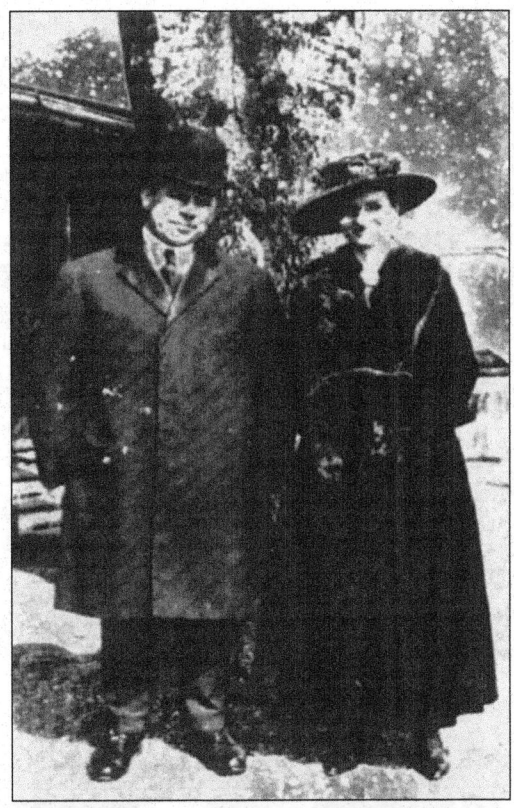

JOHN T. AND GUSSIE MEARS. Mr. and Mrs. Mears came to Chincoteague in 1912 with their children: Robert, Braidwood, Jack, and Elsie. Mr. Mears was the manager of the D.J. Whealton Seafood Company. One night, Mrs. Mears woke her sons Jack and Robert to inform them of a fire and get them to quickly dress. To their horror, nearly the entire town was ablaze. Without any fire equipment, the men in town formed a line and used buckets to try to stop the fire. Unfortunately, the Mears family's home was the fifth house to ignite and burn to the ground. Mr. Mears moved his family into a residence on Cleveland Street until a home for the family was completed on Church Street. The top photo depicts the Mears in the early 1900s wearing clothing that more than likely was factory produced. The bonnet and hat, as well as the fine coats, suggest that they were an affluent family. The bottom photo finds the Mears, years later, nicely dressed and perhaps ready to go to church. (Courtesy of Robert Mears.)

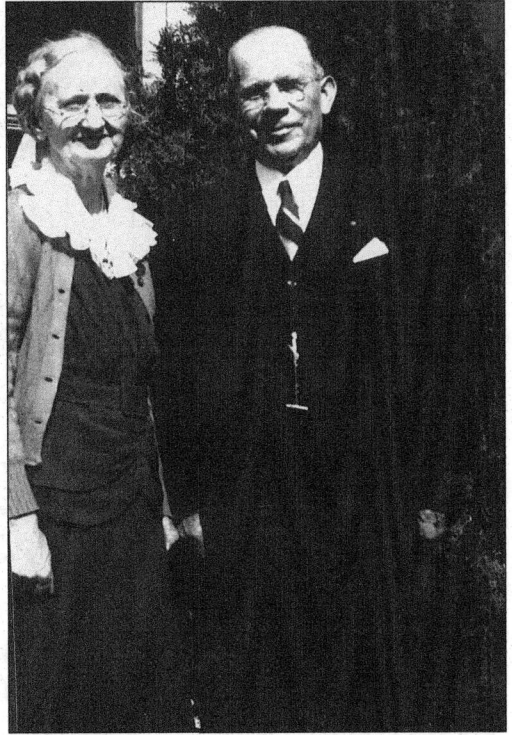

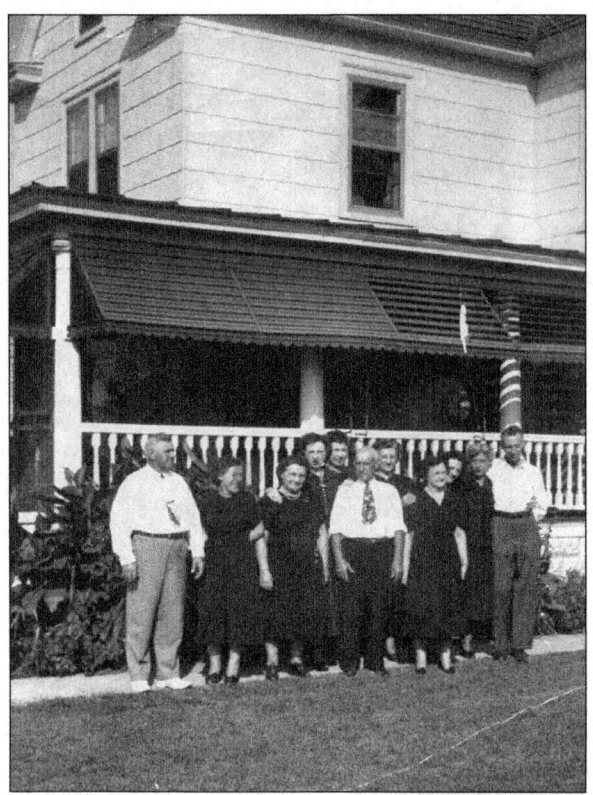

THE SAVAGE FAMILY. Fred Savage, Lee Savage's father, poses with the Savage clan, all of whom are home for a visit. The 11 brothers and sisters posed for this photograph in the early 1900s. All the children were born and raised on Chincoteague but have since moved to various places. Each lived to be in their nineties. Donna Mason, Lee Savage's daughter, reports that her Great Aunt Suzy was still swimming at 92 and even taught her how to swim. (Courtesy of Donna Mason.)

THE MEARS FAMILY. Robert Mears, a lifetime friend and business associate of Lee Savage, poses with his family. They are as follows, from left to right: (top row) Blanch, Elsie, Gussie, and John Mears; (bottom row) Robert (holding son Jerry), Margaret, and Jack Jr. Jack was in the Coast Guard and came home to visit his family. Robert Mears is the author of *The Waterman* and *Wild Ponies* and the son of John T. and Gussie Mears. He is a lifelong resident of Chincoteague Island and is married to Blanch, who is standing behind him. (Courtesy of Robert Mears.)

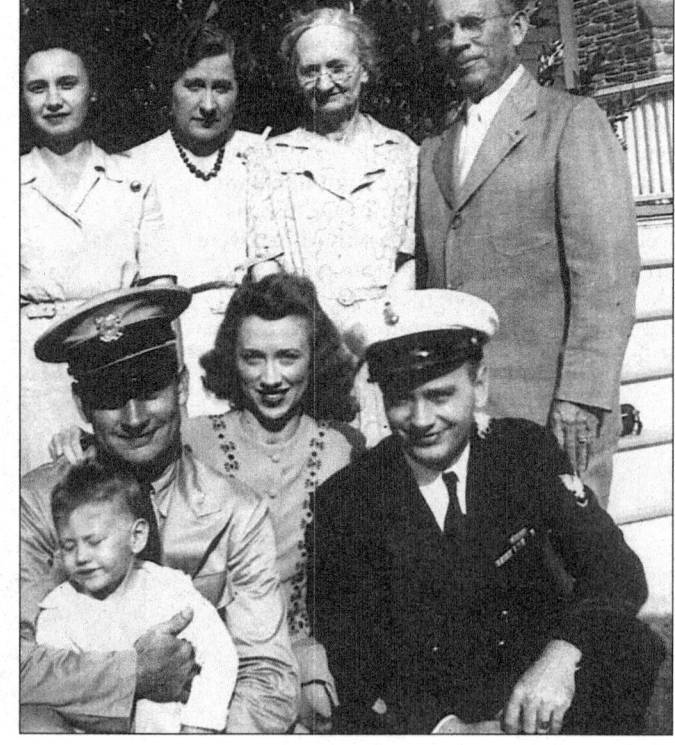

ELIZA WHEALTON REYNOLDS. Eliza, known as a folk healer, was the sister of J.A.M. Whealton, who introduced the cultivation of oysters to the area. This branch of the family was known to have Native-American blood, which may account for her vast knowledge of the medicinal qualities of local plants, herbs, and wild roots. Her second husband was a member of the Nanticoke tribe, and Eliza traveled with him to help heal tribal members when they were sick. She is most noted for a cure she performed on Mrs. Arena Thorton, a cancer patient who was sent home from Johns Hopkins to die. Reynolds put a mixture of ground herbs, carbolic salve, and hog lard on Thorton's nose, where her cancer was located. Eliza also gave her patient a secret mixture to be taken orally. The cure worked and Thorton lived another 20 years. Reynolds treated many islanders for cancers and malignant tumors. Unfortunately, she died with her secrets, having only shared them with the male members of her family, who simply were not interested in carrying on her legacy. (Courtesy of Kirk Mariner.)

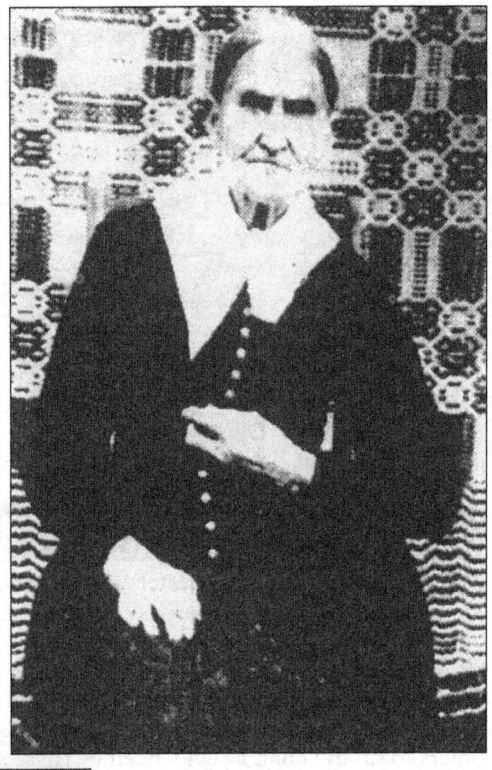

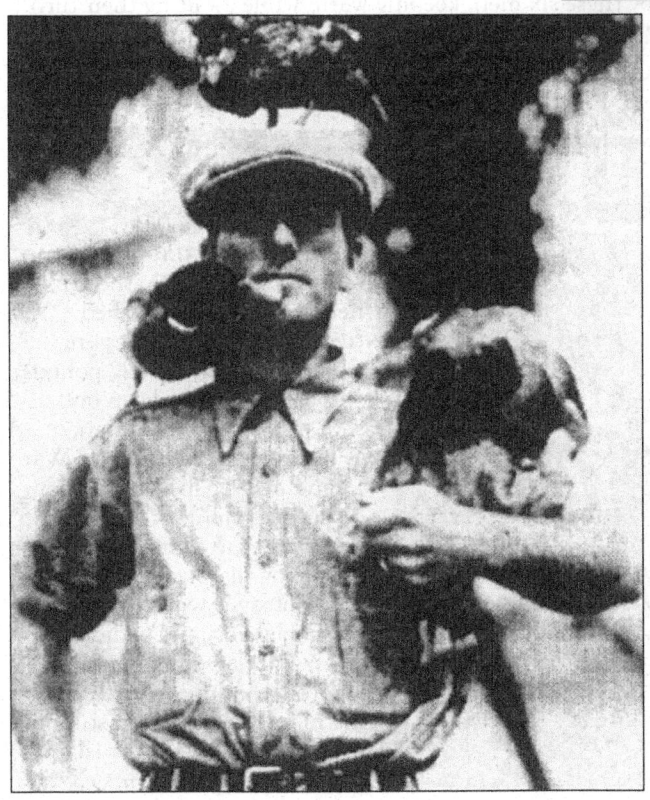

THOMAS J. REED (1901–1993). Reed was born on May 24, 1901, on Chincoteague Island. He quit school when he was 11 years old and worked until he was 20, selling waterfowl to restaurants. He was known as an "outlaw gunner," in light of the fact that he was always breaking the game laws—he would hide his ducks in the hollows of his decoys. He later began a wild duck farm on Deep Hole Road, where he raised and trained wild ducks. In 1933, he lost most of his flock when a storm passed through. In 1960, Reed sold ducks to the producer of *Misty*, only to have the ducks fly home after they were released. A local Chincoteaguer said that Reed, at some point, also raised terrapins in Deep Hole. (Courtesy of Kirk Mariner.)

BARBERSHOP. Wallace N. Jester was a barber for Chincoteague residents for 74 years. Locals say he was a kind and generous man who gave gumballs to children who came into his shop to have their hair cut. Jester also made house calls on the elderly, offering his services to them. He appeared in the 1961 movie *Misty* as the island barber. In 1980, his photograph appeared in *National Geographic* when Chincoteague was featured. In 1983, he was in *Ripley's Believe It or Not* for barbering in the same shop from 1908 until 1982. This local site was also a place for old-timers to sit and chat, as evidenced by these six men, keeping warm while awaiting their turn.

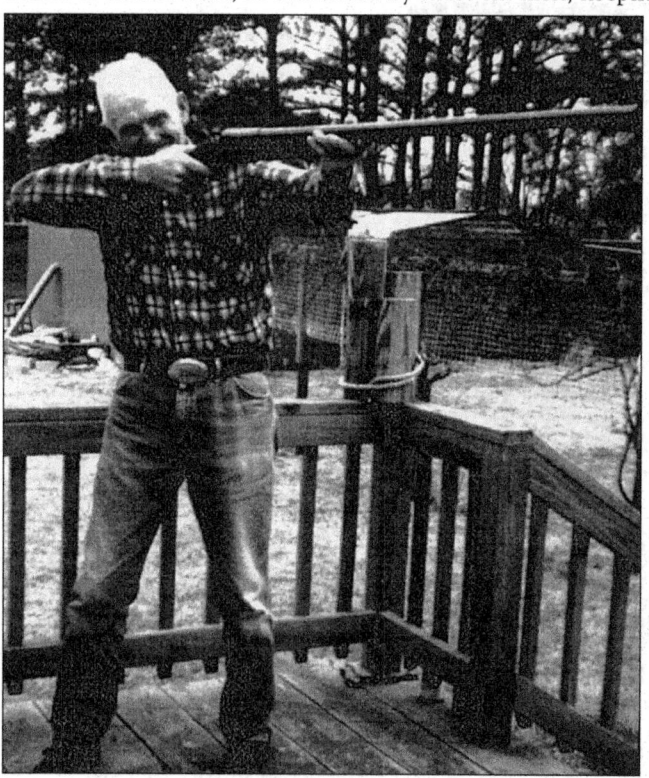

HERMAN WHEALTON. Herman Clifford Whealton is shown here sporting his modified treasured 4-gauge duck gun, which weighs almost 22 pounds and can fall 87 ducks in one shot. A very patriotic man, Whealton served in World War II, and in 1963, began to follow his father's (John Whealton's) tradition, started in 1928, of driving his truck around Chincoteague with marching music blasting, and swords, guns, and flags flapping in the air. Today, in the year 2000, Herman Whealton can still be seen driving around the island showing his patriotism.

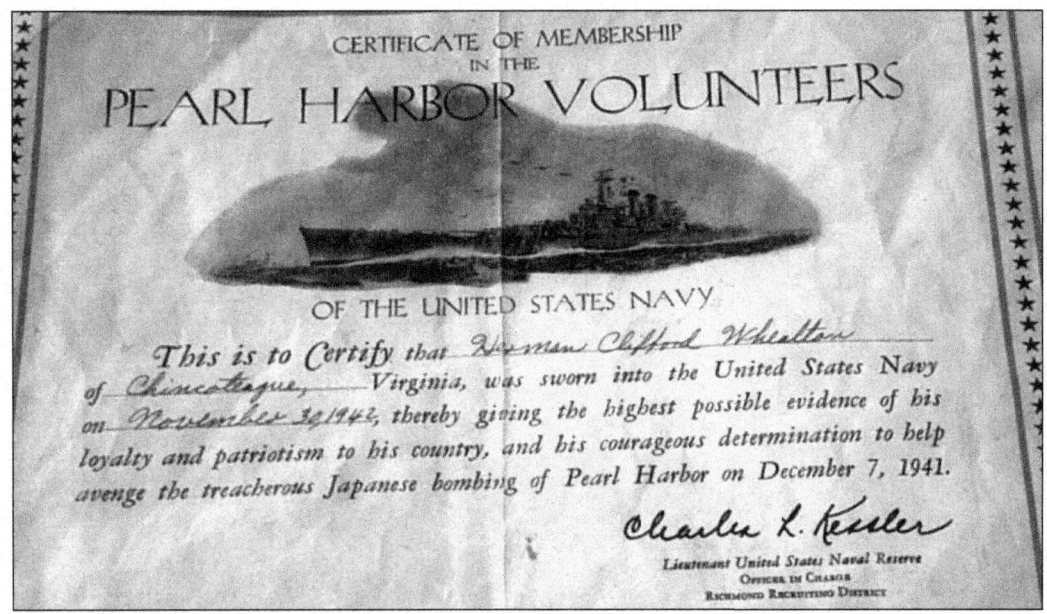

PEARL HARBOR VOLUNTEERS. Herman Whealton, a descendant of D.J. Whealton, served in World War II and was a Pearl Harbor Volunteer, as seen in this certificate of membership dated November 30, 1942. The certificate acknowledges his loyalty by stating that Herman gave the "highest possible evidence of his loyalty and patriotism to his country, and his courageous determination to help avenge the treacherous Japanese Bombing of Pearl Harbor on December 7, 1941."

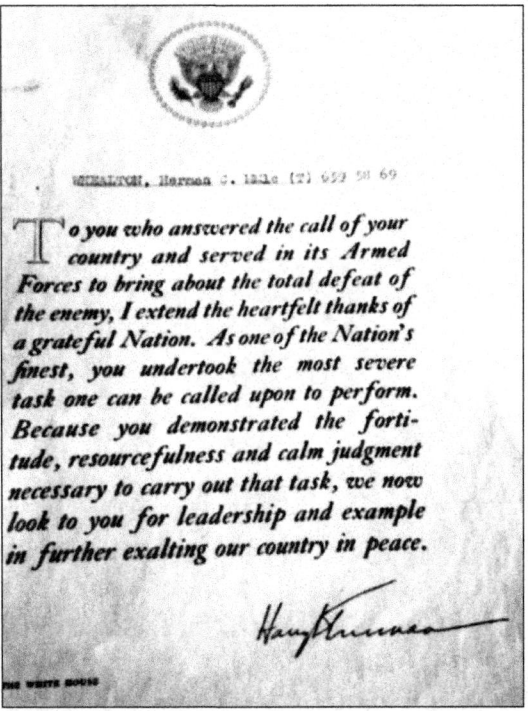

HEARTFELT THANKS. President Harry Truman, whose original signature can be seen in this letter to Herman Whealton, extends his "heartful thanks" to Whealton for serving his country in World War II. The President further encourages Whealton to continue his patriotism: "We now look to you for leadership and example in further exalting our country in peace."

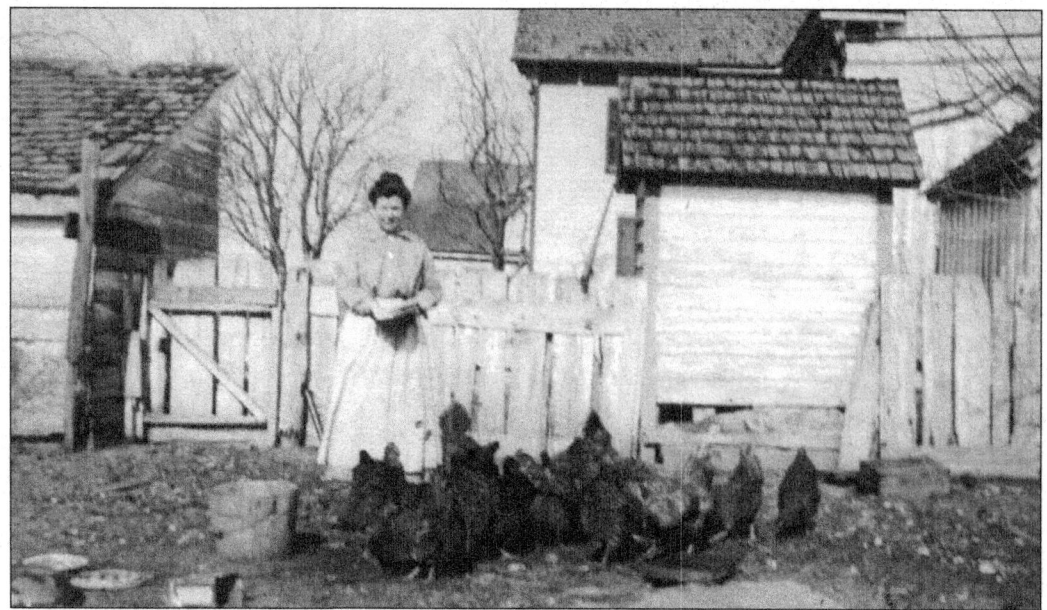

FEEDING THE CHICKENS. This woman was married to a member of the Savage family; she stopped to pose for a picture while feeding her chickens. A bucket in the foreground suggests that there are still other chores to be done. The chicken industry was prevalent on Chincoteague in 1949 and continued into the 1960s, until many islanders lost their chickens during the storm of 1962. (Courtesy of Donna Mason.)

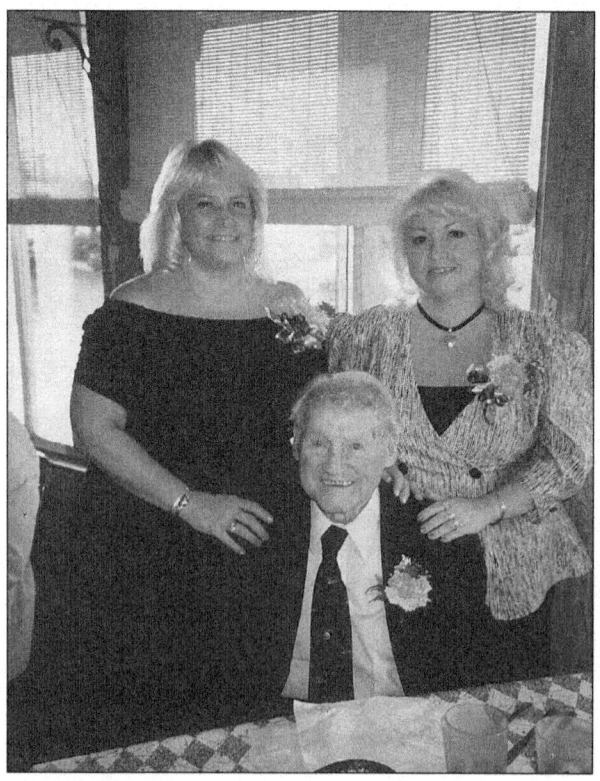

A BIRTHDAY PARTY. In this photo, Donna Mason (left) and her sister, Sherry Potts, pose with their father, Lee Savage, on his 90th birthday. As many as 30 people attended his party at the Kiwanas Club. When Donna was asked what her father's favorite cake was, she replied that he really did not have a favorite because he liked anything sweet. (Courtesy of Donna Mason.)

DONALD LEONARD. Donald is pictured here with his herd of ponies, 14 of which he donated to the Chincoteague Volunteer Fire Department. Leonard's family came to the island in the 1900s from Sweden. His grandfather, John, was an avid fishermen and was well known throughout the island for his angling skill. After John arrived and began pound fishing, 13 fishing companies sprang up around the island. As a boy, Donald would venture out to sea with the men, and he would often get sea sick. At 13, Donald told his father he wanted to quit school. His father said, "Go pack a pillowcase with clothes enough for a week. You're going out to sea," adding in no uncertain terms it was either the sea or school. The young Leonard did go out to sea with a fishing crew for a week. As soon as they returned, Leonard asked his father if he could go back to school.

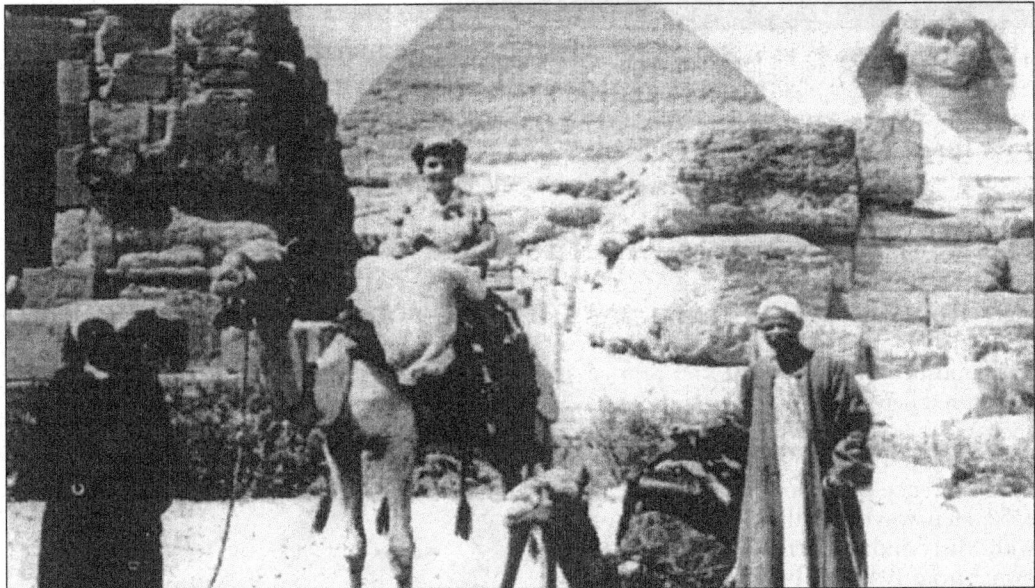

HALLIE WHEALTON SMITH, C. 1950–1960. Hallie was the sister of causeway builder John A.M. Whealton and the daughter of goose farmers Joshua and Nancy Whealton. A college graduate—rare for women of the time—she returned to Chincoteague to teach. She married Protestant minister James Smith and settled with him in Camden, NJ. When Smith died in 1948, Hallie was free to travel, as seen in this photo. She contributed generously to the poor and to education, and her father's goose farm became the site of Chincoteague High School. Because she ordered newspapers not to print her birth or death dates, her true age was unknown at the time of her demise in 1965, although many have put it at 94. (Courtesy of Kirk Mariner.)

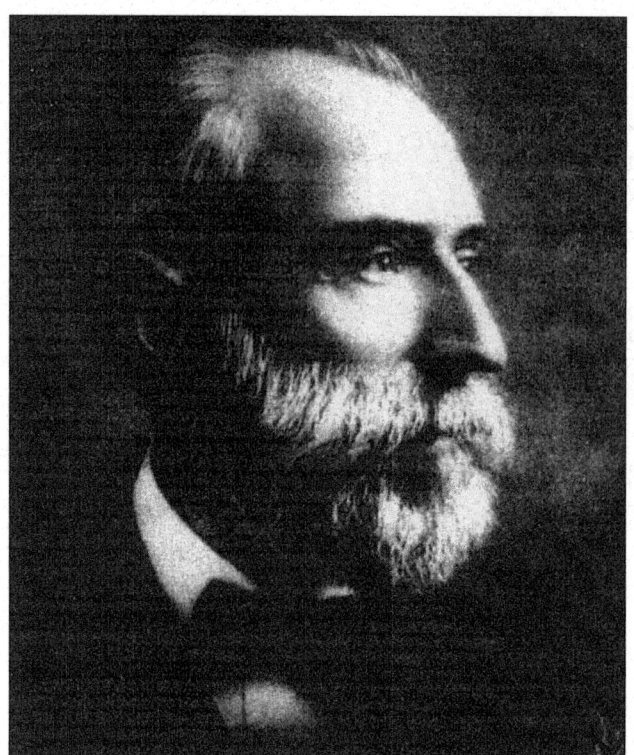

D.J. Whealton. Whealton was the president of the Bank of Chincoteague as well as being the president of Chincoteague Toll Road and Bridge Company. He owned "the Big Store" (the Whealton Mercantile Company) with his brother, J.W. Whealton. D.J. was instrumental in the success and organization of the Whealton Oyster Company, which always had plenty of workboats moored behind his building. Being the entrepreneur that he was, he took advantage of those boats by selling gas out of 55-gallon drums to fishermen. He was Chincoteague's first self-made millionaire. He died in April 1925. (Courtesy of Kirk Mariner.)

Marguerite Breithaupt Henry. A writer, Henry was born in Milwaukee, WI, on April 13, 1902. She authored *Misty of Chincoteague*, which was published in 1947. She is pictured here with Misty, the famous pony from her book, whom she purchased from Clarence Beebe for $150. Henry lived in Illinois with Misty and was her owner from 1946 until 1957, when she returned Misty to the Beebe Ranch to be bred. While staying with Henry, Misty had quite a following—as many as 300 people would come to see her on her birthday. (Courtesy of Kirk Mariner.)

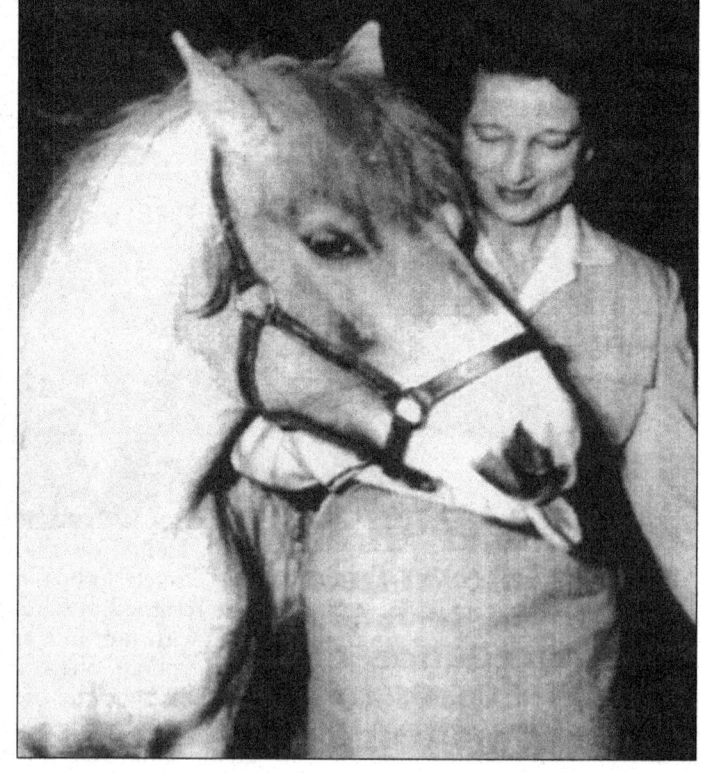

Five

LODGING
A Place to Call Home

Chincoteaguers lived in one- and two-room homes, one-and-a-half-stories high, made of red cedar, lime, and cedar blocks. Lath was often used to build chimneys. Sparsely furnished, the cabins were decorated with posters, cheap prints, and bottles stuffed with red flannel. In 1840, 500 people lived in a total of 26 houses. The well-to-do also lived in log houses, one-and-a-half-stories high, boarded outside and plastered inside. These homes were supported on huge cedar blocks. Great hearths held logs as large as a man. In the early 1900s, houses had outside pumps for drinking water that would often freeze in the winter and had to be primed for the water to start flowing freely. Also, many homes had their own vegetable gardens tended by the women and children in the family.

Most boardinghouses and hotels opened between 1876 and 1905, and ranged in size from cottages to the 52-room Atlantic Hotel, which boasted an excellent seafood buffet. The hotel was patronized by produce buyers, fertilizer salesmen, and bachelors who worked in the community. Dentists also frequented the town, spending one day a week at the hotel as practitioners, bringing their portable dentistry equipment with them. During this period in Chincoteague, the construction of residences and schools was underway.

The Island Manor House, built by Dr. Nathanial Smith and Joseph Kenny, is said to be the "most historic and romantic inn" constructed prior to the Civil War. Dr. Smith treated Union troops during the war, and Kenny was the island postmaster. The two built a large T-shaped house. When the pair married sisters from Baltimore, they divided the house in half, moving the front half to the lot next door. After 150 years, the house was rejoined and is now a bed and breakfast at 4160 Main Street.

After World War II, there was an increased demand for contractor services (carpenters, electricians, plumbers, and painters). Ranch houses, resembling 1920s bungalows with a breezeway and garage, began to appear. In 1950, the old houses were remodeled, and many new ones were built.

In 1962, motels, hotels, restaurants, and gift shops replaced shucking houses on the waterfront, and increasing real estate sales kept agents busy. In the 1980s, the houses were buff and pink, blue and dun, white and red, and yellow.

The year 2000 witnesses Chincoteague as a bustling town, offering a variety of accommodations including motels with heated pools and fitness centers, bed and breakfasts, inns, rental homes, quiet campgrounds, and hotels that offer piers for crabbing and fishing, along with boats to rent.

THE ISLAND'S OLDEST HOME. The Timothy Hill House, said to be the oldest house on the island, is thought to have been built sometime after 1821. Capt. Timothy Hill was originally from New England and decided to stay in the area after his boat wrecked. He married local girl Rebecca Russell in 1822. This home was originally located in Deep Hole and was moved in 1980 to 4463 Main Street. In 1885, a tragedy occurred at the home of Timothy Jr. and Zipporah Hill when Mr. Hill's daughter Jennie was murdered. The killer was Thomas W. Freeman, a 20-year-old deck hand who lived on the Hill's farm. When Jennie declined Freeman's proposal of marriage, he became extremely distraught, writing his feelings in letters that were not mailed and blaming Jennie's mother. On June 18, 1885, Jennie and her mother were gunned down with a .32-caliber pistol as they made their way through the front gate. Miraculously, they struggled to a neighbor's home, during which time Freeman took his own life. Jennie died during the night, but her mother survived the shooting. Jennie was buried in a graveyard next to the house, and her mother dedicated a window in the Methodist church at 6254 Church Street in her memory. (Courtesy of Kirk Mariner.)

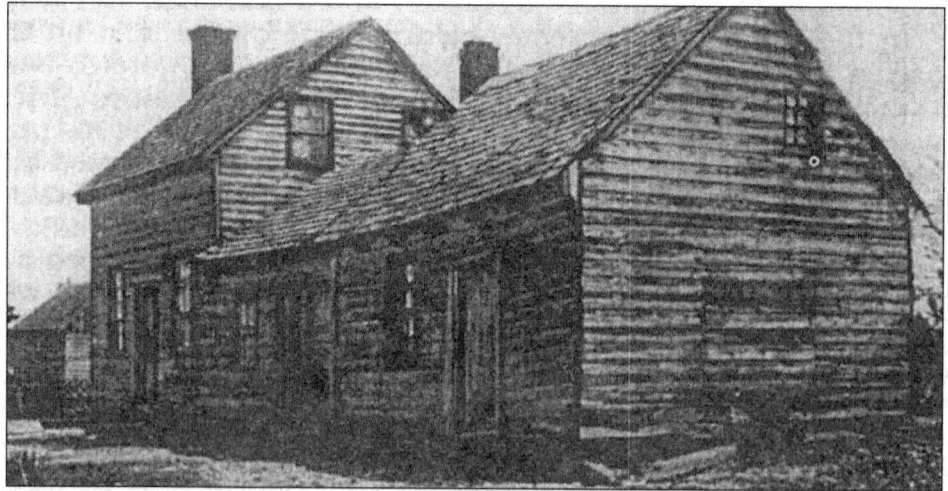

THE SARA LEWIS HOUSE. In the early 1800s, this home was located on the east side of the island on the old Kendall land near Assateague Channel. Most parcels subdivided from this land were split into 30-acre lots. The people who lived here were fairly poor and relied on cattle and farming for their livelihoods. (Courtesy of Kirk Mariner.)

THE ZADOCK CARTER HOUSE. Now located at 4694 Main Street, this house was moved from Deep Hole sometime in the 1980s. The ground on the west side of Main Street consists of oyster shells from the years of dumping by the booming seafood business, which enabled the land to be filled in and buildings to be erected. Zadock Carter served in Company A, First Regiment, Loyal Eastern Shore of Virginia. (Courtesy of Kirk Mariner.)

THE "ROUND HOUSE." This home was owned by the collector of customs, John Caulk, who worked for Governor John M. Clayton of Delaware before coming to Chincoteague. His function as collector was to register boats and collect the fees. His residence doubled as the customs house. The front of the house is hexagonal, an unusual feature for its time period. The home, originally situated on Main Street, is now the site of the Methodist church parking lot. (Courtesy of Kirk Mariner.)

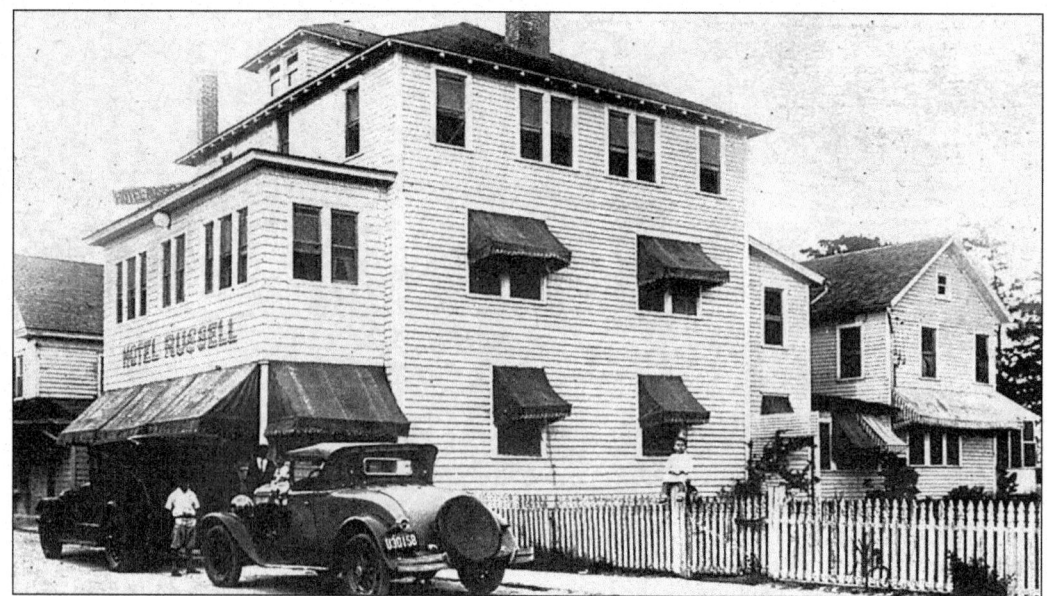

HOTEL RUSSELL. Destroyed by fire on September 28, 1968, this beautiful hotel was originally owned by Elva Jefferies; a third story was added before the structure became a hotel. Today, Bill's Seafood Restaurant is located on the site. Emma R. Russell (1875–1952) ran both the Channel Bass Inn and Hotel Russell. (Courtesy of H&H Pharmacy; collection of John E. Jacob.)

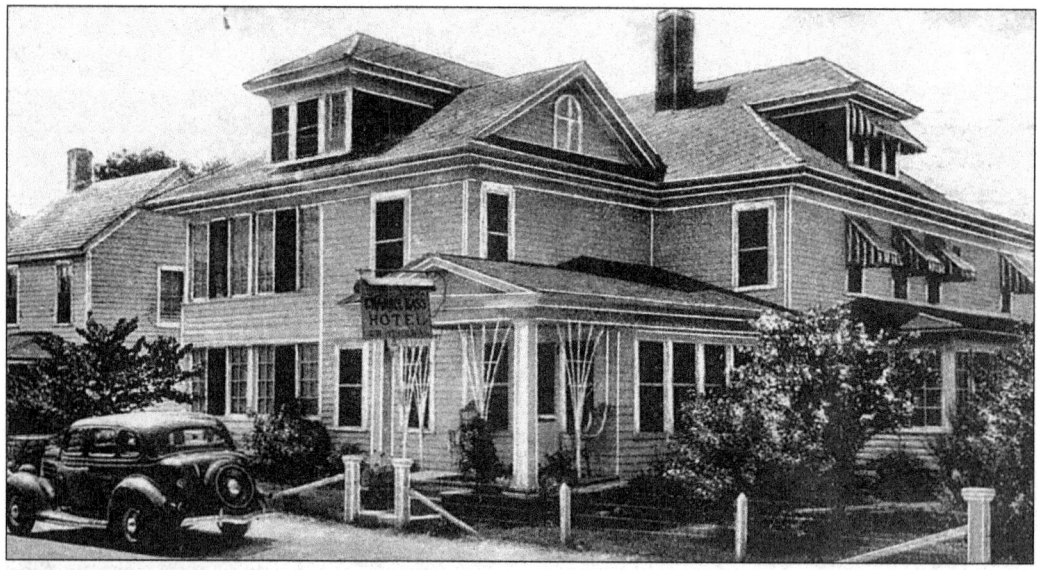

CHANNEL BASS INN. Located at 4141 Main Street, this inn was one of only two small hotels on the island in 1962. John W. Winder, one of Chincoteague's mayors (1921–1931), was once the occupant of this lovely inn. The building was eventually moved from Main Street to Church Street. Purchased by James Hanretta in 1972, the inn catered to an affluent clientele. In the 1980s, Channel Bass was known for the most expensive meals and accommodations on the Eastern Shore. It has six furnished, air-conditioned rooms with a view of the Chincoteague Bay, and received a "four-star rating" in the Mobile Travel Guide in the mid-1980s. (Courtesy of Albertype Company; collection of John E. Jacob.)

THE BUNTING HOME. This postcard shows William Bunting's home, which he purchased from D.J. Whealton after losing his own home in the blaze of 1920. Whealton moved into this house at 4130 Main Street in 1902. The three-story home had stained-glass windows and a widow's walk; the front gates were adorned with marble pedestals. The house was replaced by a Jones & Mason Service Station and, later, by a Shore Stop. (Courtesy of Kirk Mariner.)

A VICTORIAN HOME. Donna and Tommy Mason own this lovely Victorian home. The year 1906 is found on a deed that was in the house's attic; however, the house was built prior to that time. In 1997, the Masons completely restored the building and transformed it into condos. (Courtesy of Donna Mason.)

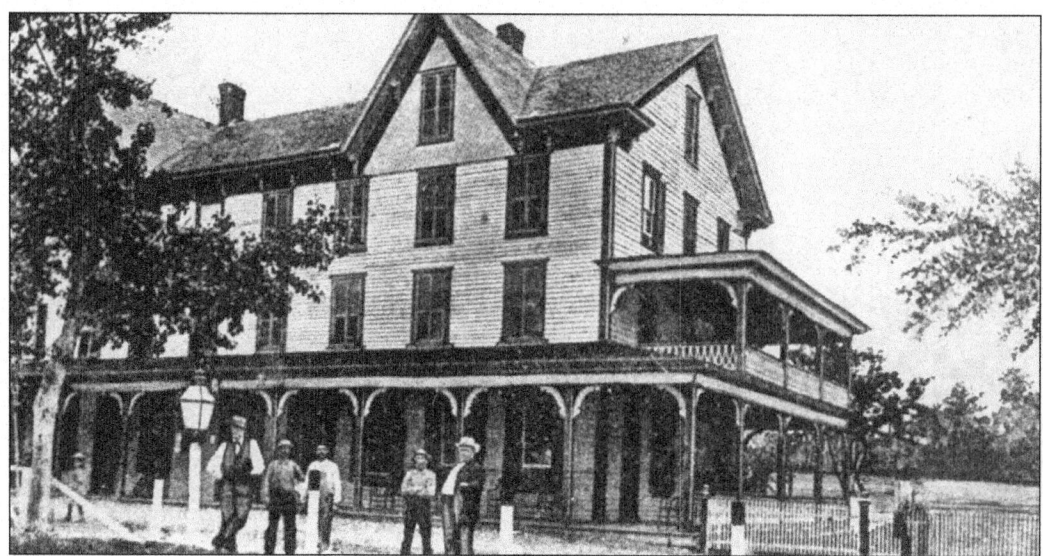

THE ATLANTIC HOTEL, C. 1906. In this postcard are, from left to right, Elizabeth Coleburn, Joseph Rowley, Joseph Snead, Charles Mumford, John Kelly, and John Warren (the hotel proprietor). Established in 1876 and built by Joseph J. English, the hotel opened at the same time the Worcester Rail Road was making its way into Chincoteague to pick up seafood. The grand hotel, the largest building in town, stood three-and-one-half-stories high, boasted 52 rooms, and cost almost $10,000 to build. In the early 1900s, only affluent passengers would be privy to its hospitality. Salesmen would stay at the Atlantic because they had access to horse-drawn buggies, which would take them on their sales calls. The hotel was patronized by produce buyers, fertilizer salesmen, bachelor employees, and by dentists, who spent one day a week at the hotel to treat the locals. (Courtesy of Louis Kaufman and Sons; collection of John E. Jacob.)

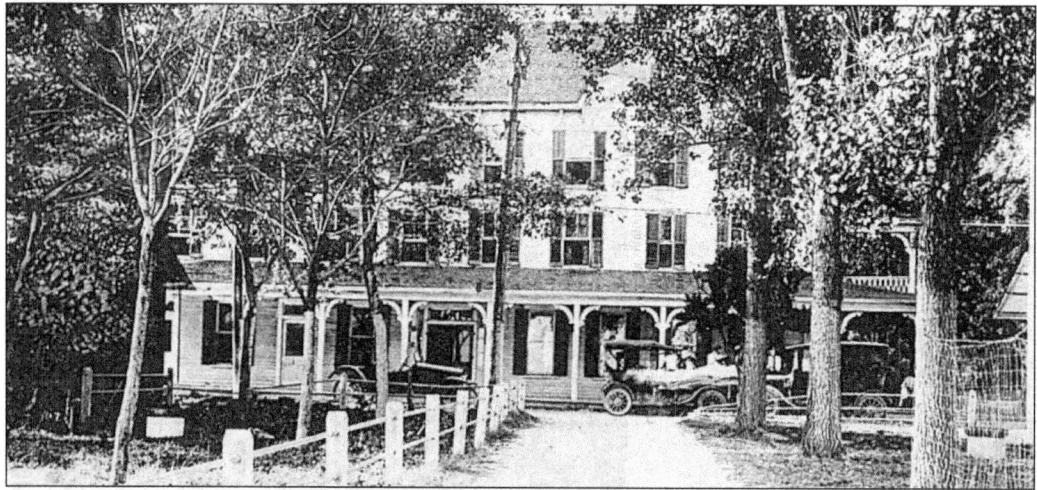

THE ATLANTIC HOTEL. This card shows a long sidewalk leading to the Atlantic Hotel. In March 1878, Joseph J. English, the hotel's owner and a school trustee, killed Stephen Pollitt, a guest at his hotel, when Pollitt did not make good on his note promising to pay his board by the end of the week. English turned himself into the authorities but escaped as they were taking him to a Drummondtown jail. The hotel was sold at auction in 1878 to William J. Matthews (1853–1933), his former partner. It stood where the Island Roxy Theater is today. (Courtesy of Louis Kaufman and Sons; collection of John E. Jacob.)

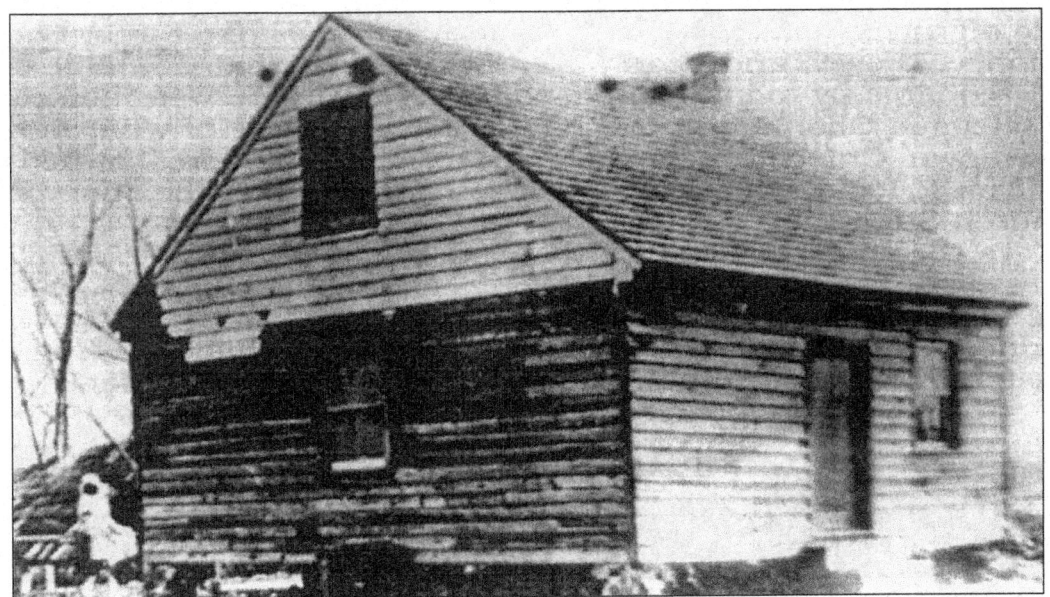

THE KENDALL JESTER HOUSE. Believed to have been built in 1727, this house stood at the northern end of the island in Wildcat Marsh at 4218 Main Street and was home to the Jesters, one of 30 families occupying the island. Many of the island occupants were quite impoverished, living only, at the time, on the natural resources of the land. Others did have at least one horse and some cattle, which was their main source of income. (Courtesy of Kirk Mariner.)

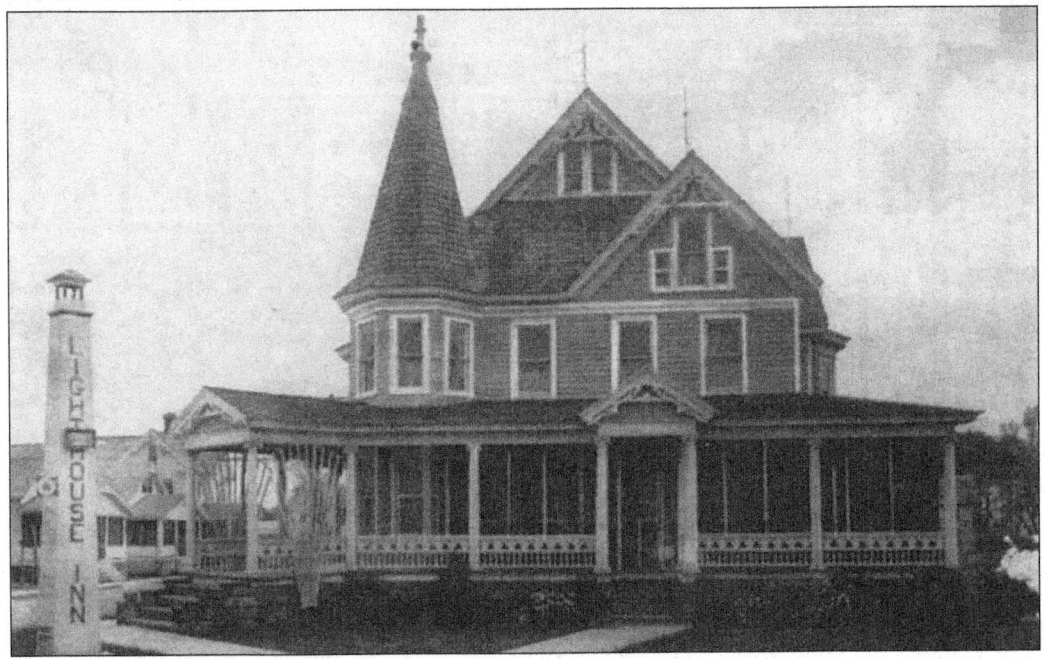

THE LIGHTHOUSE INN. This inn was originally the Kendall J. Jester House, pictured at the top of the page. An addition was put on the older home that included a wrap-around porch and gingerbread trim. In the 1960s, after being operated as the Lighthouse Inn, the building was torn down by Wheatley Watson so the Lighthouse Motel could replace it. The inn is still referred to as the Lighthouse Inn. (Courtesy of Kirk Mariner.)

AN ASSATEAGUE HOME. This old home was floated over from Assateague to Chincoteague in the early 1920s. Owned by Jay Cherrix, it is located next to Tidewater Expeditions on East Side Drive. The building, which houses Cherrix, his wife, and five children, looks very much as it did when it stood on Assateague.

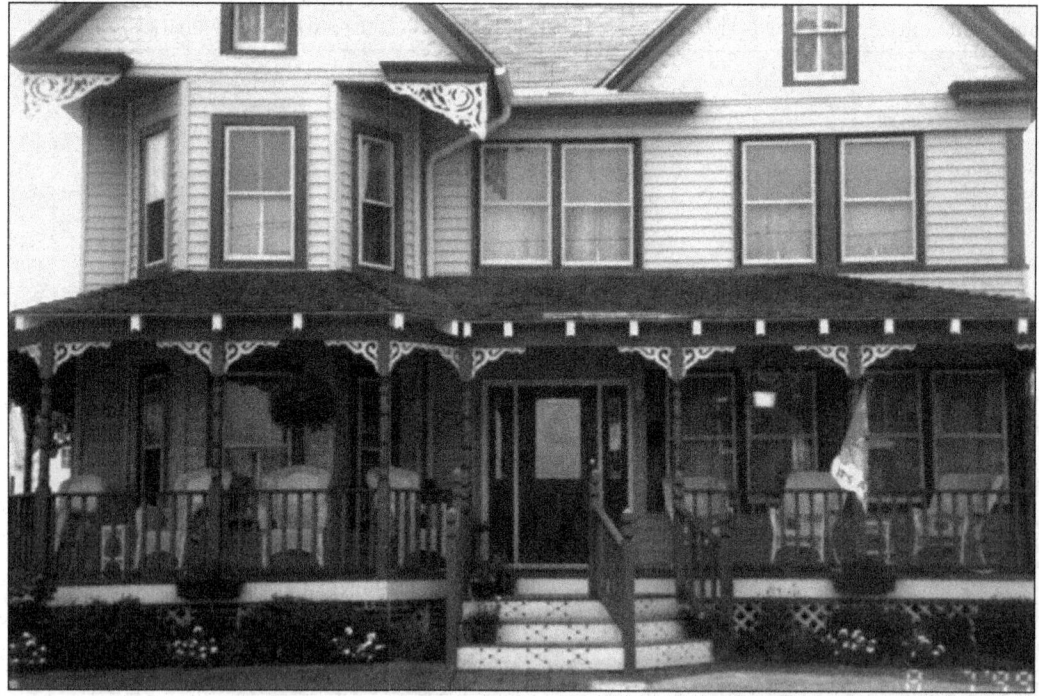

THE WATSON HOUSE BED AND BREAKFAST. The Watson House, built in 1898 by Robert Watson, was located at 4240 Main Street. This bed and breakfast has recently been renovated to include six guest rooms, all with private baths. Opened in 1992 for business, it has been featured on the Learning Channel's *Romantic Escapes*. David Snead, his wife, JoAnne, and the Derricksons are the innkeepers of this Victorian country home.

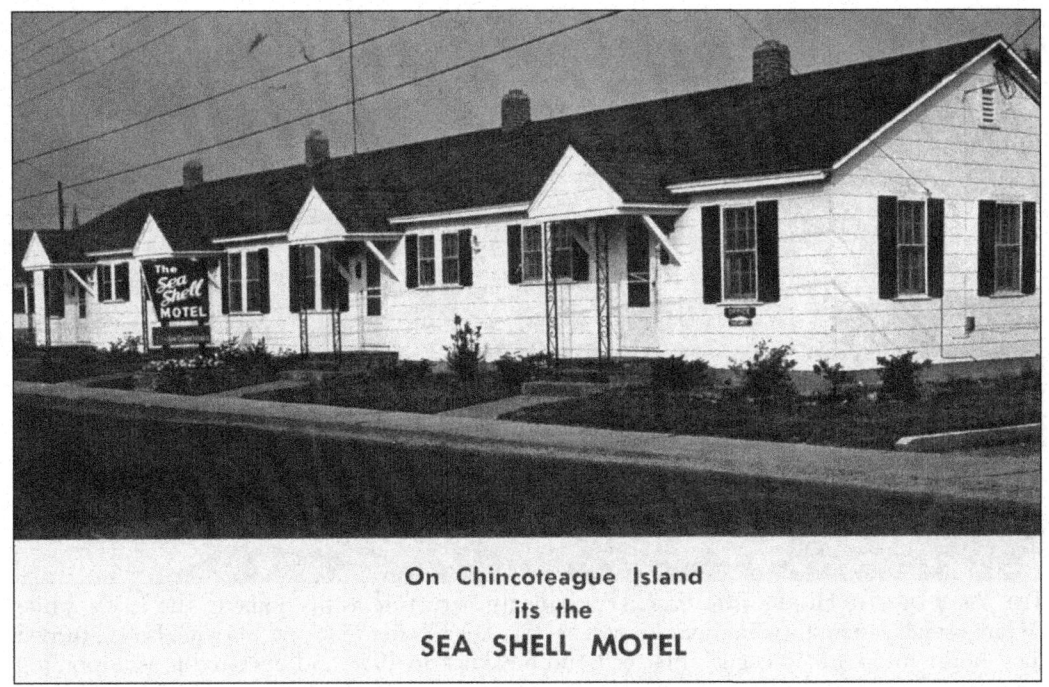

SEA SHELL MOTEL. This family-oriented hotel was started in 1965 by Robert and Nancy Conklin. Nancy Conklin's great-grandparents, John Wesly and Nancy Fletcher, lived on the island. Photographer Robert Conklin is related to the Jesters and Kendalls. Originally, four apartments were remodeled and offered as a comfortable vacation haven. In 1969, six rooms and a pool were added. Today, the Sea Shell Motel has a total of 40 units. Many of its original clientele return year after year, now with their children and grandchildren. Chris, the Conklin's middle son, acquired the motel three years ago and continues the family tradition of providing a warm, friendly atmosphere for vacationing folks. (Courtesy of Nancy and Robert Conklin.)

THE YEAR OF THE HORSE INN. Ed Clarke built this structure as his home in the 1930s, while he ran a small restaurant next door known as "Clarke's Corner." He and his wife, Isabel, turned their house into Chincoteague's first bed and breakfast in 1958 and operated it as a rooming house for itinerant fishermen. In 1978, after Clark expanded the inn, it was sold to Carlton and Jean Bond and renamed the Year of the Horse Inn because of the couple's fondness for the Chincoteague ponies. In 1999, the inn, located on the Chincoteague Bay on Main Street, was purchased by Richard Hebert. (Courtesy of Richard Hebert.)

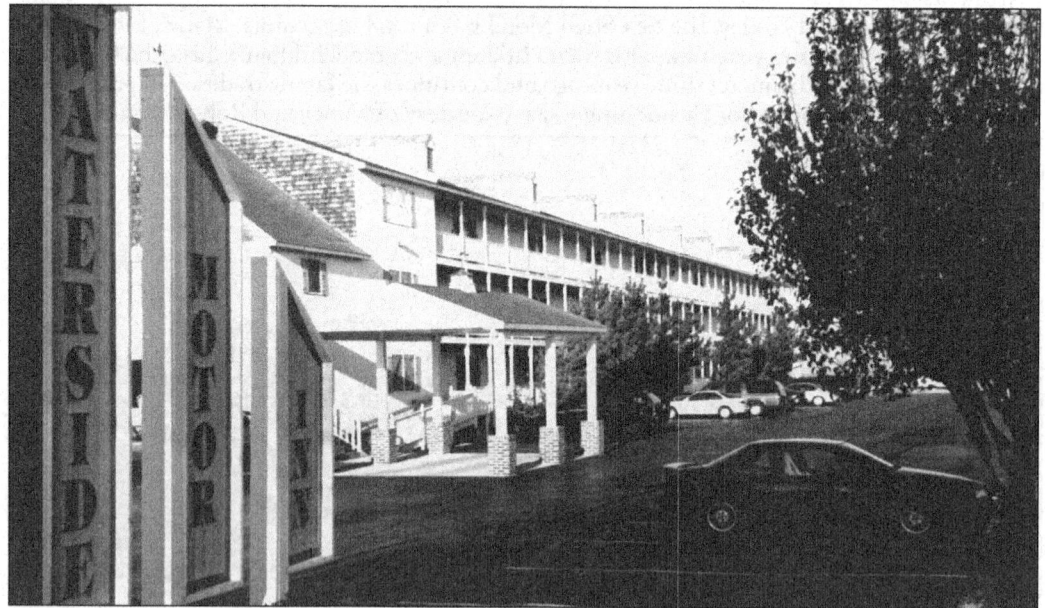

WATERSIDE MOTOR INN. This inn opened in June 1987 on the site of the former Mason Seafood business, an oyster-shucking and processing plant. It represents Chincoteague's modern development and is unlike the majority of the island's lodgings, which were originally built as residences. Donna Mason, Lee Savage's daughter, owns this motor inn located on the Chincoteague Channel. (Courtesy of Donna Mason.)

Six

EDUCATION
READIN', 'RITIN', 'RITHMETIC

Education did not come easily to the barrier islands. The year 1840 is recorded as the date of the establishment of the first school. The islanders considered this of primary importance, for at the time the town had no stores, no public buildings or inns, and not even a collective neighborhood—but it did have its first school.

In 1852, about 20 islanders petitioned the government for the establishment of a free, or public, school. To meet the government's requirements for a public school, parents had to "fudge" student attendance numbers, since requirements stipulated that 40 students had to be eligible for education. The petition was granted. The second school was erected on Greenwood Cemetery (now called the Bloxom House), but was, from the start, too small and built too far from the homes of most students. To help pick up the overload of students, a third school was built in 1869—this one on 5321 Main Street. It served as the Good Will School House and the Divine House of Worship for church meetings.

In 1878, the Church Street school was the first to place students into corresponding grades; within a few years, there were three grades, with three teachers instructing 242 youngsters. In 1883, two private schools were established; three years later, the first African-American school opened with a total of 20 students. By 1885, the school population had risen to nearly 700.

In 1890, Assateague had its first and only school, so by 1898, six schools existed on the two islands: Church Street, Goodwill, Down the Island, the African-American school, Assateague's school, and the Up the Island School.

The year 1922 saw the erection of a new brick high school—the old frame high school was moved and used for additional instructional space for 75 high schoolers and 366 elementary schoolchildren. By now, school buses had replaced wagons, and hot soups were served as lunch. During World War II, schools also were used for rations recordkeeping and the distribution of food coupons, as well as community canneries. In 1951, a 12th grade was added to Chincoteague's high school.

A new and modern high school was built in 1959. This became the era of racial integration. Over the next 15 or so years, schools expanded as Chincoteague's population grew and then stabilized. The educational system became as modern and updated as any on the Delmarva Peninsula.

A STUDENT GROUP. These young scholars are standing before their school in Assateague. Note the differences in height of the children, indicating the variances in ages; yet all were grouped into a one-room class. The first recorded teacher was John W. Field, who taught first through sixth grades. He and his descendants acquired much Assateague property over time, and it was his heir, Samuel Field, who caused many of the residents to leave the island for Chincoteague to make a living. (Courtesy of Elsie Jones, who dates this photo as the late 1800s.)

THE SCHOOLHOUSE, C. 1907. The Accomack County School Board had this one-room schoolhouse built on Assateague in 1890 for grades one through six. The building served not only as a schoolhouse but as a meeting place for various organizations and religious groups. It had no running water, and was heated by a coal stove that the students kept running. Lillian Mears Rew reports, "The desks were merely benches, without backs. These were arranged end-to-end around the room."

GRADUATES IN 1910. As early as 1905, Chincoteague High School held "closing exercises," during which time two students received diplomas. In 1907, Martin Davis was the only graduate. This 1910 image features 12 graduates in front of the old high school. Pictured, from left to right, are as follows: (seated) Emmett Fedderman, Charles Jones, LeRoy Jester, and Arthur Marshall; (middle row) Fred Dryden, Cynthia Watson Jester, Helen Davis Custis, Oneita Adams Houge, Bertie Adelotte, Elizabeth Coulburn Tilghman, Loula Watson Smith, and Clifton Marshall; (back row) Principal James L. Madden and his assistant, Daniel G. Conant. (Courtesy of Katherine Tolbert.)

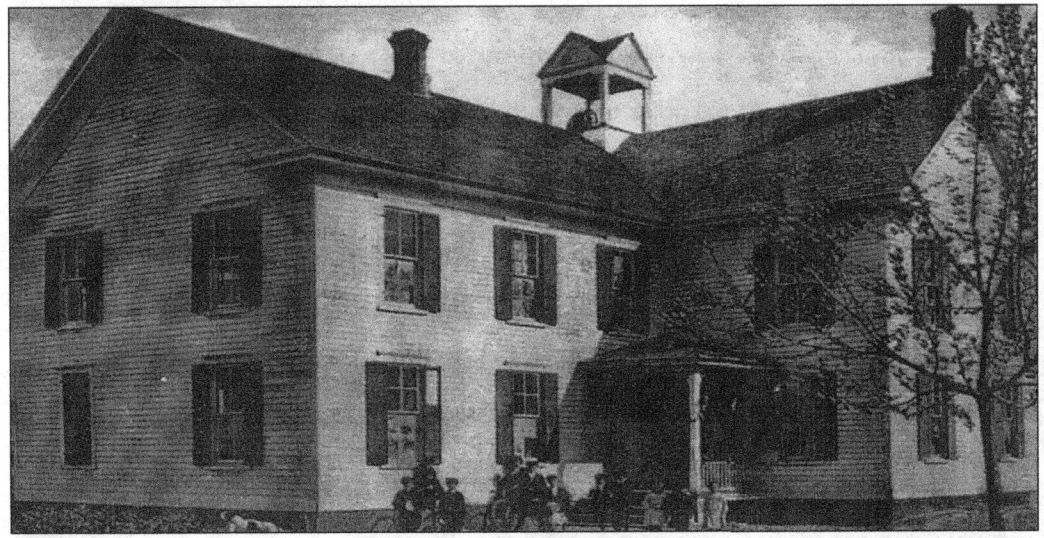

THE OLD SCHOOL. In his *Once Upon an Island*, Kirk Mariner reports that in 1875—six years after the state constitution mandated public education—a school was established on Church Street. In 1883, as the island and the student population rose, expansion became necessary; this was followed by the construction of an entirely new building by John A.M. Whealton and A.T. Matthews around 1888. The new building is pictured here in 1916. The bell atop the roof became a symbol of education in the small town. (Courtesy of Katherine Tolbert and Amanda Rhodes.)

"Skiffing" to School, c. 1919. When maintaining a school on Assateague became impossible after nearly all the families moved to Chincoteague because of Samuel Field's no trespassing rules, the school folded. Those youngsters still on the island had to be transported to Chincoteague to attend school. The skiff in the forefront of this image is the type of boat that took students across the water. The vessel could hold several children, though many seats were not needed, since Assateague Village was disintegrating and, in fact, had all but entirely disappeared by 1925. (Courtesy of Curtis Badger.)

The Collins Children. This early 1920s photo shows students posed on the lawn in Assateague Village. In the background are typical Assateague homes, nearly all designed in a box-rancher style and painted white. The Collins sisters are, from left to right, Ruth, Margaret, and Ada. The girls were likely the relatives—perhaps the daughters—of the lighthouse keeper. Presumably, they were the last of Assateague's schoolchildren; most students had already moved to Chincoteague to continue their education. (Courtesy of Curtis Badger.)

 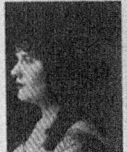 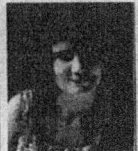 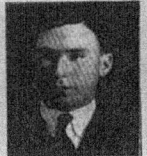 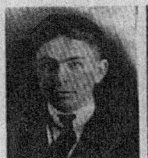

ELIZABETH BAKER — ELODIE V. BOOTHE — GLADYS BOWDEN — MARGARET CHERRIX — ELIZABETH C. CLAYVILLE — HENRY WARREN CONANT — JENNIE LEONARD — FLOYD HILL — EDNA MAE MERRITT

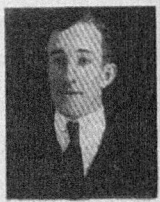 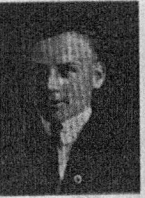 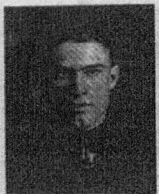

LUCIAN LINWOOD POWELL — LEE SAVAGE — CHRISTINIA B. TARR — GLADYS ELIZABETH TARR — CLARENCE THORNTON — JULIETTE THORNTON — EUNICE TWILLEY — EARL WATSON

 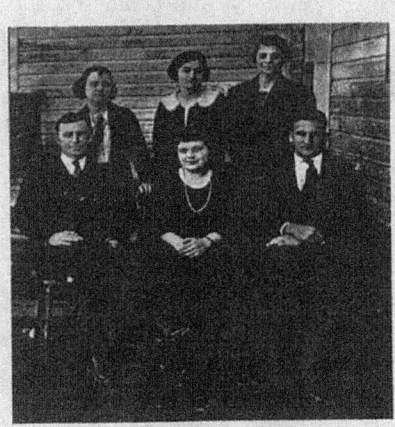

DIXIE ROBERTSON — PROF. JOHN E. DAVIS — PROF. CHARLES S. ADKINS

A SENIOR CLASS COLLAGE. This collage of 1922 graduating seniors from Chincoteague High School indicates the size of the school and, through the students' attire and poses, the tenor of the time. Notice the fine dresses of the young ladies—in dark colors and wearing jewelry in some cases—and the ties and stiff shirt collars of the gentlemen. Nearly all the fellows have short, well-trimmed hair while the women have long hair. Some of these young people represent the well-known families that have been around since the first settlement—Cherrix, Tarr, and Savage. When asked what their favorite hobbies were, Lucian Powell answered "Kissing the ladies"; Juliette Thornton said, "Autoing"; and Elodie Boothe responded, "Telephoning." The two gentlemen referred to as "professors" are the school's principals. The faculty (in the bottom right photo) included principal Charles Adkins, who taught Latin and French; Iona Wimbrough, history and English; Anna Green, commercial studies; Harry Rasin, math; Annabelle Lynch, science and history; and Dixie Robertson, music. The class flower was a white rose and their colors were black and orange. The class motto was, "With the ropes of the past we will ring the bells of the future." (Courtesy of Donna Mason and *The Sea Conch 1922*.)

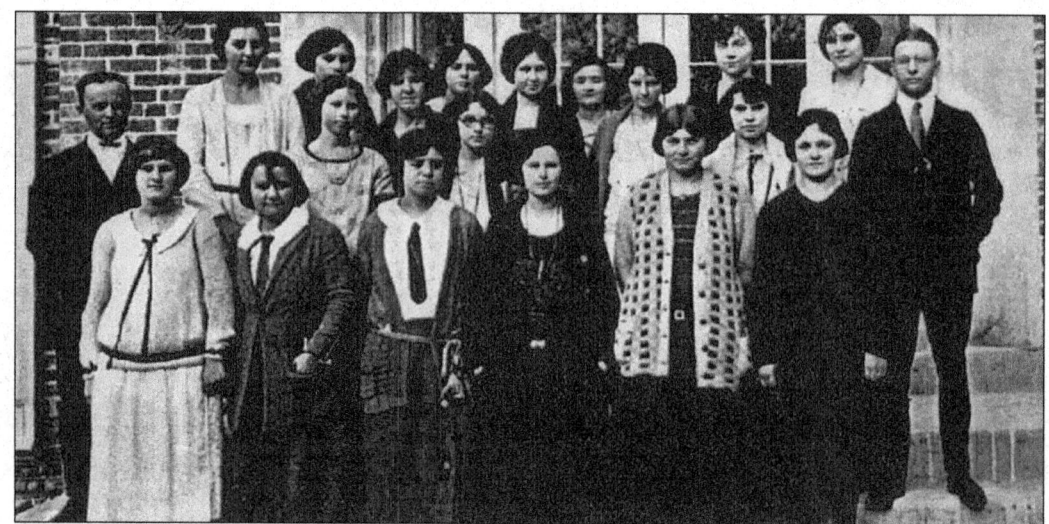

FACULTY MEMBERS, 1924. Principal Stanley Clarke (second row, far right) taught French, history, and geometry. E.E. Neff was his first assistant and science and math teacher. The two classes per grade were taught by Elizabeth Tilghman and Melva Sharpley, seventh grade; Lula Russell and Lula Phipps, sixth grade; Bernice Jefferies and Lillian Mears Rew, fifth grade; Blanche Bowden and Iona Bowden, fourth grade; Alda Merritt and Ida Bloxom, third grade; Anna Belottee and Mary Henderson, second grade; and Audrey Gladden and Bertie Adylotte, first grade. William J. Matthews was the school's trustee. (Courtesy of Katherine Tolbert and *The Sea Conch 1922*.)

A COLLAGE, 1936. In *The Watermen and Wild Ponies*, Robert Mears remembers his school days: "We graduated from high school in the 11th grade. Our prom was held in the upstairs hallway of the school since there was no auditorium . . . It was something very special and a last time to enjoy our teachers. We were so lucky. We had good teachers who were a great influence on us as well as good examples." This 1936 class graduated from what was referred to as the "new high school." (Courtesy of Maury Enright.)

THE 1949 BAND. Chincoteague's high school band, directed by John A. Hornberger (in white uniform), was one of the best on the Eastern Shore. Organized January 12, 1947, the band was supported by the community and became a first-class musical ensemble clad in professional uniforms at the tune of $2,900. The price of the musical instruments for 51 boys and girls was approximately $8,000. There were also six majorettes and six color guards. Nancy Bennett Conklin was the pianist. The school went without a band from about 1965 until it was restored sometime in the early 1970s. (Courtesy of Maury Enright and Chincoteague High School 1949 Souvenir Program.)

THE 1949 FOOTBALL SQUAD. This team portrait illustrates the football uniforms of the period. Note the bowl-style helmets and how unprotected the players' legs were. Teaguers supported their team, as was apparent in the number and variety of advertisers found in the players' souvenir book. The squad included the following, from left to right: (front row) Ronnie Savage, Sonny Stringfellow, Lee Kleckner, Fred Tolbert, Floyd Brasure, Wayne Tolbert, Terry Powell, and Roy Clemmons; (middle row) Robert Booth, John Harmon, Thomas Conklin, Dicky Williams, Ronnie Beebe, Billy Fisher, and Warren Large; (back row) Billy Derrickson, (manager), Edward Waterhouse, Rex Bell, Robert Tull, Raymond Horner, A.J. Smith (head coach), Barry Fisher, Wayne Collins, Elmer Johnson, Bob Birch, and Barry Andrews (assistant manager). (Courtesy of Chincoteague High School.)

THE FACULTY, 1951. This image of Chincoteague's faculty reflects a happy group of teachers, most of whom remained in education for the long haul and served as instructors for grades seven through twelve. In the front row are Elsa Mears (far left), Winnie Tucker (second from left), and Iona Burton (second from right). Mr. Thomas Phillips was principal. In the back row, third from the right, is the well-known Lillian Rew, town historian. In her book, *Assateague & Chincoteague, As I Remember Them*, she writes, "For the past several weeks one section of the seventh grade . . . taught by Mrs. Lillian Mears Rew, has had as a unit of work, a study of Virginia." (Courtesy of Katherine Tolbert.)

SEWING CLASS, C. 1951. These young ladies are engrossed in the work at hand, which seems to be a sewing lesson perhaps in a home economics class. Notice the old-fashioned sewing machines, the large spools of white thread, and the girls' hairdos and attire. Pictured from left to right are Louise McGee, Lana Merritt, Etta Lou Day, Nadine Booth (seated), Judith Trader, Elsie Mae Savage, Mrs. Anne Reynolds (teacher), Gloria Tull, Nancy Derrickson (seated), Esther Thorton, Darlene Birch, and Estelle Waterhouse (seated). (Courtesy of Katherine Tolbert.)

THE SCHOOL BELL, C. 1957. An early token of education in Chincoteague's history, this bell was in use from 1913 through the 1950s, and teacher Elsie Mears was in charge of ringing it. Its early morning "clang" summoned the island's youngsters to begin their school day. The bell was later donated to the Oyster Museum. Featured here are, from left to right, Elsie Mears (retired), Paul Merritt, Mr. and Mrs. Carl Bond (who donated the bell to the museum), teacher Marguerita Hill (retired), Mayor Terrell Boothe, teacher Melva Tarr (retired), museum curator Nicki West, and Lillian Williams. (Courtesy of Katherine Tolbert.)

LILLIAN MEARS REW'S CLASS, PRE-1959. Rew taught from 1923 until her retirement in 1968. Except for the 1945–1946 school year, when she taught in Temperanceville, VA, Rew spent the rest of her career in Chincoteague schools. It was while teaching that she began her study on the history of the island and published *Assateague & Chincoteague, As I Remember Them*. During an interview with one of Rew's former students, this bit of information was revealed: "Miss Lillian was no dummy; she got us—her students—to help research the island's history which she produced in a book form. She was one outstanding teacher who represented what education was all about." Rew is standing on the right. (Courtesy of Katherine Tolbert.)

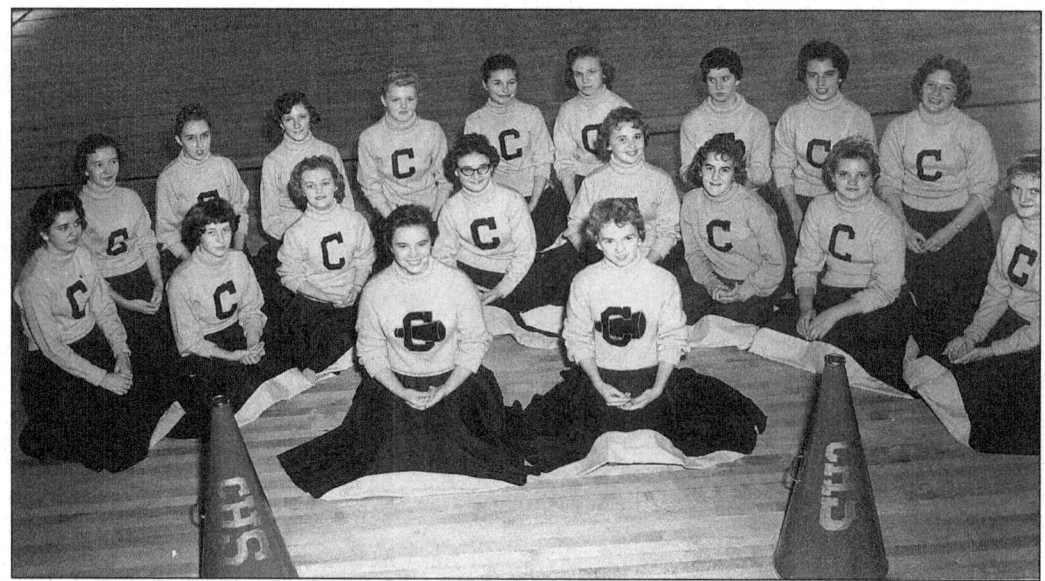

THE CHEERLEADING SQUAD. This picture emphasizes the importance placed on cheering for the Chincoteague Ponies. These young ladies are posing in their school-spirited sweaters and with their skirts flared. The two cheerleaders in the front, wearing slightly different sweaters, are the squad's co-captains. (Courtesy of Maury Enright.)

SHOP CLASS. Even back in the mid-1960s, shop class was popular, though these students appear to be too well dressed for actual work. One male student in the photo raises in hand what appears to be a rubber sledgehammer or mallet while a female student holds an object on the shop table for him to hit. (Courtesy of Maury Enright.)

THE 1972 GRADUATING CLASS. Some of the members of this more recent high school class went on to achieve great success, while others met with bad luck and even tragedy, as four of them died before their time. (Courtesy of Maury Enright.)

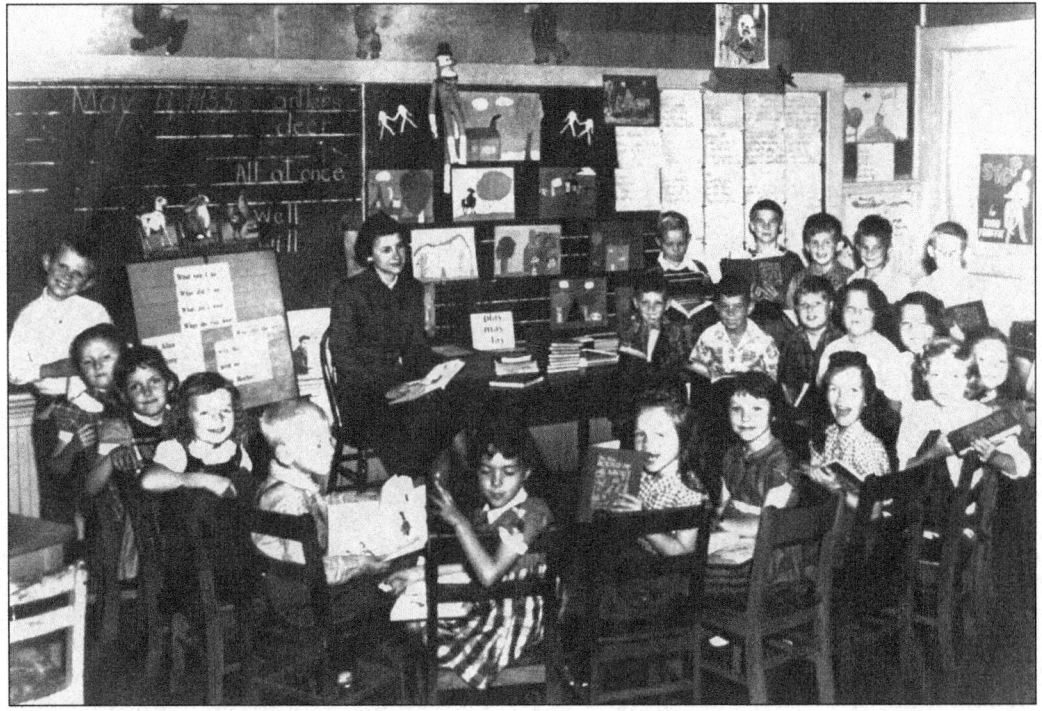

AN OLD-STYLE CLASSROOM. This image shows a typical classroom in the late 1940s or early to mid-1950s. The 21 students seen here are well dressed and seem to be attentive, though in a small, crowded classroom. Notice the lined, slate chalkboards, the wooden desks, and the samples of student handwriting exercises and the art projects taped to the chalkboard. (Courtesy of Maury Enright.)

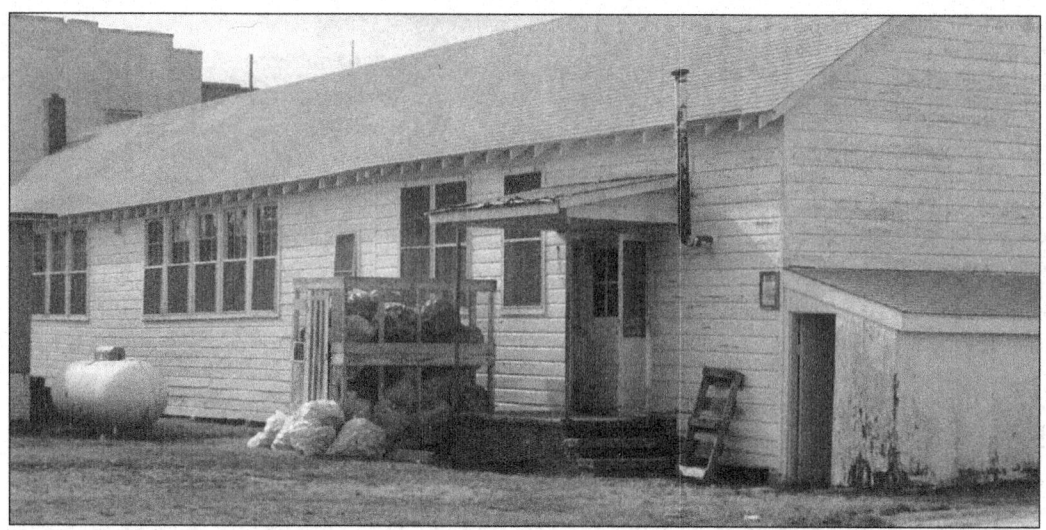

THE OLD SCHOOL/CAFETERIA. The history of education on the island is a confusing one because of the various schools that were built, closed, re-opened, and moved, not counting those that were private or public, or independently supported; others held only grades first through third, while still others were complete elementary schools and partial high schools. Featured here is the elementary cafeteria, which was built c. 1959 as an addition to the brick school that was built in 1922.

CAFETERIA WORKERS, C. 1959. This image shows the first cafeteria workers, since none of the schools on the island served lunch until this point. Students bought snacks from local stores or walked home for their noon meal. When this cafeteria opened, students sat at long tables slurping bowls of soup and pints of milk. In comparison to the mega-sized schools of today, this cafeteria is small and has hardwood floors instead of concrete ones. Behind the two boys on the right is a cooler, or ice box—what the old soda machines looked like. On the rolling tray in front of the cafeteria ladies are cartons of milk. (Courtesy of Katherine Tolbert.)

Seven

OCCUPATIONS
VOCATIONS AND VACATIONS

In the 1670s, settlers came to the north end of Chincoteague to cultivate large farms and raise strawberries, potatoes, and corn. These early settlers also had livestock consisting of sheep and cows. In the latter part of the 17th century, the settlers on Chincoteague relied heavily on fishing, egging, oystering, and clamming for their livelihood. Irish potatoes, sweet potatoes, and corn became a part of crop-raising and were a large part of the food supply. These hardy people were also blessed with having an abundance of soft- and hard-shell crabs. In the late 1800s, oyster companies were started. It was common for these companies to have from 600 to 1,000 barrels of oysters shipped weekly by steamer up north to Pennsylvania and other Northern locations. In the early 1900s, fish companies also became prevalent. The fish that were frequently caught included sturgeon, drum, croaker, hogfish, bluefish, butterfish, trout, and flounder—most of them migrating species found inshore. Ducks and terrapin were also shipped up north and to finer restaurants and hotels that considered them a delicacy. Other enterprises included a tomato packing company and salt-manufacturing ventures.

In the 1900s, D.J. Whealton owned the D.J. Whealton Oyster Company, as well as the largest mercantile store on the island. Sometime between the 1930s and early 1940s, during the Depression, the poultry business found its way to the island. It proved to be very profitable—so much so, that in the 1950s, "Chicken City," where most of the chicken houses were located, produced one million chickens a year. The chicken industry declined in 1962 after an Ash Wednesday nor'easter slammed into the island, killing up to 350,000 chickens and ruining the chicken houses as well.

After the 1962 storm, Chincoteague rebuilt itself with new bed and breakfast inns, restaurants, museums, off-shore fishing, and other tourist attractions. The islanders started to rely on tourism to keep their town thriving.

Today, tourists frequent the island to visit Chincoteague National Wildlife Refuge, which offers a haven for bird watchers and naturalists. Activities available include camping, biking, hiking, surf fishing, crabbing, and shell collecting. A close-up view of the Assateague ponies is available. The pony penning also helps the economy of Chincoteague and is said to be "Christmas in July" to the local businesses.

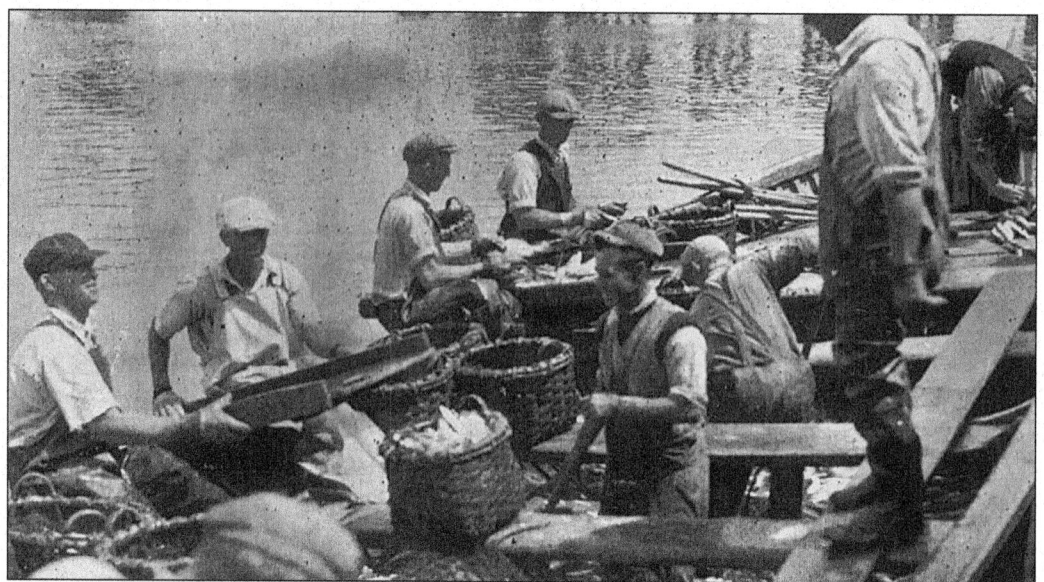

OYSTERS. In the 1800s, Chincoteaguers started to count on seafood as a means of earning a living. Oysters were plentiful to begin with, but by the late 1800s they were not reproducing fast enough naturally to keep up with the demand. John A.M. Whealton showed the islanders how to cultivate and harvest the oysters, and the Chincoteague variety soon became a coveted commodity. The most sought after oysters were grown in the sandy bottom of Tom's Cove. In the 1800s, a local oysterman earned, on average, $700 for a seven-month season. (Courtesy of Robert E. Wilson.)

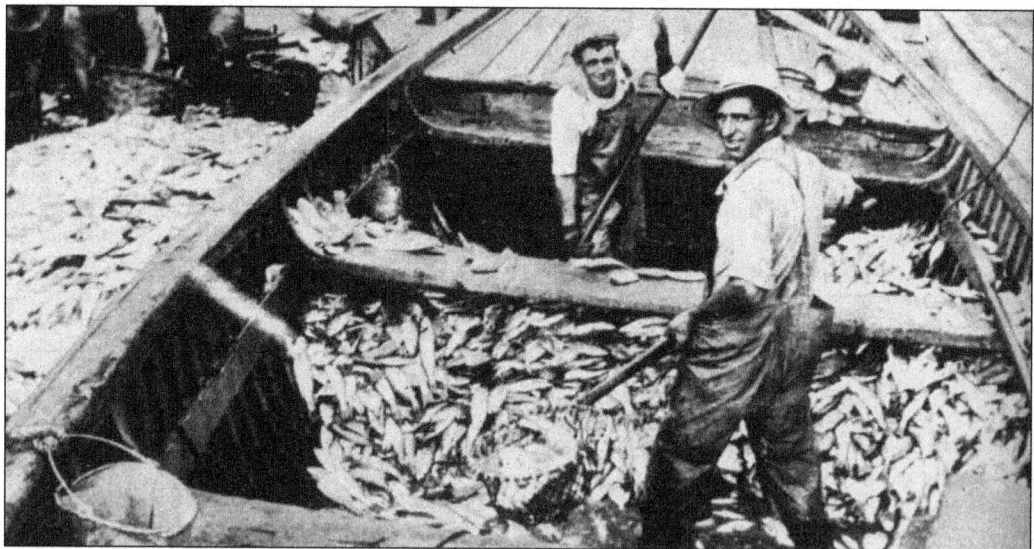

UNLOADING A FISHBOAT. This 1932 photo shows local fishermen unloading trout to sell to the Leonard Fish Company, one of the biggest seafood dealers on the island. In the early 1900s, John Leonard came to Chincoteague from Sweden and became a prominent fisherman. At one point, there were 13 fish companies on the island. Pound fishing (a technique in which pound nets attached to poles were put out in the ocean to catch fish) was very popular and allowed fisherman to catch large amounts of fish, as this photo documents. In December 1928, this company had a catch that was worth $3,500. (Courtesy of Robert E. Wilson.)

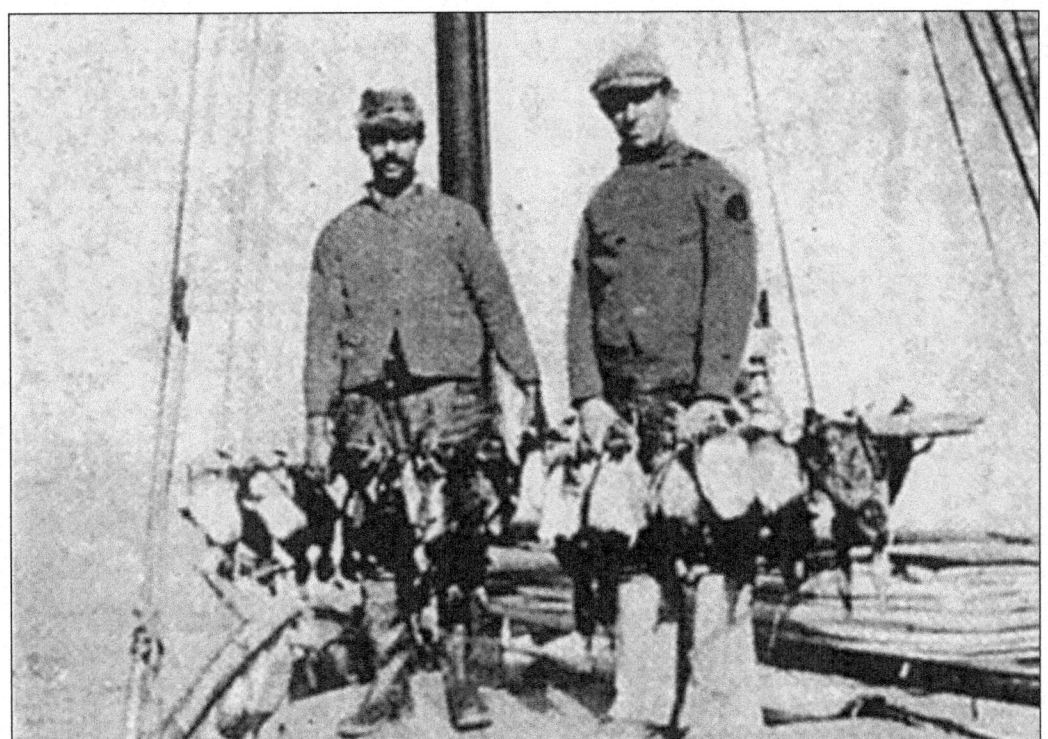

A Day's Worth of Duck Hunting. Selling ducks up north was a lucrative business. In 1915, one hunter could kill up to 100 ducks a day. A variety of ducks were hunted by market hunters in the winter, including mallards, blacks, pintails, redheads, and canvas backs. These ducks were sold to local and northern customers. In today's market, domestic ducks are raised and sold to restaurants and hotels.

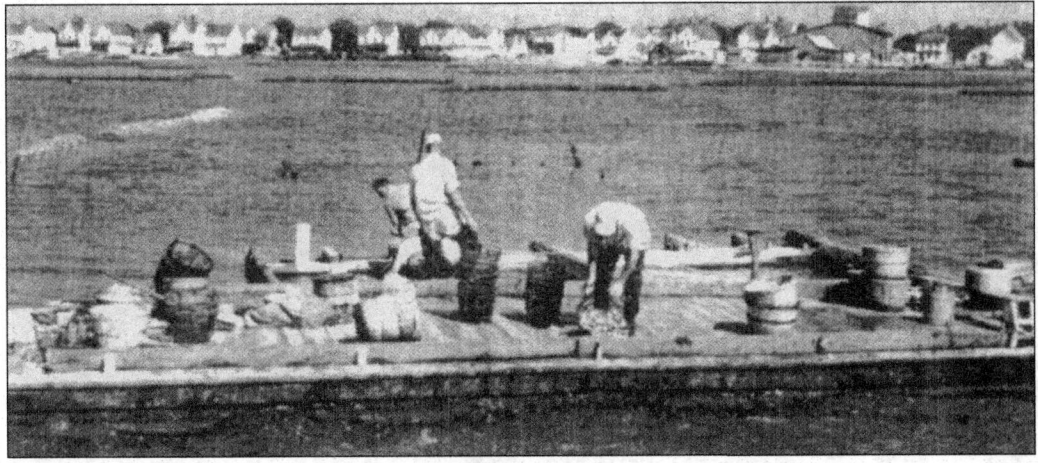

Gathering Clams from Floats. In the 1960s, Chincoteague's seafood business was booming. Clamming found its niche on the island, which has an estimated 100,000 acres of clamming grounds. Savage & Mears had a seafood company that included both oysters and clams, and the Burton Seafood Company, one of the most lucrative clamming businesses on the island, shipped 1.3 million clams to market in one day in 1957. (Courtesy of Kirk Mariner, *The Commonwealth*, July 1956.)

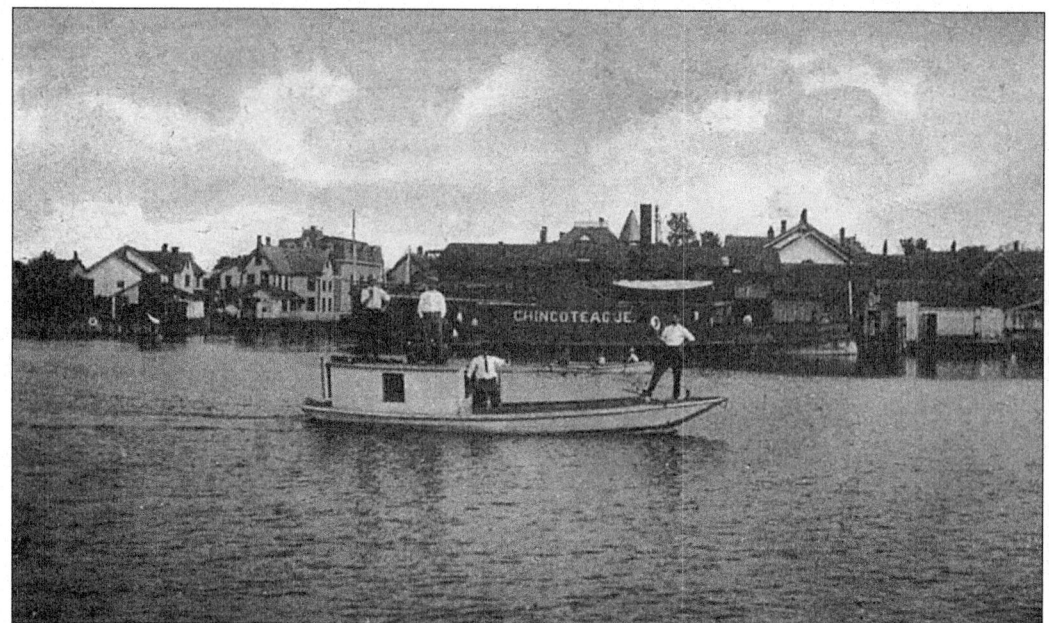

THE WATER FRONT, C. EARLY 1900S. Moored behind the work boat is the ferry *Chincoteague*. The work boat carries a cabin, allowing the watermen to stay out on the water for long periods. In the distant background, behind the work boat and the ferry, is the railroad dock. To the left of the boats is the northern side of the docks. (Courtesy of Louis Kaufmann and Sons; collection of John E. Jacob.)

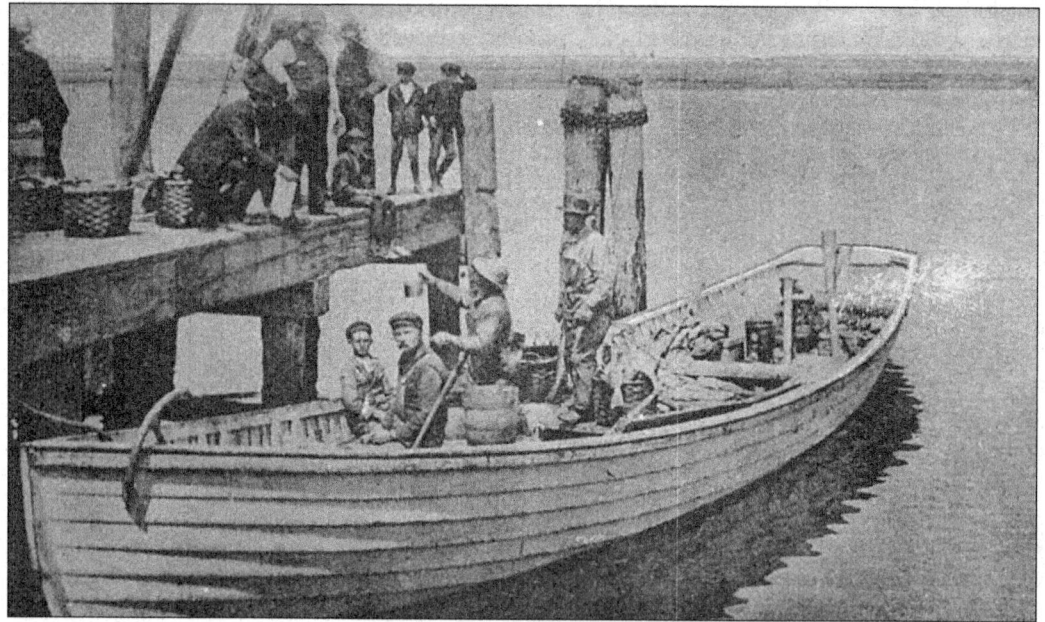

AN EARLY MORNING CATCH, C. EARLY 1900S. Curious boys stand on the dock looking to see the day's catch. The men on the dock have thrown a line to the fishermen to help them tie up. This 1¢ postcard, signed "Lovingly, Auntie," sends wishes of a Happy Thanksgiving to a nephew along with a message to "Be a good boy in school this week." (Courtesy of Louis Kaufmann and Sons; collection of John E. Jacob.)

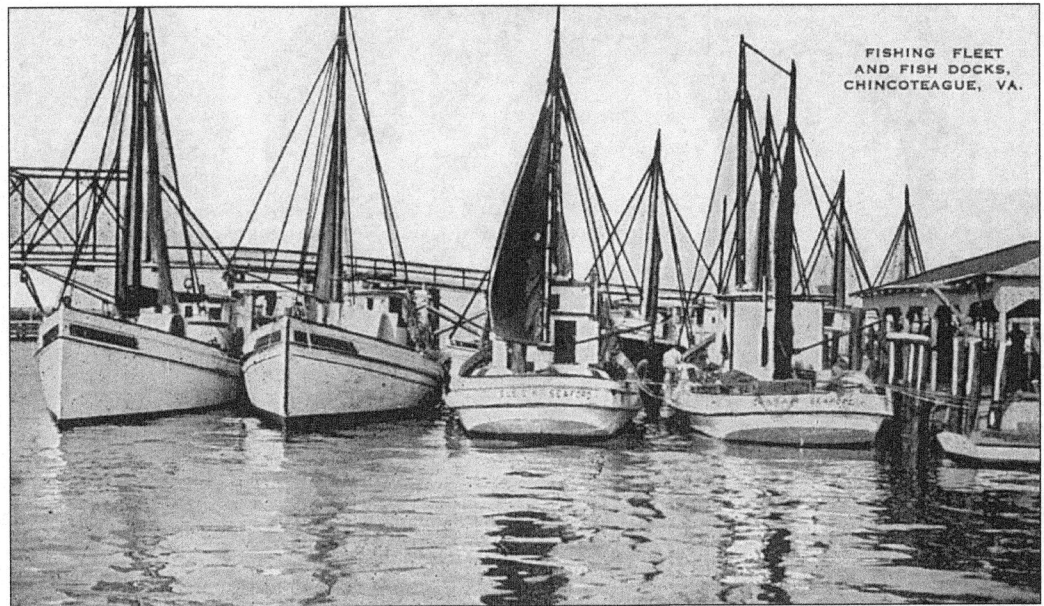

THE FISHING FLEET. These fishing boats are docked and ready to go for the next fishing expedition. The fleet can bring in thousands of pounds of fish from the ocean on a daily basis. The fishing was very promising in the late 1800s through the mid-1900s. The text on the back of this postcard encourages people to "Visit Chincoteague on your next vacation." (Courtesy of H&H Pharmacy; collection of John E. Jacob.)

THE LIDIA S. This 1940 image is of Lee Savage's boat, the *Lidia S.*, named after his mother. Used to carry cargo, it also served as a source of transportation, as well as a form of leisure for the busy fishermen. This type of vessel was made with a cabin, enabling fishermen to stay on the water without having to worry about weather or time of day. The boat is moored across from Chincoteague's waterfront and railroad dock. (Courtesy of Donna Mason.)

CLAMS. This 1956 photo was taken inside the Burton Seafood Company. The employees are sorting clams into baskets under the watchful eye of an inspector. These tasty clams are planted as seedlings on clam flats, where they burrow into the mud and grow until they are mature and ready to be harvested. (Courtesy of Kirk Mariner.)

AN AUCTIONEER. On the last Thursday of July, the annual pony penning auction takes place at the carnival grounds in Chincoteague. Bernie Pleasants was the auctioneer for 33 years. During his career, Pleasants raised $139,000 in 1999 and a record $155,800 in 1998, with one foal selling for $7,000. In 1967, when Pleasants first began, ponies sold for $23.50. The proceeds from the auction go to the Chincoteague Volunteer Fire Company.

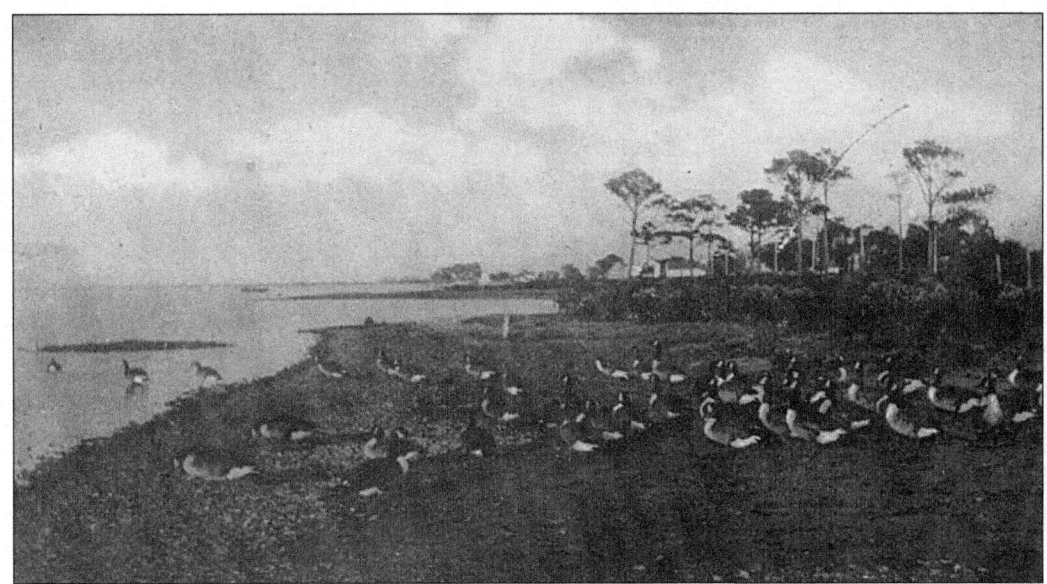

WHEALTON'S WILD GOOSE FARM. Joshua Whealton started his flock by catching some geese and clipping their wings. He eventually had over 1,000 birds, which he sold live to buyers up north for $5 a pair. In 1959, Chincoteague High School was built where Whealton's farm once thrived. Hallie Whealton Smith donated land to build the school. The message on the back of this postcard, which is dated May 20, 1921, merely states, "Regards." (Courtesy of Louis Kaufmann and Sons; collection of John E. Jacob.)

TERRAPINS. These diamondback turtles were a favorite treat of many locals and are considered a delicacy in restaurants across the country even today. Miles Hancock raised terrapins in Chincoteague on his small farm in Deep Hole from the early 1900s until the early 1950s. He sold them to restaurants in Washington, D.C., and Baltimore, which used them to make stew that consisted of terrapin, salt, black and cayenne pepper, a blade of mace, rich cream, sweet butter, flour, and whole cooked terrapin eggs, which were added last. Terrapins range from the Gulf Coast to Cape Cod, MA, and weigh between 3/4 of a pound to 3 pounds. The females measure up to 9 inches in length, while the males usually are 5 inches long. They are no longer sold from Chincoteague, and protective legislation has restored some populations that had become depleted by the turn of the 20th century. (Courtesy of the late F.W. Brueckmann, Tingle Printing; collection of John E. Jacob.)

THE MCCREADY OYSTER HOUSE. This October 1960 photo shows men on the roof of the building, probably inspecting damage from a recent fire. The stack of oyster shells they are standing on is indicative of the vast amount of oysters that were being harvested and sent to eager customers. The shells were used by locals for roadways and drain fields, and were used by oystermen for planting, which occurred between March 20 and September 15. Planting shells encouraged spats (young bivalve mollusks) to attach themselves to the planters and grow into baby oysters. It is better to plant shells in shallow water so they can get the benefit of the sunlight. An acre of oysters can bring $300 to $500. (Courtesy of Donna Mason.)

SAVAGE & MEARS, C. 1950S. Workers take a break from shucking to pose for a picture in front of the Savage & Mears Oyster and Clam House. The women shuckers shown here were probably making a good day's wage; efficient shuckers today make between $50 and $100 per day, more than the standard wage per hour. Presently, there are only three shucking houses on the island. (Courtesy of Donna Mason.)

THE SEABEE. This late 1940s ad narrates the account of the only seaplane business in Chincoteague. Established by Lee Savage, owner and aviator, the company provided transportation for islanders and any cargo needing conveyance, since Chincoteague had no airport. Notice the brief phone number "59" in Savage's ad for the Seabee. (Courtesy of Donna Mason.)

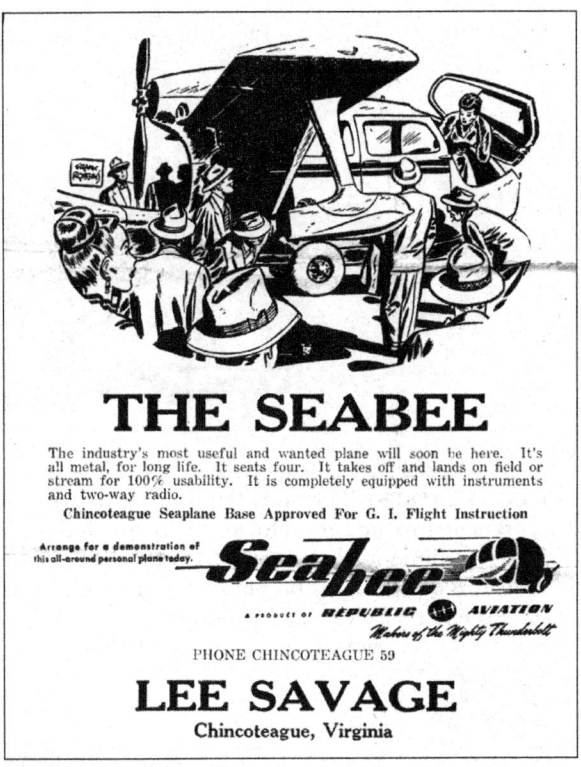

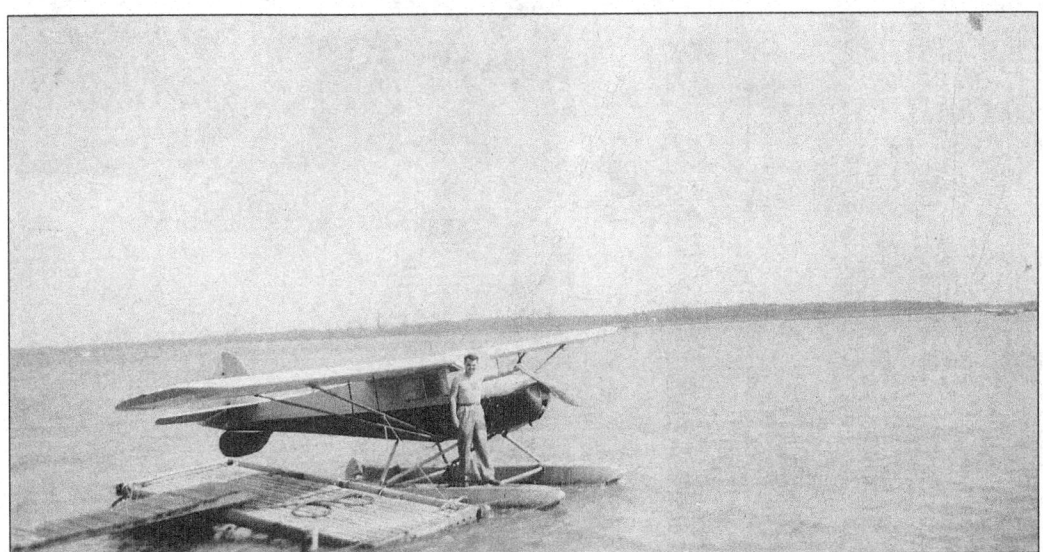

THE FLOATING DOCK. Savage trained ten U.S. veterans with flight lessons that were approved by the Veterans Administration and the G.I. Instruction program. The gentleman standing in front of the plane may be one of his students. The amphibious Seabee plane had a floating dock attached to the land that served as a base for loading and unloading passengers. Manufactured by Republic Aviation (makers of the Thunderbolt, a World War II fighter plane), the Seabee was considered to be a top-of-the-line model. (Courtesy of Donna Mason.)

THE PONY EXPRESS. The Pony Express was begun in the late 1960s by Lee Savage. This creative entrepreneur invested in vehicles for recreational purposes. Here, a jeep is used to pull what looks like a hand-made passenger trailer with a canvas or aluminum roof. The Pony Express took visitors on a tour of the island on dirt roads, allowing them to enjoy the island scenery and observe the ponies meandering along the beaches. The Pony Express continues today, although Savage no longer owns it. (Courtesy of Donna Mason.)

MISTER WHIPPY. Another successful Lee Savage business was the Mister Whippy ice-cream truck, which began in the mid-1960s. At one time, he had four to five trucks in operation. Savage's route, which took him all over Chincoteague, eventually included Pocomoke, Maryland, and Saxis, VA. This photo of a Mr. Whippy's truck was taken in the 1970s with Savage, himself, serving ice cream to the children. He eventually sold the franchise to a local Chincoteaguer. (Courtesy of Donna Mason.)

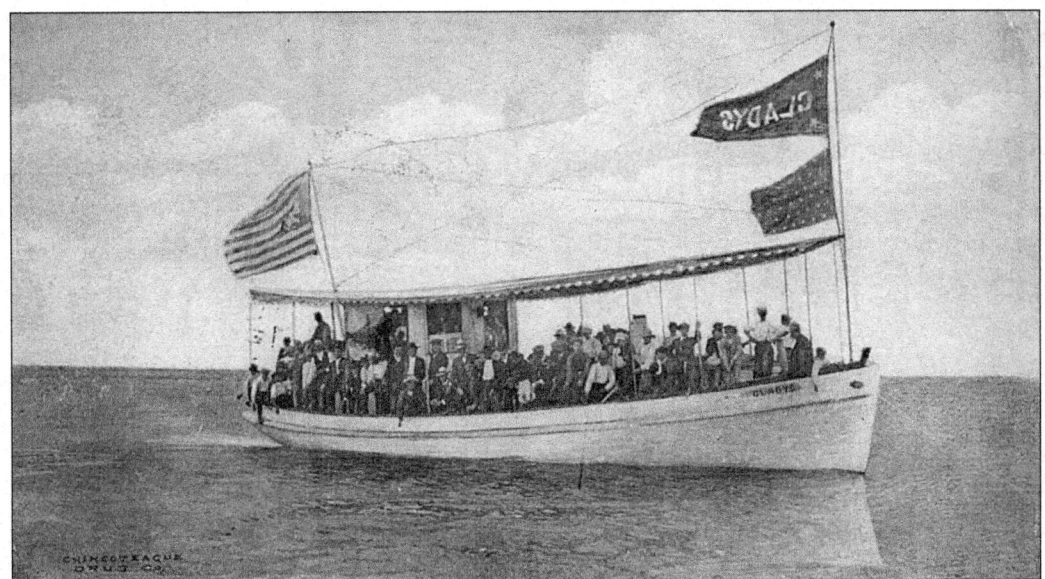

A PRIVATE YACHT. The author of this postcard, which sports a 1¢ stamp and is dated February 3, 1909, writes his sister that he is getting better now, and he "ways more than ever" at 150 pounds. He has also handwritten across the front of the postcard, "Can you find my picture in here. Brother. HJD." The author must have been a guest on the crowded yacht. C.E. Babbitt Jr., who is identified as the owner of the yacht, was likely a generous man to allow this group of men to enjoy an outing. (Courtesy of Chincoteague Drug Company; collection of John E. Jacob.)

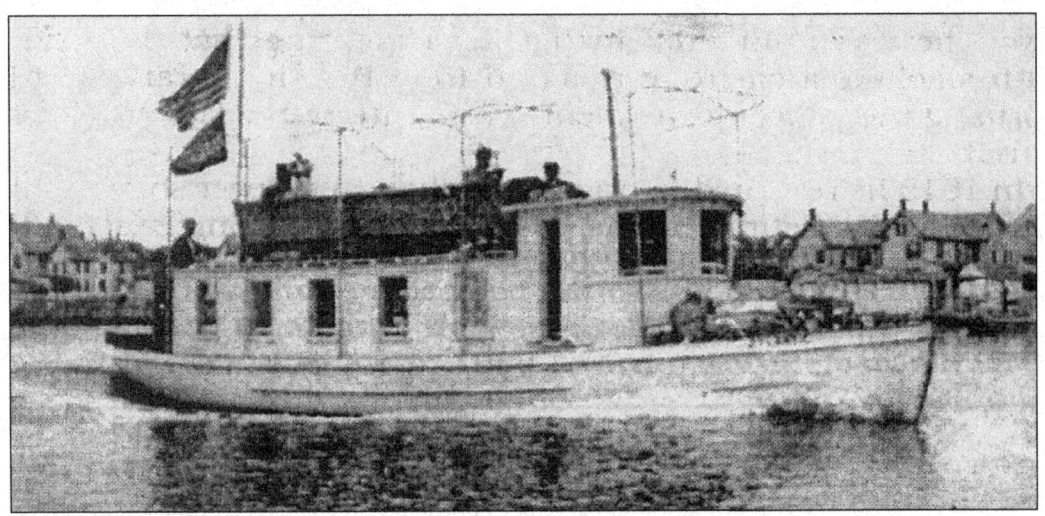

THE U.S. MAIL BOAT. This 1912 photograph shows the mailboat bringing its cargo to Chincoteague. These boats carried passengers and freight, as well as the post. One boat, the *Widegon*, came back and forth from Franklin City and was later replaced by the *Lillie Agnes*. An additional mailboat called the *Globe* came from Wishart's Point. Carrying the mail was considered an honor among the skippers of the boats. (Courtesy of Kirk Mariner.)

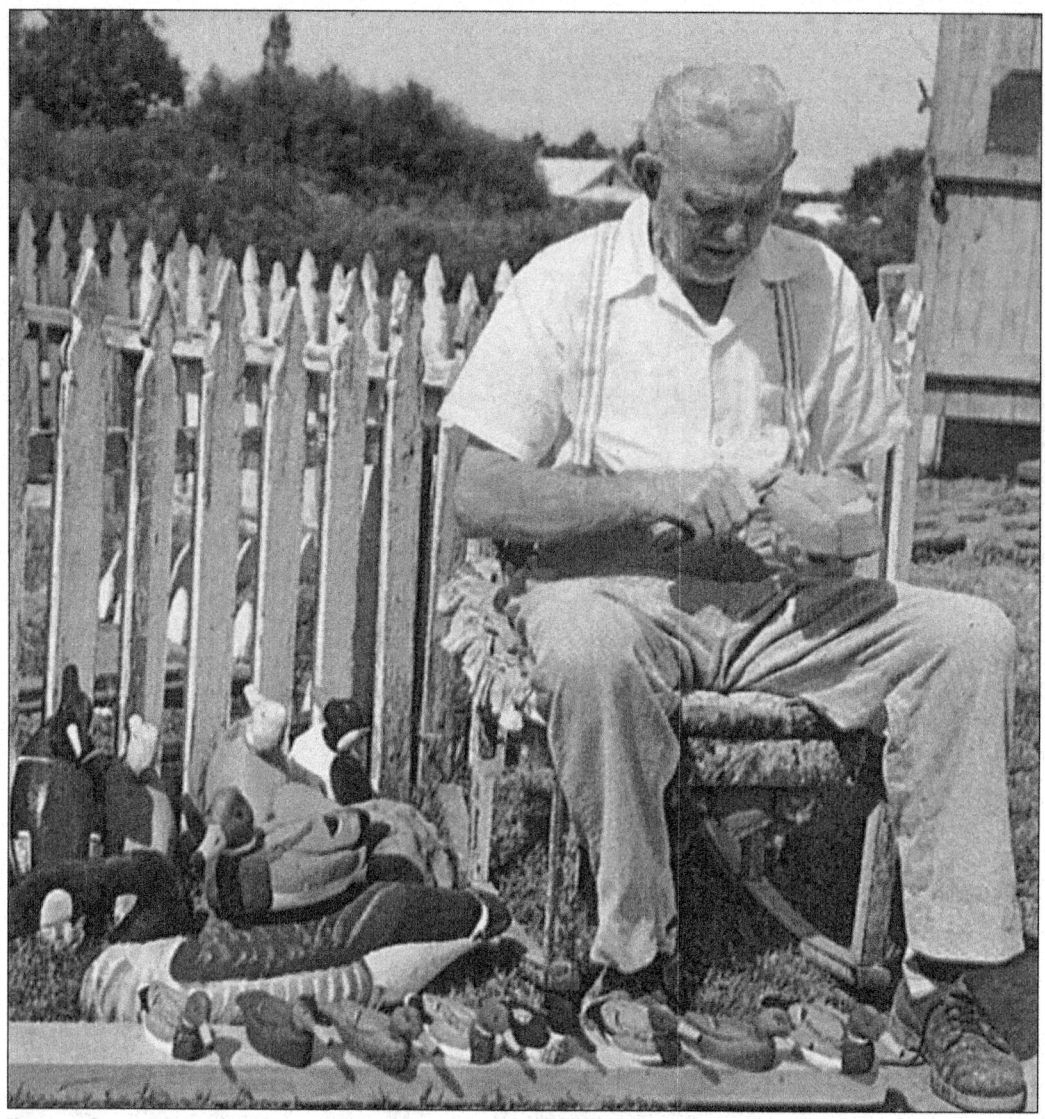

DUCK CARVER. Miles Hancock, pictured here, became a carver in the late 1920s, but he also guided hunting parties aboard a gunning houseboat, named the *Tarry Awhile*, along with raising terrapins in Deep Hole. Hancock was also featured as a duck carver in the movie *Misty*, which premiered in 1961. The early 1900s brought many market duck hunters to the area who shot up to 100 ducks a day; thus, the necessity of decoys was undeniable. For this reason, duck carving was at its height between 1915 and the early 1940s. Some of these early Chincoteague decoys have brought in handsome amounts of money. A newspaper article in the *Daily Times* tells of an auction at the Chesapeake Wildlife Showcase where a wood duck carved by Ira Hudson, c. 1915, sold for $82,500. Roe Terry, Cork McGee, Reggie Birch, Jay Cherrix, and Cigar and Mark Daisey are a few of the remaining island carvers. In particular, Jay Cherrix, grandson of carver Ira Hudson, produces as many as 400 decoys a year, many of which are on display at his store, A Work of Art. Replicas of Hudson's work are reproduced by Cherrix and include certificates of authenticity. Along with the numerous variety of ducks Cherrix carves, he also creates large egrets and phoenixes. Cherrix's latest project is a life-size carving of a Chincoteague pony. (Courtesy of Tingle Print Company; collection of John E. Jacob.)

TIDEWATER EXPEDITIONS. In 1991, Tidewater Expeditions, which offers kayaking to experienced and novice boaters, was established. It is run by Jay Cherrix. Daily guided ecological tours, teaching people about the marshes and wildlife in the area, are available. This tour also offers an outstanding up-close experience with the Assateague ponies. Cherrix's family, on his father's side, was one of the original five families that settled on Assateague.

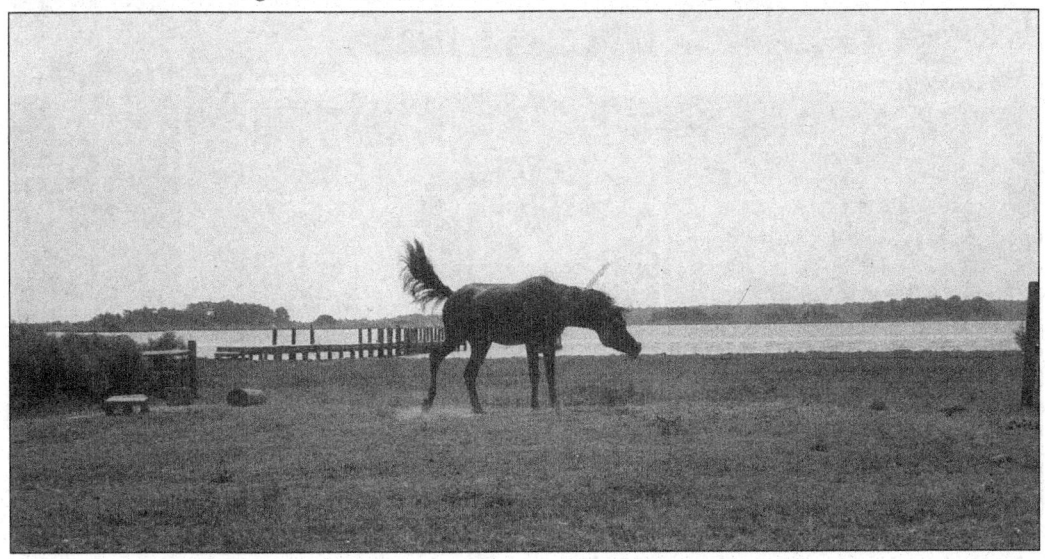

STRIKING CADET. Donald Leonard introduced this beautiful Arabian stallion to his herd of 14 mares in the summer of 1999. Striking Cadet now resides on Leonard's property with his new band of mares. The Arabian was chosen to breed with the Chincoteague ponies to improve their conformation. The foals that are produced will generally show the desirable Arabian characteristics, carrying their tails higher and having more predominate necks and smaller heads. However, one trait that is not desirable is the thin skin of an Arabian, which is not conducive to protecting ponies against biting insects. Because of this, the ultimate goal of breeders is to produce Chincoteague foals that are one-quarter Arabian.

THE REFUGE WATERFOWL MUSEUM. The museum shown here in collage form is owned by John A. Maddox, who opened it in 1978 because of his love for the art of water fowling. Upon visiting the museum, visitors immediately see a celebration of the history of hunting and carving. Maddox started carving as a young man and always had a great respect for his fellow carvers and hunters. He established this museum to hone the Chincoteague carvers' skills and to preserve their art form. The museum contains antique wildfowl decoys of all varieties, carved by outstanding craftsmen, as well as samples of decoys that are being crafted today. The museum has 7,000 square feet of space to house these exhibits, which also include boats, weapons, and traps. The exhibits and events are frequently rotated. (Courtesy of Refuge Waterfowl Museum.)

Eight

PONY PENNING
ROUND UPS AND GIDDY UPS

Pony penning is a tradition that began with the early colonial settlers of Chincoteague and Assateague Islands. The ponies and other livestock were rounded up annually, and the young were branded so they could be identified by their rightful owners. There are many legends surrounding these ponies. One states that pirates put the ponies ashore to graze; another is that a boat on its way to the English colonies wrecked, and the ponies came ashore on the south end of the island. This was supposedly witnessed by the Native Americans living in the area who rescued the crew. By far, the most popular (and least likely) legend is that the ponies that roam freely on Assateague and Chincoteague are the descendants of horses that survived a Spanish shipwreck in the early 1800s. This story comes from the local Teaguer's oral history, which has been handed down through the generations; however, no documentation of this event has been found in any manifests that were kept in Norfolk or Philadelphia. Manifests are itemized lists of a ship's cargo that are shown to customs officials. These manifests, dating from the 1800s, did not verify any ponies aboard passing ships or shipwrecks in the region. People speculate that this may not necessarily mean the manifest does not exist—merely that it has not been found to date.

Another theory on how the ponies came to the islands dates back to the 1600s, when the animals were left by their owners on the shore to graze, creating free pasturage and free fencing for the farmers. This allowed livestock owners freedom from paying damages their livestock may have caused by being "free roaming"; it also enabled them to evade taxes levied against the livestock. Whichever theory is true, these hardy ponies continue to thrive today, with one herd—the Maryland herd—living on Assateague Island National Seashore Park and the other herd—the Virginia herd—inhabiting the Chincoteague National Wildlife Refuge.

The Maryland herd includes 170 ponies and is owned by the Maryland Park Service. The Virginia herd has approximately 150 ponies and is owned by the Chincoteague Volunteer Fire Department. The ponies are separated by a fence that extends 100 feet into the water to discourage them from swimming around it. This works because the ponies do not swim out past breaking water. Ponies will, however, venture into the water to seek relief from pesky bugs.

The Virginia ponies participate in the annual pony penning, which is held the last Thursday in July and draws crowds of 50,000 to 55,000 spectators during the three-day event.

A CAPTURED PONY, C. 1904. At least two pony pennings were held on Assateague each year; the ponies were driven into the water so they could be easily roped. However, too many ponies drowned this way, and the practice was discontinued. When the pennings began on Chincoteague in the 1920s, the selected animals were taken to the mainland on scows and sold. The price for a pony ranged from $35 to $75. Today, the average price for a pony is $1,750, and those with special markings can go as high as $7,000. (Courtesy of Dr. William H. Wroten.)

PRUNING SHEEP, C. 1914. Sheep penning began in colonial times and was discontinued around the 1920s. The sheep were rounded up in the spring for an annual shearing and branding event on Assateague. Chincoteaguers would come over in row boats and watch the activities. The women would prepare food over fires lit in the sand while some of the men sheared the sheep and others looked on. The wool was kept, and some of it was sold to make various apparel, which was warm but itchy. (Courtesy of Dr. William H. Wroten.)

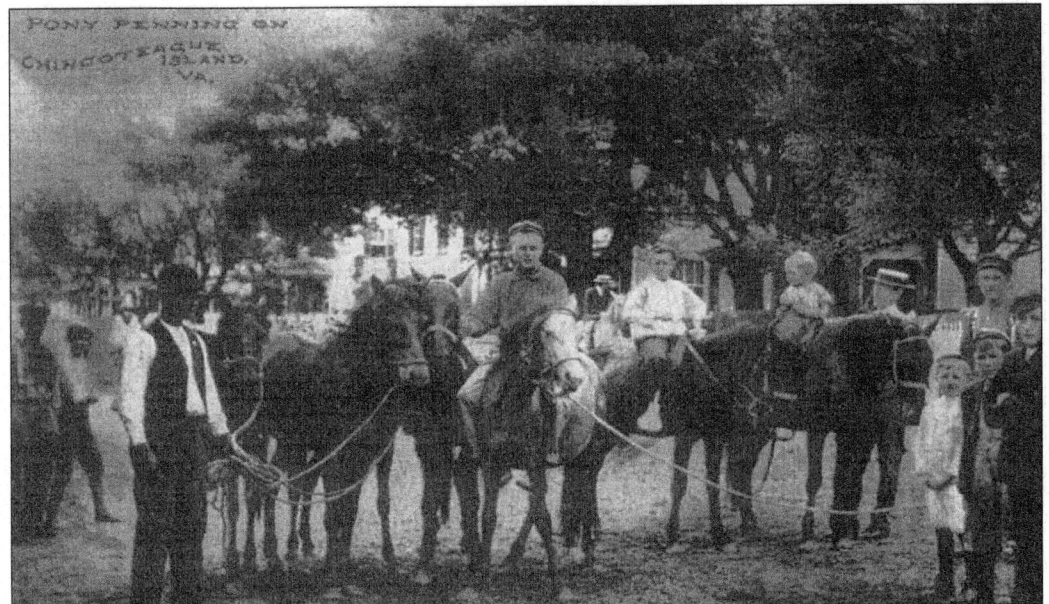

PONY PENNING DAY. This early 1900s postcard depicts a "saltwater cowboy" mounted and ready for pony penning. Saltwater cowboys were brave men who herded the ponies into the Assateague Channel for the annual pony swim. The horses beside him are probably domestic ponies that will be used to guide the wild ponies into the channel. In 1920, the pony penning on Chincoteague started as a result of Samuel Fields, a landowner who would not allow people to cross his property to round-up their ponies. (Courtesy of Katherine and Wayne Tolbert.)

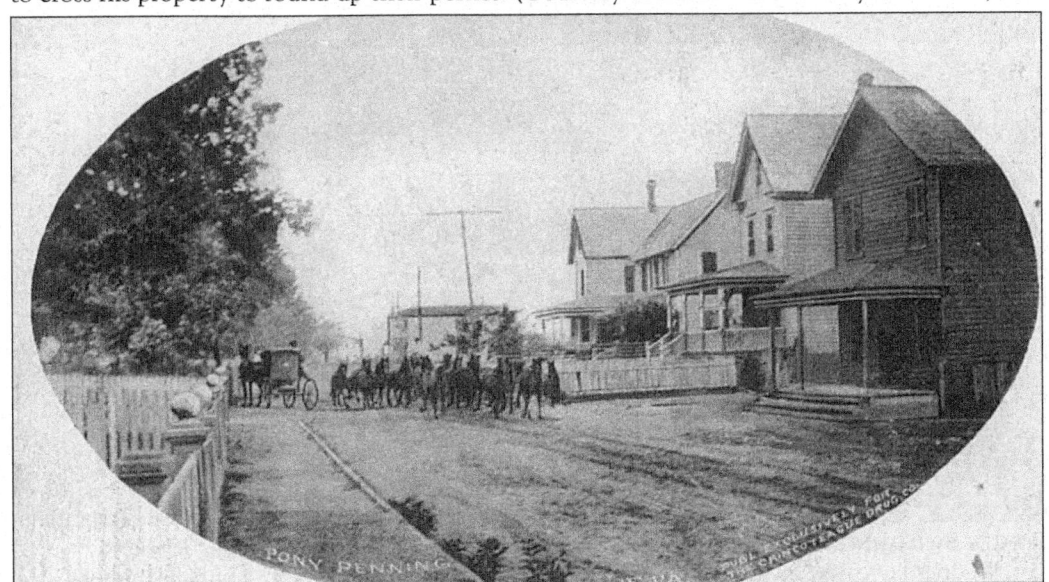

DASHING PONIES. The ponies depicted in this early 1900s postcard are being guided by a lone cowboy with a horse-drawn carriage. He is keeping them on the right path to the corral and the crowd that will greet them. Along with looking over the horses that would be auctioned the next day, the men also courted the women present, who would wear their finest dresses. At the annual dinner, there was always an abundance of food and liquor supplied by the locals. (Courtesy of Albertype Company; collection of John E. Jacob.)

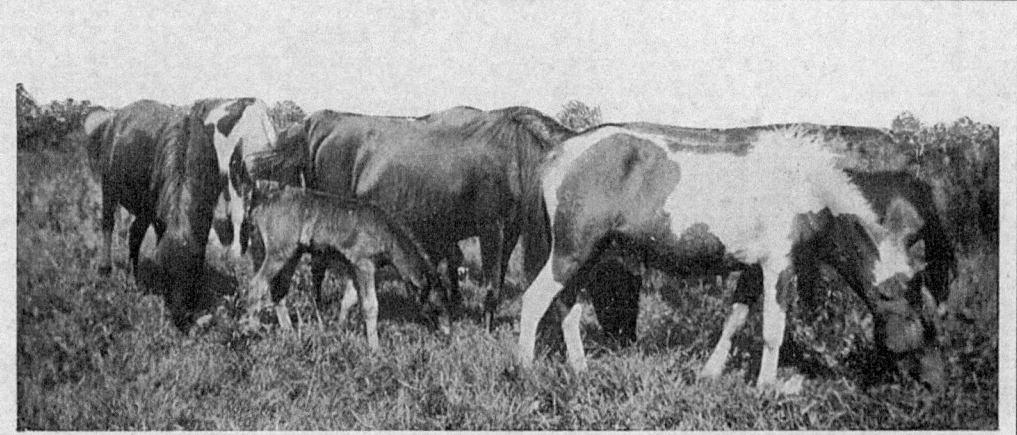

Nature made Chincoteague an Island, surrounded it with channels and bays filled with game fish from early Spring to late Fall. These waters furnish the world famous "Chincoteague Oysters and Clams."

The Island is about seven miles long, each end marshlands offer roaming grounds for the wild ponies. These ponies roam at will eating the salt grass and myrtle bushes. They are rounded up and sold the last Thursday in July, Pony-Penning day. Thousands of visitors witness the biggest "Wild West show of the East" every year.

Chincoteague is connected to the mainland by good roads, is very modern in every way. Good hotels — theatre — churches — Western Union and telephone connections, a nice place to visit, a grand place to spend your vacation.

PONIES. The original ponies of Assateague and Chincoteague Islands were sorrels, bays, and sables. They were solid in color, and only began to have spotted coloring in the late 1940s. (Courtesy of H&H Pharmacy; collection of John E. Jacob.)

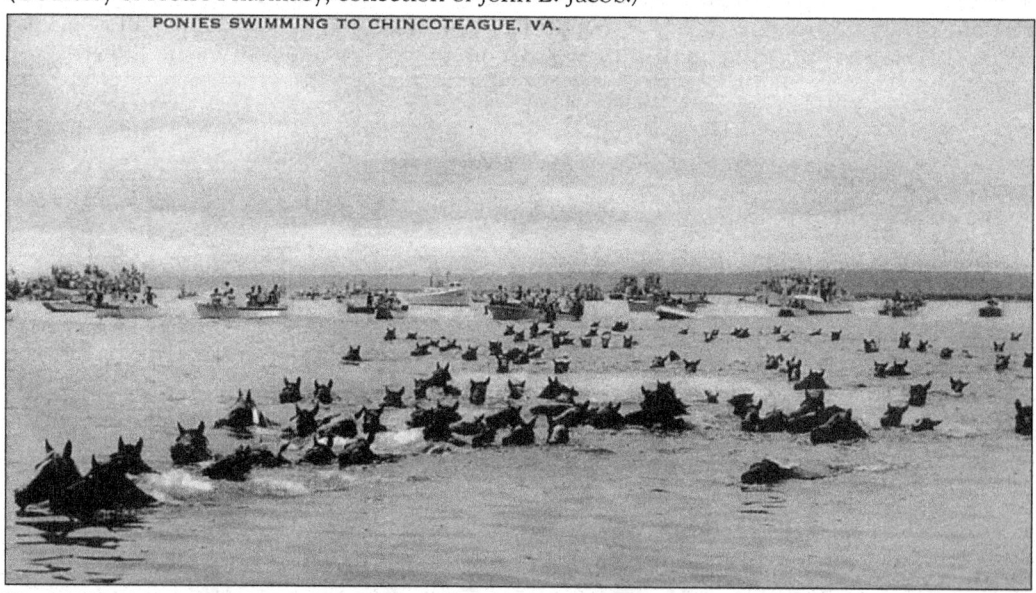

PONIES SWIMMING FROM ASSATEAGUE. The ponies swim over to Chincoteague Island on the last Wednesday of every July to be rounded up and sold at auction on Thursday. About 100 ponies are shown in the water making the swim in this postcard. Those not sold make the 4.5-minute return swim on Friday. Also, the foals that are not fully weaned go back to Assateague with their mothers. In the fall, these foals are taken off the island so their mothers do not have to carry them through the winter. The colts are driven to the carnival ground to be cared for, and in the spring, they are returned to the island and released. (Courtesy of Artvue Postcard; collection of John E. Jacob.)

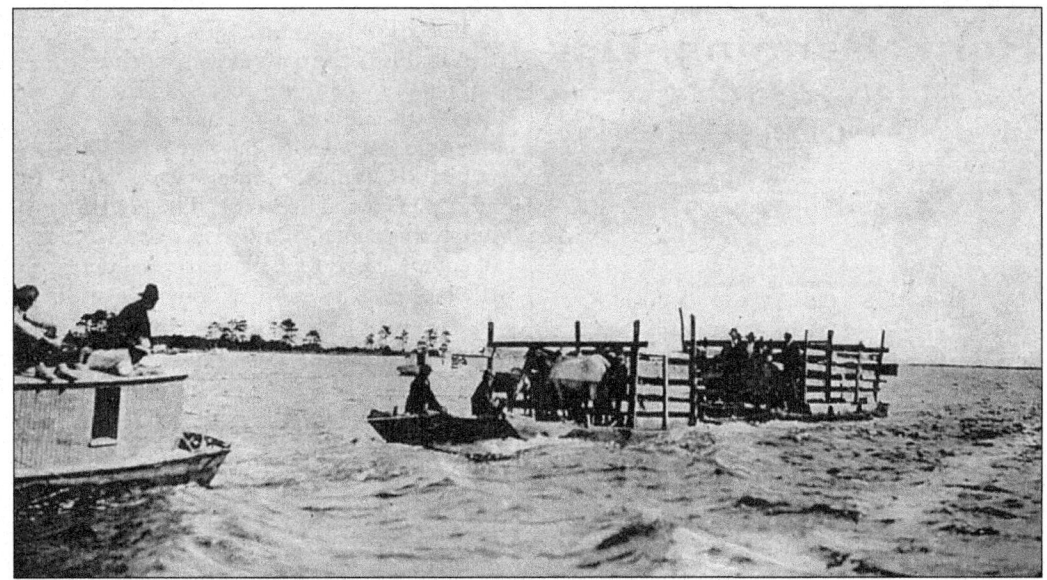

SHIPPING PONIES, CHINCOTEAGUE. This 1920s image shows the pregnant and very young ponies as they are shipped across the channel from Assateague to Chincoteague for the auction. The majority of the ponies make this swim. The barge also helps the younger ponies that do not swim well. The 4.5-minute swim takes place on the slack tide, which occurs exactly halfway between low and high tide when there is no current. (Courtesy of Louis Kaufmann; collection of John E. Jacob.)

DOWNTOWN PONY PENNING. Early morning buyers and spectators gather to look over the ponies corralled between Mumford and Cleveland Streets before the annual auction. The Volunteer Fire Company took over the event in the early 1920s to raise funds to buy and update equipment by coordinating the annual pony pennings and overseeing the carnival. The profits from both are given to the fire company to buy new equipment. This started after a second fire in 1924 swept through downtown Chincoteague, and the firemen only had one pump available to fight it. (Courtesy of Kirk Mariner.)

Pony Penning Day

July 26, 1934

Chincoteague, Va.

6:00 to 8:00 a.m.	- Pony Round-Up.
10:00 a.m.	- Pony Race.
11:00 a.m.	- Wild Pony Riding.
12:00 noon	- Seafood and Chicken Dinner (served at fire house) 30 & 35c

Water Demonstration Sponsored by
Sixth U. S. Coast Guard District.

1:30 p.m.	- Swimming Race [75 yds.]
2:15 p.m.	- Selfbailing Surfboat Race [¼ mile with capsize].
3:15 p.m.	- Race Point Surfboat Race [1 mile row].
4:00 p.m.	- Beach apparatus Drill (to be held on Carnival grounds).
4:30 p.m.	- Presentation of loving cups to the winners by Commander C.J. Sullivan

5:00 p.m. - Seafood and Chicken Supper (served at fire house) 50 & 35c.

6:00 p.m. - PRIZE FIGHT (held on Carnival grounds).
Battle Royal (4 negroes)
4 ROUNDS
Parks Bull Vs Kid Justice.
6 ROUNDS
Red Shreaves of Onley, Va. Vs Bobby Grimes of Newport News, Va.

7:00 to 11 p.m. - Carnival Features
11:15 p.m. - Wild Pony to be given away on Carnival grounds.

Flyer/Handbill for Pony Penning events, 1934.

A PONY PENNING SIGN. This 1934 handbill lists the day's events for the annual pony penning occurring the day before the auction. The hardy people of the time started their day at 6 a.m.; lunch (which they called "dinner") was served at 12 p.m. at the firehouse. The price for lunch was a mere 30¢ to 35¢. A variety of competitions took place throughout the morning, including a pony race and wild pony riding. During the afternoon, water races between the different Coast Guard stations were held, the winners receiving a loving cup. Dinner was served at 5 p.m., and a prize fight was held after a fine meal of seafood and chicken pot pies. The highlight of the day for many people was when a wild pony was given away at the end of an exciting day. This tradition of raffling a pony continues today. (Courtesy of Robert Mears.)

A WORLD WAR II ARMORED CAR. The parade, an integral part of this 1950s annual pony penning, is underway on Main Street heading towards the carnival grounds. The armored car shown in the front of the line sports two guns on a turret and tows an artillery cannon. A carnival, pony swim, and auction accompany the parade. During the first carnival, the women's auxiliary served a free dinner to everyone who came, and the whole town pitched in to supply the items for the dinner, including pot pies, potatoes, and oysters. (Courtesy of Donna Mason.)

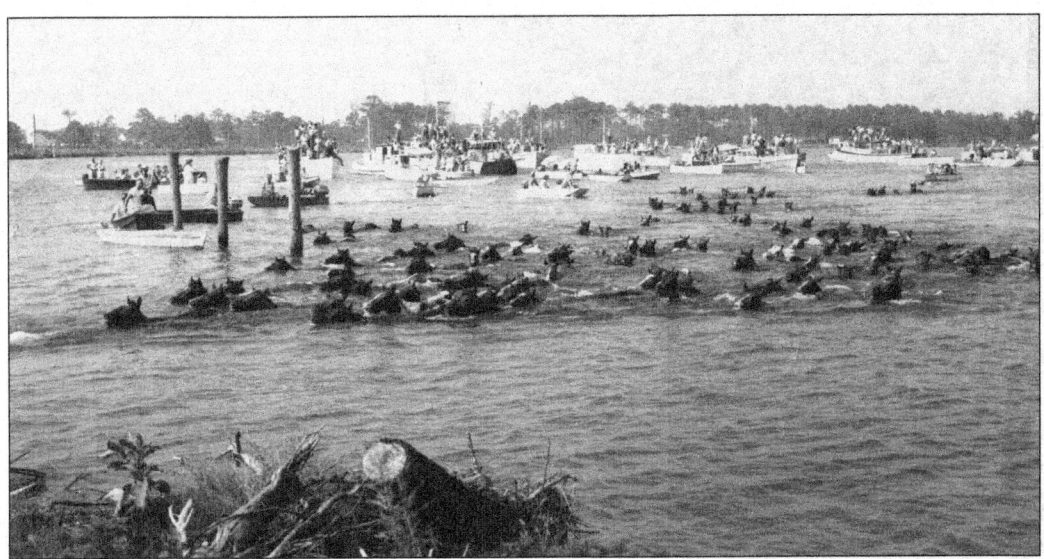

THE PONY SWIM. This 1950s postcard shows the ponies navigating the pilings as they near the end of their swim across the Assateague Channel. Even city slickers can be pony owners—the fire company offers buy-backs. People may bid on foals that they will own; however, the foal is taken back to Assateague never to be sold again. The proud owner will receive pictures of their foal and be able to keep tabs on their purchase throughout the years. This is possible because the foals are marked on their haunches with the year they were purchased. They can also be identified by their unique markings. (Courtesy of Roland Bynaker.)

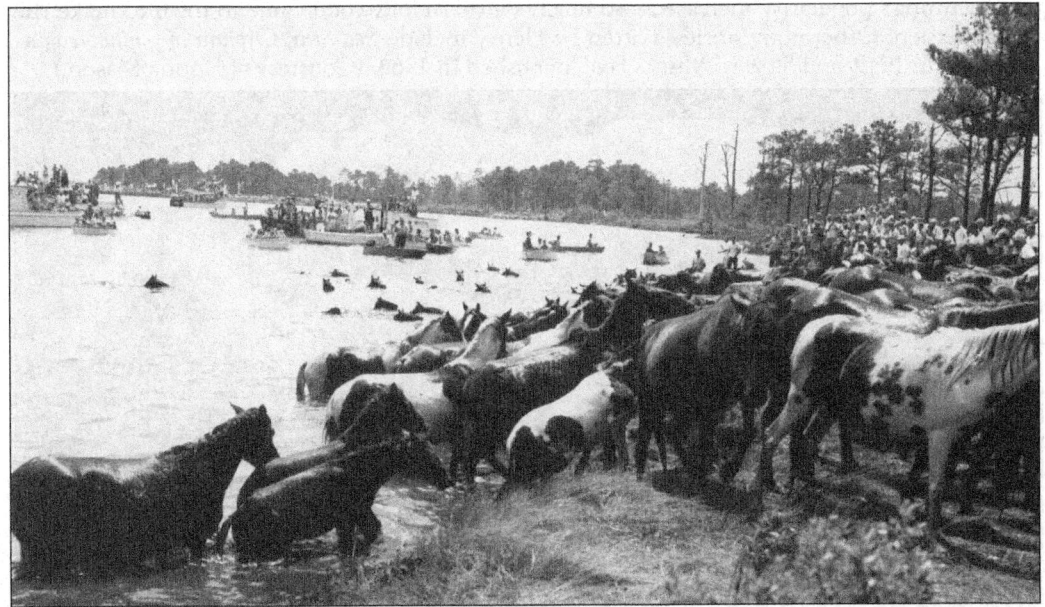

PONIES ASHORE. This 1950s photograph shows ponies climbing ashore after their short swim from Assateague, where they had been free to graze and live unencumbered all winter. The ponies' mainstay is marsh grass; however, they also eat poison ivy and seaweed. The salt on the blades of marsh grass they consume requires them to drink twice as much water as domestic ponies, giving their bellies a bloated appearance. A local saying regarding the ponies states, "A Chincoteague pony can get fat on a cement slab." (Courtesy of Donna Mason.)

MISTY, THE MOVIE. This 1960s photo shows a crew filming *Misty*, which featured many local Teaguers. The movie is based on Marguerite Breithaupt Henry's book *Misty of Chincoteague*, which was published in 1947. Adults and children alike love the story of the Chincoteague pony who swam over in the annual pony swim. Following the publication of the book, the pony penning's popularity increased—so much so, that Hollywood came to town to make the movie version. Other pony stories written by Henry include *Sea Star, Orphan of Chincoteague*, published in 1949, and *Stormy, Misty's Foal*, published in 1964. (Courtesy of Donna Mason.)

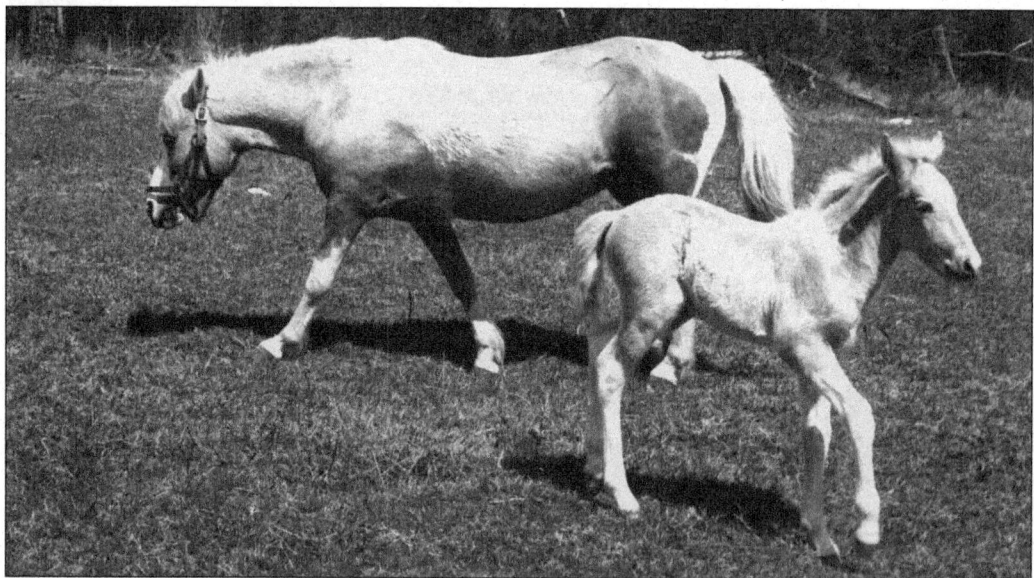

MISTY. This rare 1962 photo shows Misty with her third foal, Stormy, so named because she was born during the Ash Wednesday storm. Misty is a descendent of the ponies that live on Chincoteague. She spent the duration of the storm in the Beebe Ranch's kitchen. (Courtesy of Dave Snead.)

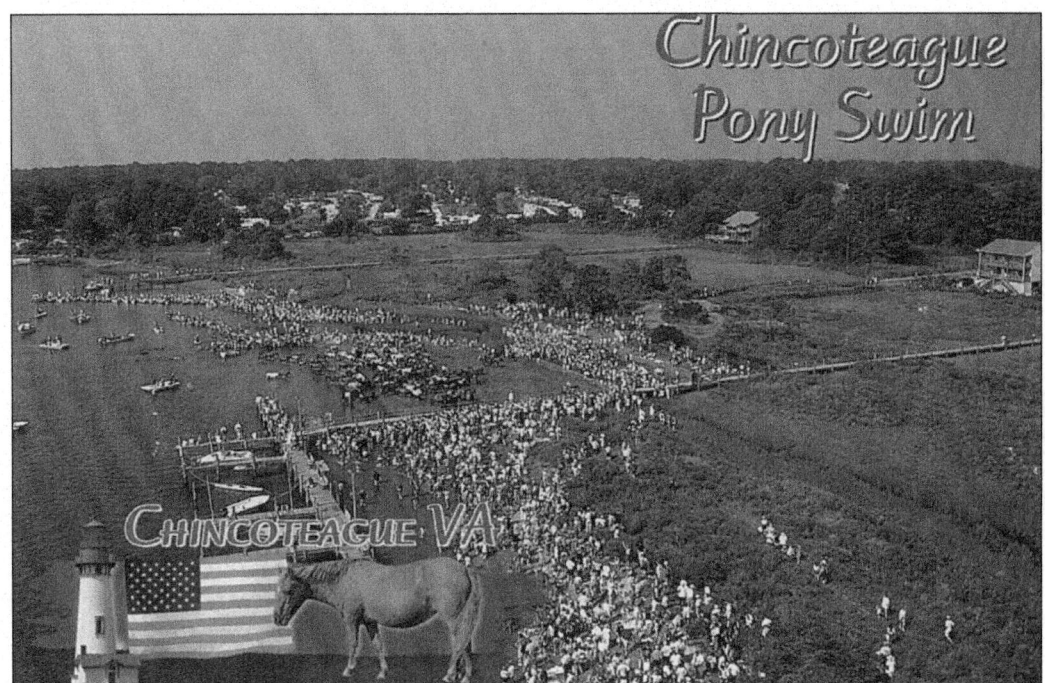

AN AERIAL VIEW OF THE CHINCOTEAGUE PONY SWIM. This photo shows the ponies after their swim, with the stragglers still making their way ashore. Spectators line the banks and fill the boats as they press in to see this spectacular annual event. The custom of donating a pony to charity each year began after the March 1962 storm, which flooded the islands of Chincoteague and Assateague, killing many of the ponies. Children all over the United States donated their pennies to help buy more ponies. (Courtesy of Roland Bynaker of Trade Winds.)

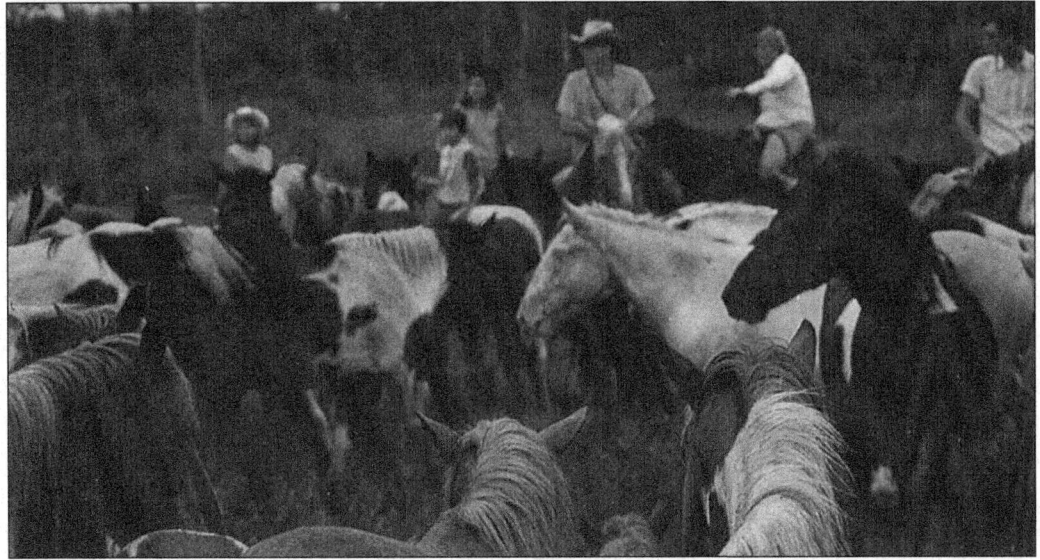

A WILD PONY ROUNDUP. In this 1970s postcard, saltwater cowboys herd ponies towards the corral. The ponies swim from Assateague to Pony Swim Lane. The cowboys then herd them on to Beebe Road to Main Street, where they are taken to the corrals at the carnival grounds. (Courtesy of the late Fred Brueckmann; collection of John E. Jacob.)

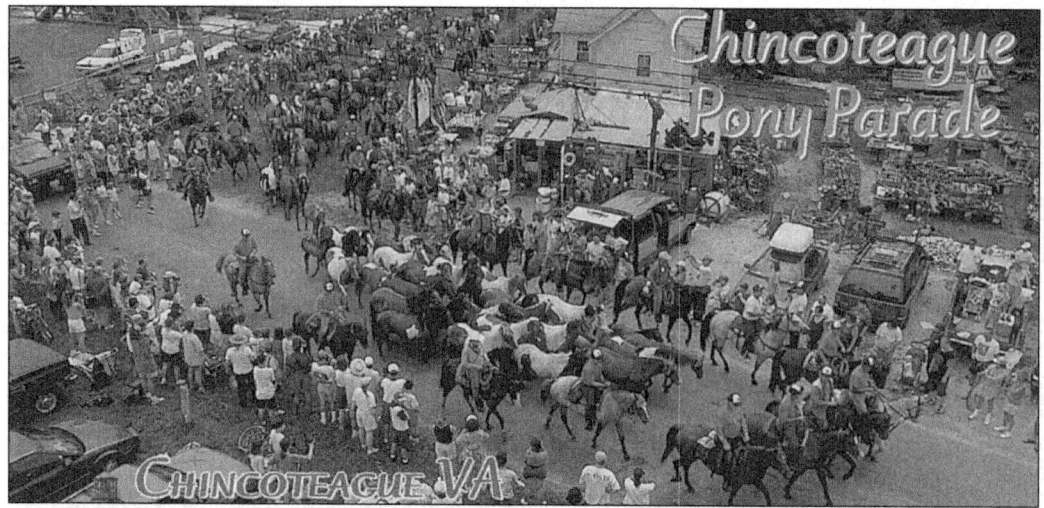

THE CHINCOTEAGUE PONY PARADE. Saltwater cowboys herd their ponies towards the carnival grounds. These ponies come from the Virginia herd on the Virginia side of Assateague Island and are owned by the Chincoteague Volunteer Fire Company. The horses on the Maryland side do not participate in this annual event. Assateague is divided by a fence that extends into the water from the beach about 100 feet, preventing the Maryland and Virginia horses from intermingling. The Maryland herd is free-roaming and takes care of itself, while the firemen's ponies are checked by veterinarians, and their food is supplemented when needed. (Courtesy of Roland Bynaker.)

THE MISTY STATUE. This statue of Misty is located on Ridge Road, across from the field where Misty used to graze. The chicken and duck represent the farm animals that shared the yard with her. This memorial is dedicated to Marguerite Breithaupt Henry (the author of *Misty*), Wesley Dennis (the illustrator), the Beebe family, and, of course, Misty herself.

Nine

DISASTERS

ROW YOUR BOATS
GENTLY UP THE STREET

Islanders are hearty people. No matter what disaster they face, they endure. From hurricanes to nor'easters, blizzards to fires, islanders have survived in spite of ferocious winds, spitting squalls, roaring blazes, the blistering sun, and ice-age temperatures.

Of record is the Hurricane of 1821, referred to as "the Great September Gust." When islanders looked out their windows the next morning, sandbars towered where the ocean pitched the previous night. A massive tidal wave tossed trees on Assateague, capsized homes on Chincoteague, and drowned six people, leaving others hanging in trees or clinging to roofs. Animals were submerged. Most homes had to be rebuilt, so the existing structures on the island date back no farther than 1821. Then, in 1933, more hard rains, tidal waters, and fierce gales submerged the island in 4 feet of water, blew out windows, ripped off roofs, and drowned livestock and poultry. The Hurricane of 1936 washed away bridges and flattened homes and businesses, including an oyster house and a canning factory. Earth-moving machines shuffled muck from one area to another and removed dead animals, especially the 5,000 chickens.

The worst was the "Ash Wednesday Storm" of March 6–8, 1962, which seemed to suddenly appear; islanders were unprepared for its wickedness. Merchants lost their goods as well as their buildings and entire businesses; homes were flushed out to sea, and those that were not were left unlivable, with waters flooding up past the 6-foot-high mark. Food was inedible, and drinking water was contaminated. The strength of the winds and torrents deluged the causeway, which acted as a dam. Crashing currents and wind gusts broke off the bridge and washed it away. Power was snuffed out, cutting off communications and requiring evacuation. Vehicles, boats, and 1,000 homes were ruined, 31 cemetery vaults were flushed to the surface, and thousands of chickens, hundreds of ponies, and many pets and livestock were engulfed.

Fires were also disastrous. The fire that occurred on Sunday, September 5, 1920, left its mark on the east side of town. Sparks quickly devoured every building in the entire block, starting at Church Street and going to the Atlantic Hotel. When the last spark went out, not one building remained. Two years later, during a snowstorm on February 25, another fire took out Whealton Mercantile, the railroad dock and offices, Whealton's Oyster Company, Wimbrow's Ice House, the Masonic Temple, and, again, the Marine Bank. By midnight, when the last flame went out, the west side of town had been destroyed.

These two major fires prompted the organization of a volunteer fire department, followed by a ladies auxiliary. The department's building is still in existence today. At the very first organizational meeting, the charter members determined that an annual pony penning and auction would be the group's major fund-raiser.

FLOATING VAULT. When a natural disaster occurs on a barrier island like Chincoteague, not only do the people and animals feel its brunt, but so do the dead. Cemetery coffins cannot be buried deep into the ground because of the water table on the island; hence, they remain near the surface. But a problem arises when a fierce nor'easter or other storm rips across the land; its gales and torrents wash the land away and raise tides and, in turn, expose the caskets. In the 1962 storm, over 30 vaults were flushed out of the ground and tossed about like toothpicks. In his book *Once Upon an Island*, Kirk Mariner writes, "One [vault] was washed out of its grave, flipped over, and swept back in, upside-down." He adds that "thirty-one cemetery vaults were washed out of the ground and strewn about like small boats." Pictured here are cement slabs that are placed on top of graves to prevent the wooden caskets from coming out of the ground during floods. (Courtesy of Robert Conklin.)

MUCHO GUSTO. One of the most vicious storms to thunder down on Chincoteague happened on September 3, 1821. The nearly $250,000 in damages (a huge sum of money at the time) that it inflicted on the area is an indication of the hurricane's ferocious forces. The ocean receded from the shore, exposing sandbars unbeknownst before and creating a massive tidal wave. "The Great September Gust" or "the Hurricane of 1821," as it had been called, took five lives—sucking them up in the tsunami. It also capsized homes and businesses, and uprooted and tossed large, old trees about as though they were mere kindling. The storm ended in Vermont and New Hampshire. (Courtesy of Kirk Mariner and *Scribner's Monthly Magazine*, April 1877.)

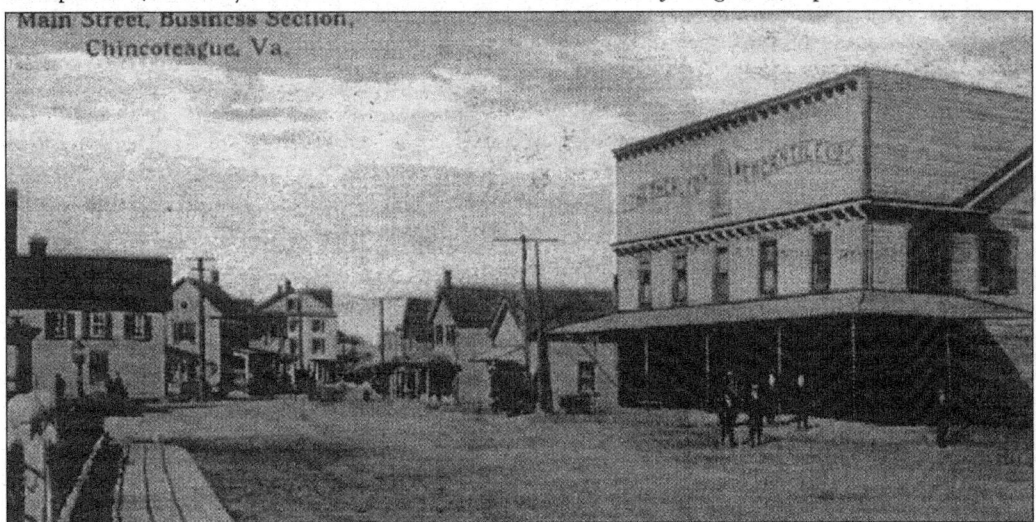

THE DOWNTOWN BEFORE THE 1920 FIRE. At 1 a.m. on Sunday morning, September 5, 1920, a blaze broke out in Doughty's ice-cream parlor and was fanned by a strong breeze. The fire spread through the east side of town, destroying the Atlantic Hotel, several homes and businesses, and a bank. Purportedly, this fire and the one in 1924 that demolished the west side of town were set by arsonists. It did not help that Chincoteague's only fire engine failed to work and a bucket brigade had to be established. Both blazes altered the entire appearance of the small town. (Courtesy of Kirk Mariner.)

THE BURNED BANK BUILDING. The Marine Bank was all but incinerated in the 1920 fire. Since the causeway was not yet built, there was no road transportation into and out of the town, thus making it impossible for firetrucks from other areas to get to the island's blaze. The town became a cinder box, with the bank being one of the first structures to be entirely destroyed. Notice how the flames gutted the inside of the building after eating away the roof. (Courtesy of Kirk Mariner.)

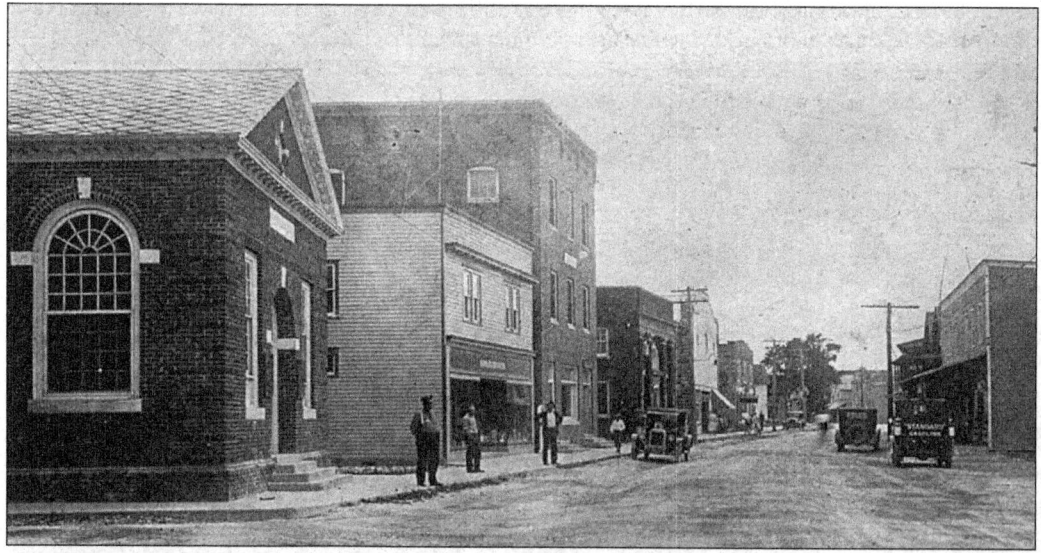

THE DOWNTOWN AFTER THE FIRE. These five buildings show how the landscape of the island changed after the first fire, which caused over $90,000 in damages. Remodeling resulted in brick and stone structures replacing older, wooden ones. The bend in the road was also straightened. This mid-1930s image shows the east side of Main Street looking south. From left to right are the Marine Bank (compare to the photo at the top of the page), Showard Brothers Hardware, the Masonic Temple, the Bank of Chincoteague, and Powell's Theater. Sadly, the Atlantic Hotel could not be rebuilt for the $25,000 it cost when it was constructed in 1876. (Courtesy of Kirk Mariner.)

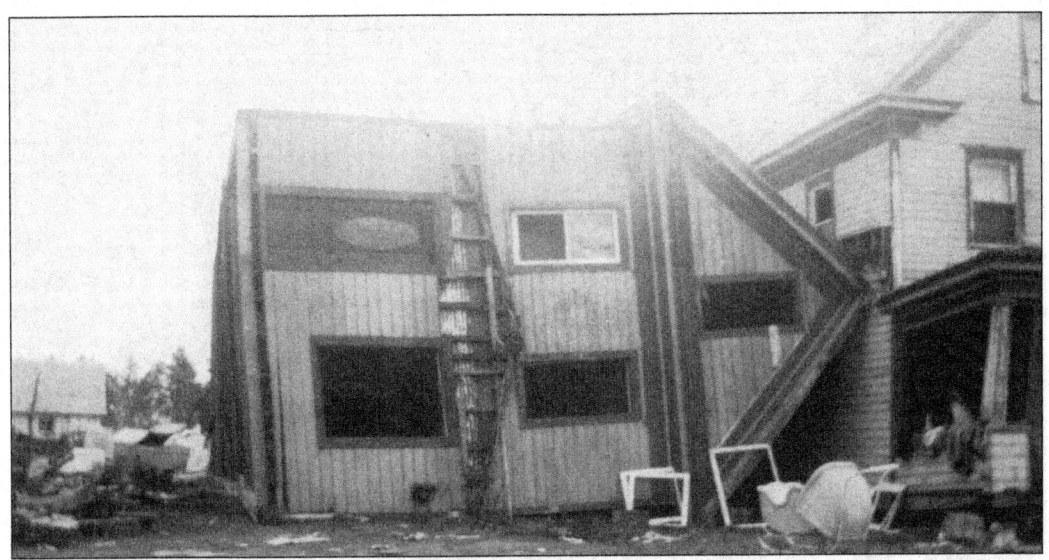

THE 1936 STORM. In this image we see the results of the September 1936 storm. Considering the weight of an entire home, it is amazing that wind alone could knock this structure over—yet the structure at 4496 Main Street was ripped off its foundation, its windows having been blown out and its porch having been torn apart. Its collapse killed an infant and resulted in damage to the building next door. (Courtesy of Kirk Mariner and *Eastern Shore News*, 1936.)

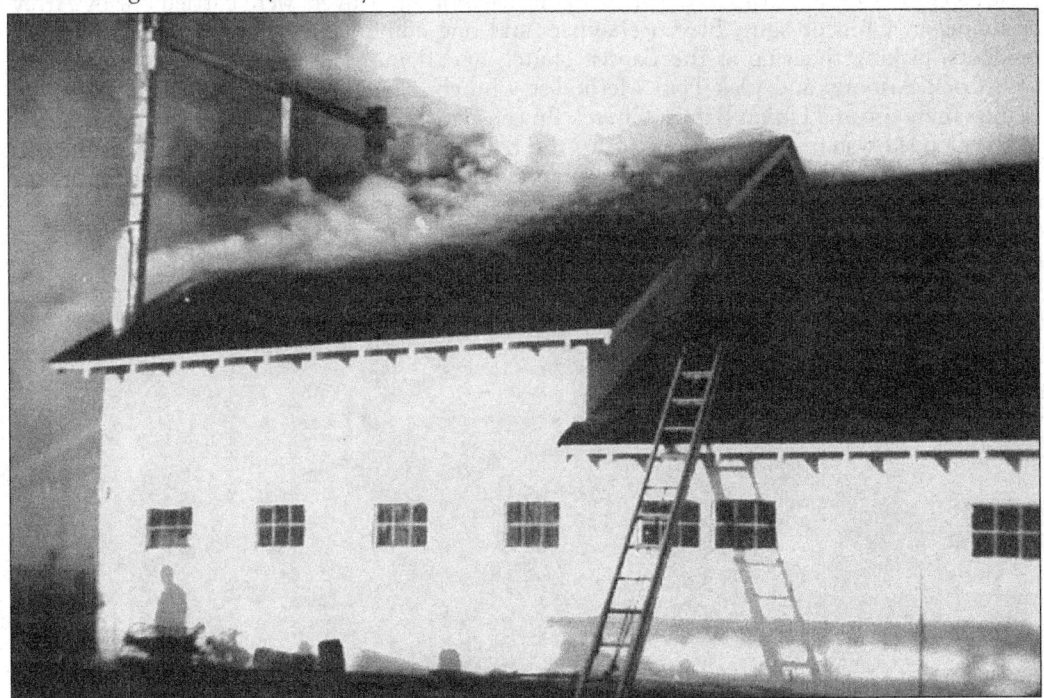

THE MCCREADY FIRE. Although not a major disaster when compared to what Chincoteague suffered in other catastrophes, a business was lost—the McCready Oyster House—in 1960. This photo shows firemen at the scene hosing down the smoldering roof through the use of a long hose (far left)—primitive by today's standards. A man precariously stoops on the roof to assess the damage. (Courtesy of Donna Mason.)

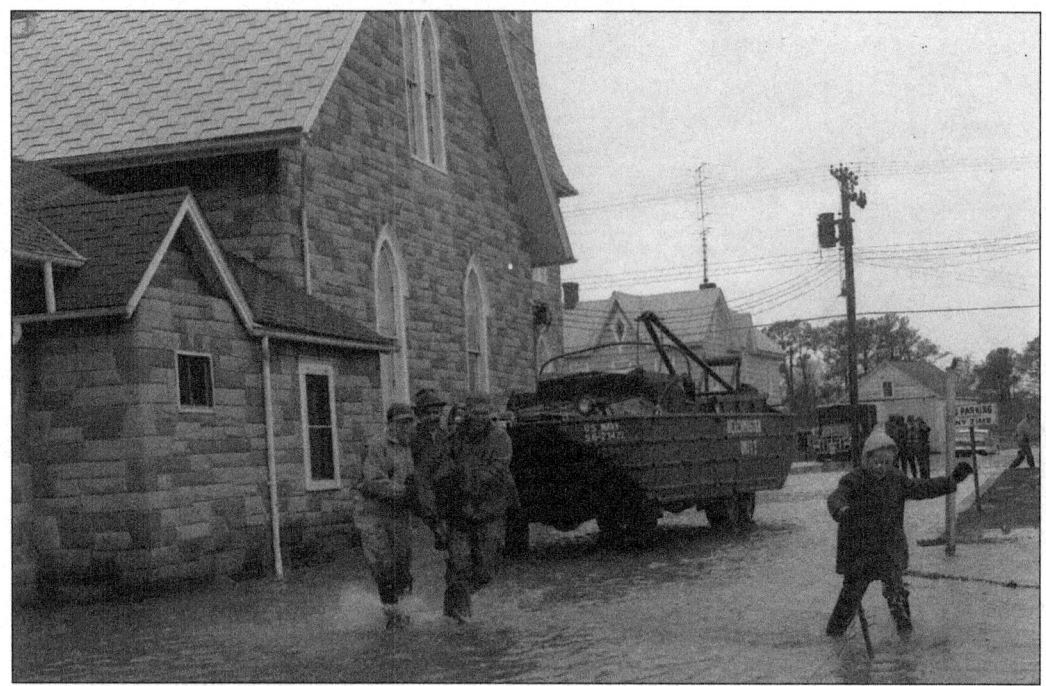

EVACUATION, 1962. During the 1962 storm, evacuation maneuvers were carried out by Army personnel in Chincoteague. Eleven choppers and one amphibious vehicle evacuated 14,000 residents, picking them up at the Baptist church and flying them to the Wallops Base, the Onancock Armory, and Oak Hall Methodist Church. Some victims sought shelter in the island's firehouse and Union Baptist Church. In the above photo, two men bolt from the church in the flooded waters carrying a victim to the helicopter (below), on which he is airlifted to a safety. The above image also shows an amphibious vehicle called a "duck." (Bottom image courtesy of Robert Conklin.)

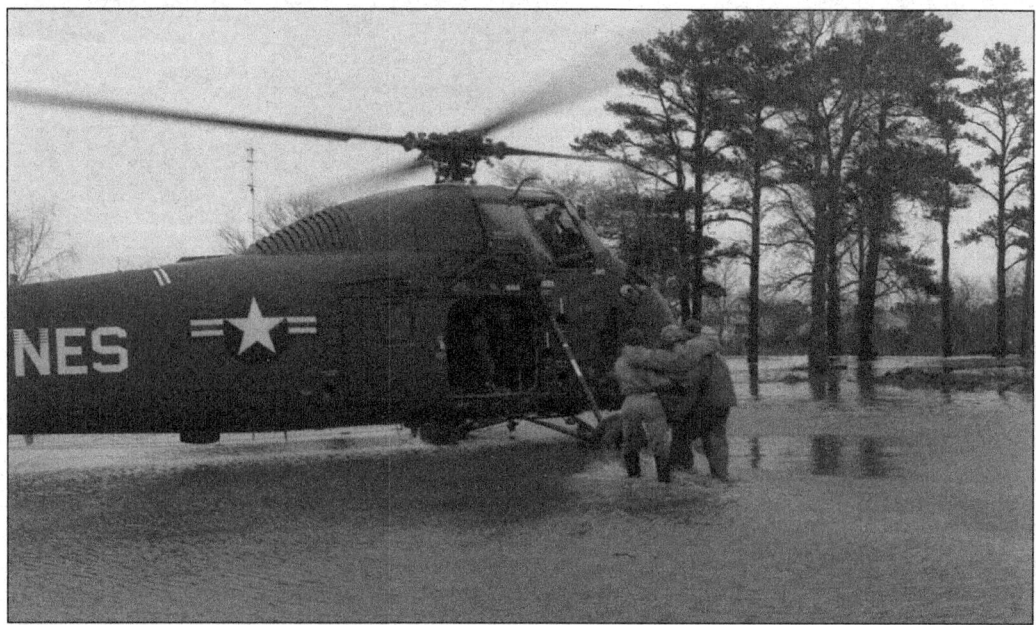

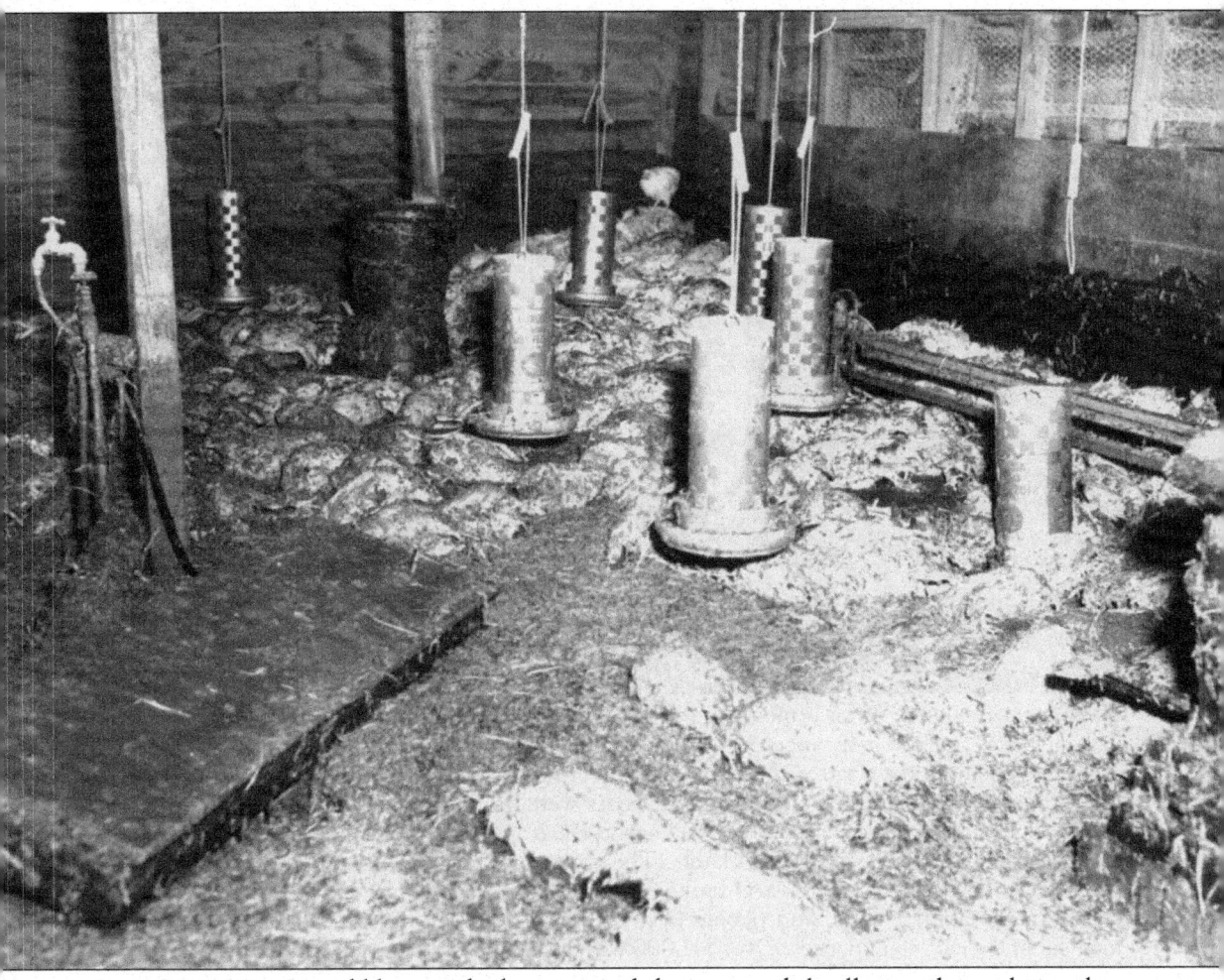

SOLE SURVIVOR. Incredibly, one chicken survived the storm, while all around, its relatives lay dead. About 300,000 chickens drowned in the 1962 storm. In this photo, the Purina feeder can be seen (second cylinder to the left), as well as the sole survivor huddled in the back corner atop a pile of chick carcasses. Many of the dead birds were taken to a Crisfield fertilizer plant. The poultry business on the island took such a big hit from the storm that the industry was essentially wiped out. (Courtesy of Robert Conklin.)

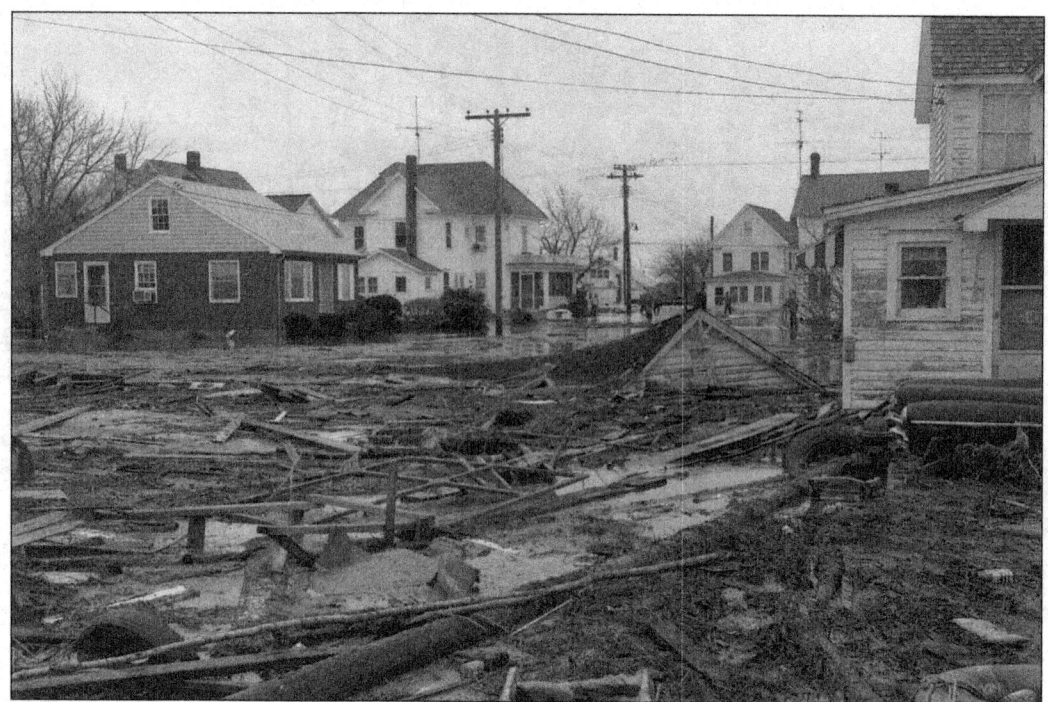

SCATTERED DEBRIS. What a mess "the flood of 1962" made. Clean-up of the island required days of labor and the assistance of personnel from the federal, state, and local governments, including the military. Scattered around are timber rafters, downed telephone poles, and muck and mire. In various places on the island, boats were grounded in the streets. Water nearly covered car roofs and store signs and rose beyond the front steps of homes. Any remaining food was unusable, and water was undrinkable. The three-day storm splashed over the causeway—with 30 abandoned cars on it—and broke off parts of its bridges and washed them away. The storm made national news, and people from all over the country sent money to help defray medical and clean-up expenses. Over $11,000 was donated by sympathetic strangers. (Courtesy of Robert Conklin.)

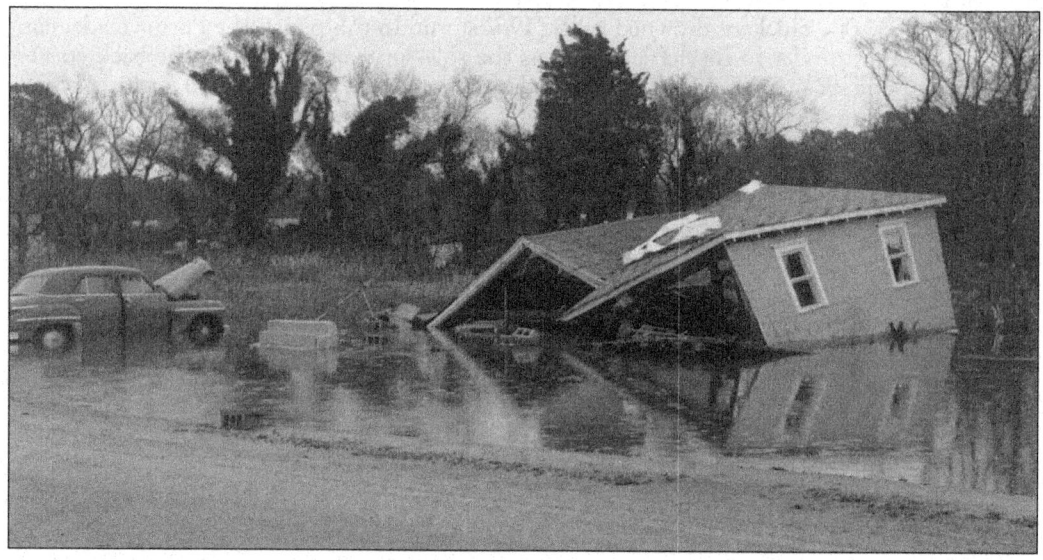

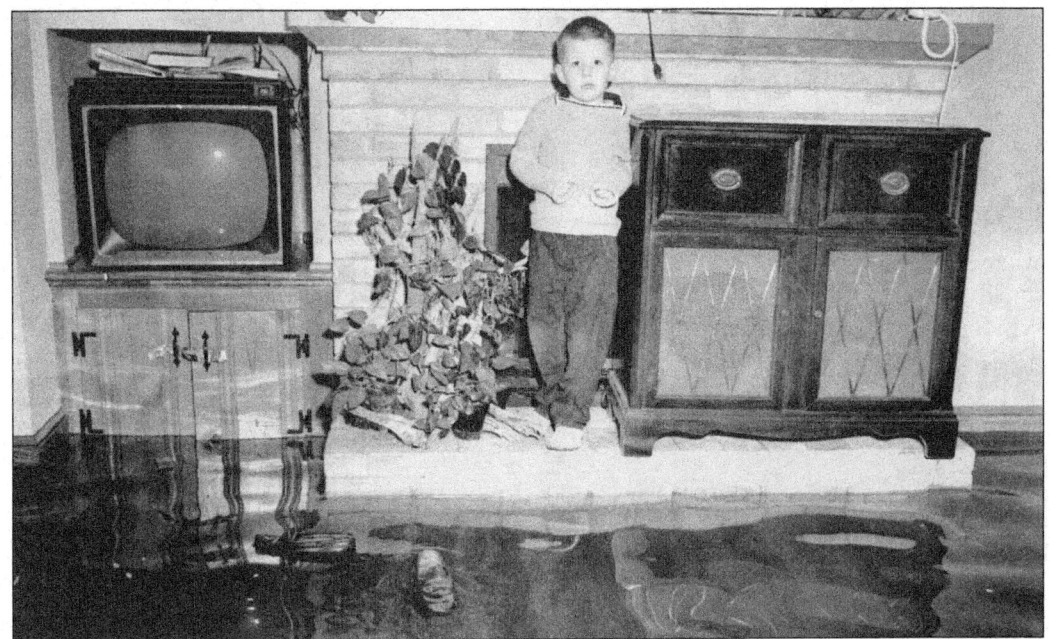

ON A HEARTH. This image documents the height of the flood waters, as photographer Conklin's son stands on the family's hearth bewildered by the rushing water. All the furniture and other possessions were ruined. Rew writes in her historical account, "The Main Street was covered with everything imaginable, including all kinds of furniture, animals, and bed clothing." Sixteen inches of water filled the bank. Water reached even higher levels in the Methodist church, where it covered the pews and drowned the organ. Mariner reports in his book that water rose 4 feet in Charlie Gall's store. (Courtesy of Robert Conklin.)

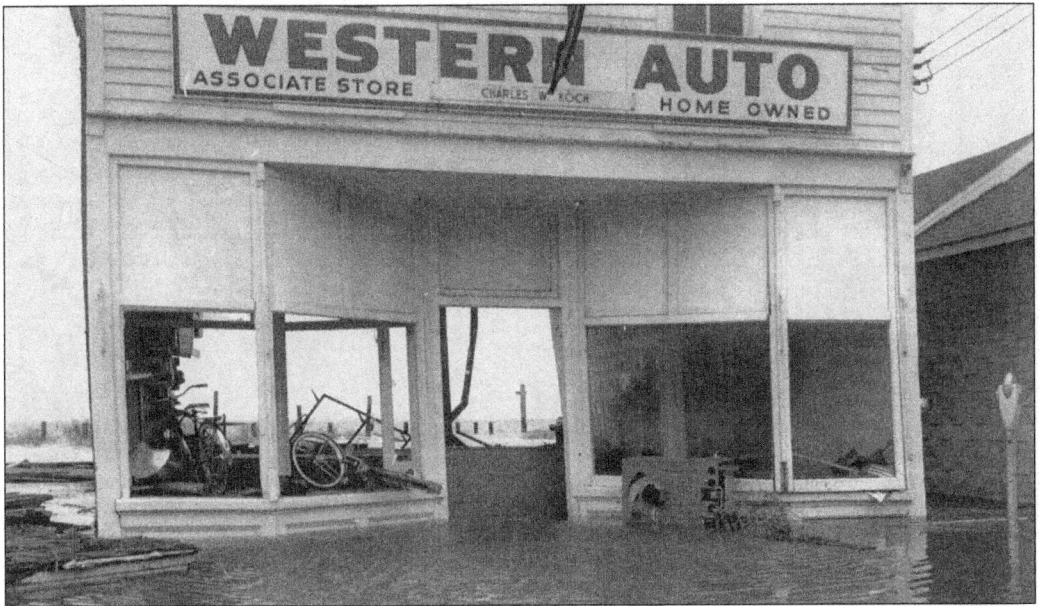

FLOODED WESTERN AUTO. Not only has this building been submerged, but all of the rear has been demolished—only bare rafters are left. Mr. Koch, the owner of the business, suffered a massive loss in this disaster. (Courtesy of Robert Conklin; collection of David Snead.)

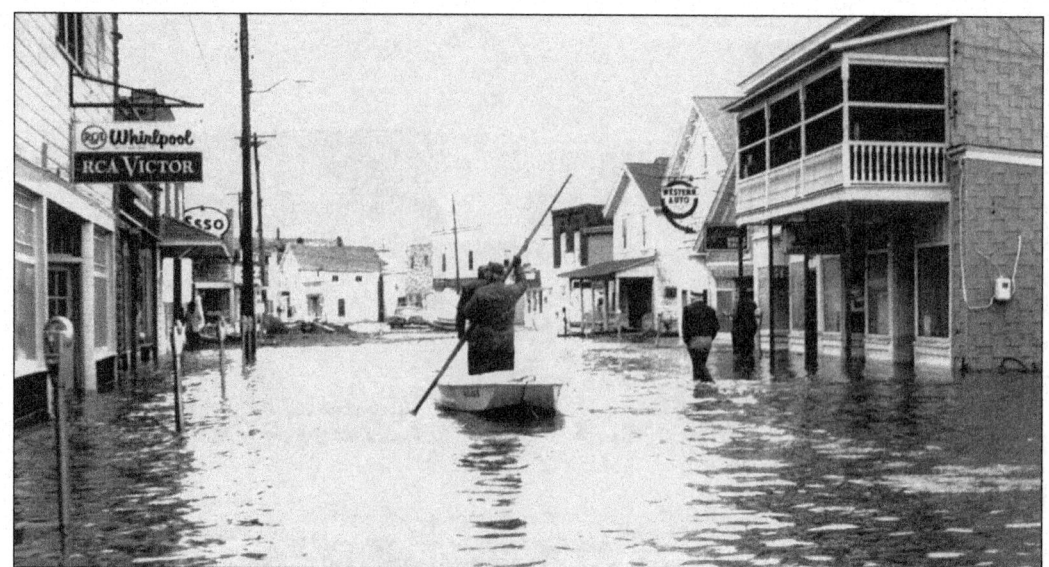

BOATING DOWN THE CENTER OF TOWN. Before the water receded, authorities rowed through town to assess the destruction. The Civil Defense proclaimed Chincoteague an "Absolute health hazard" because of the contamination of drinking water by raw sewage, dead chickens, and ponies. The famous horse, Misty, was of great concern to a world that had fallen in love with the pony in Marguerite Henry's book. But Misty was alive and well in the kitchen of the Beebe Ranch when the worst of the storm hit; she was flown out of Chincoteague right after the storm to give birth to her third foal, Stormy, who became the main character in Henry's third book in the series. (Courtesy of Robert Conklin via David Snead.)

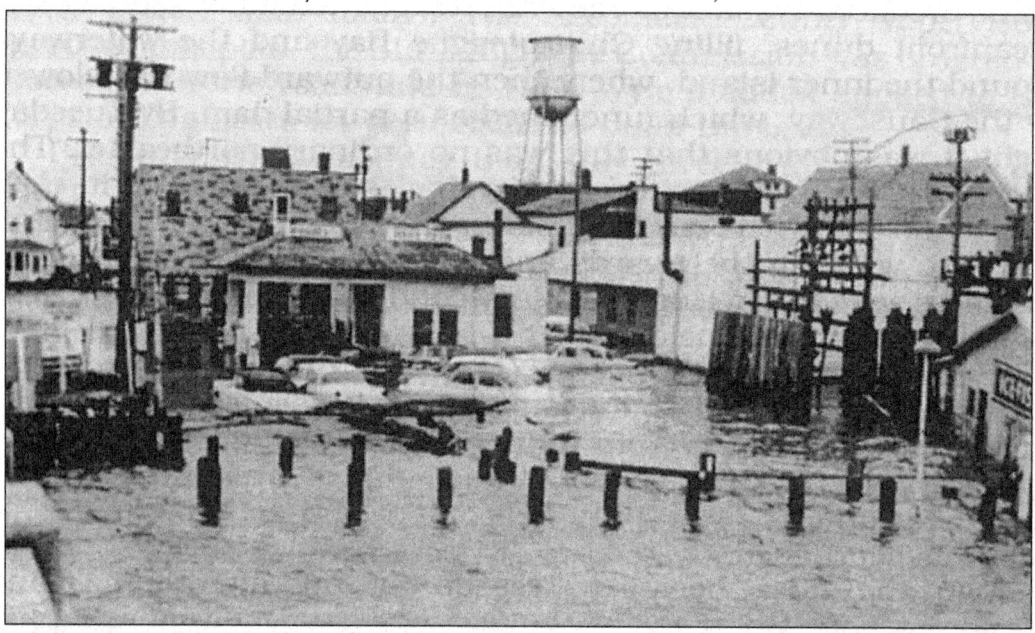

A VIEW FROM THE BRIDGE. This image was taken after the storm while driving across the causeway into town. Not only are docks under water, but so are cars and electrical equipment. Imagine the danger this combination held. Boats broke away from the sinking docks and made their way throughout the town on the flooded roads. (Courtesy of Kirk Mariner.)

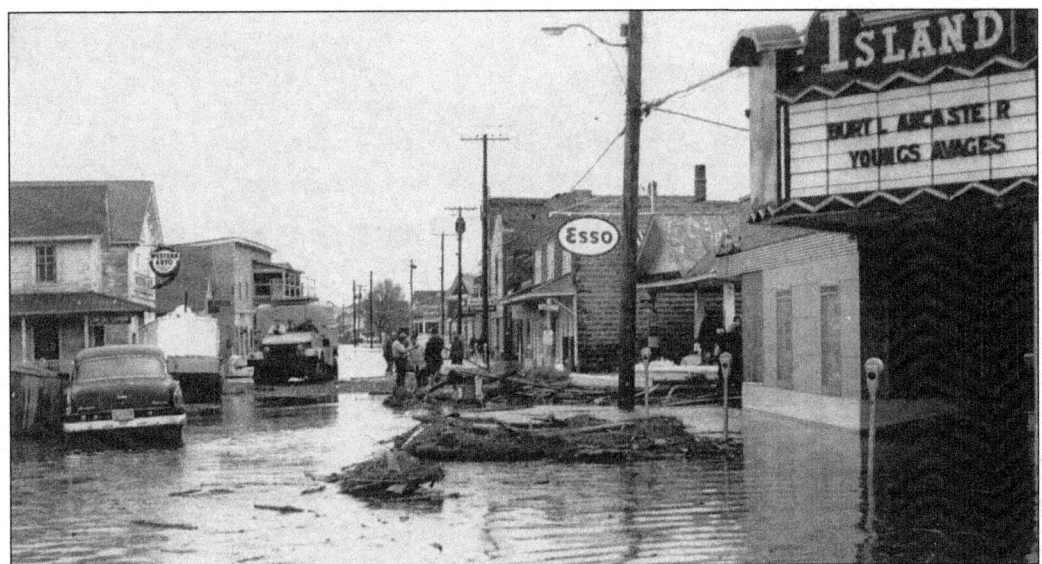

THE ISLAND THEATER. In this image, the well-known Island Theater takes center stage. Built in 1946 where the Atlantic Hotel stood before the fire, the theater's marquee indicates that Burt Lancaster's 1961 film *Young Savages*, with Dina Merrill and Shelley Winters, was the last show to play. On the right is the Esso station with a boat rammed into its pillar. A group of men are in front of it trying to clean up the mess. A vehicle approaches, carrying a load of people who are probably cleaning help. (Courtesy of Robert Conklin via David Snead.)

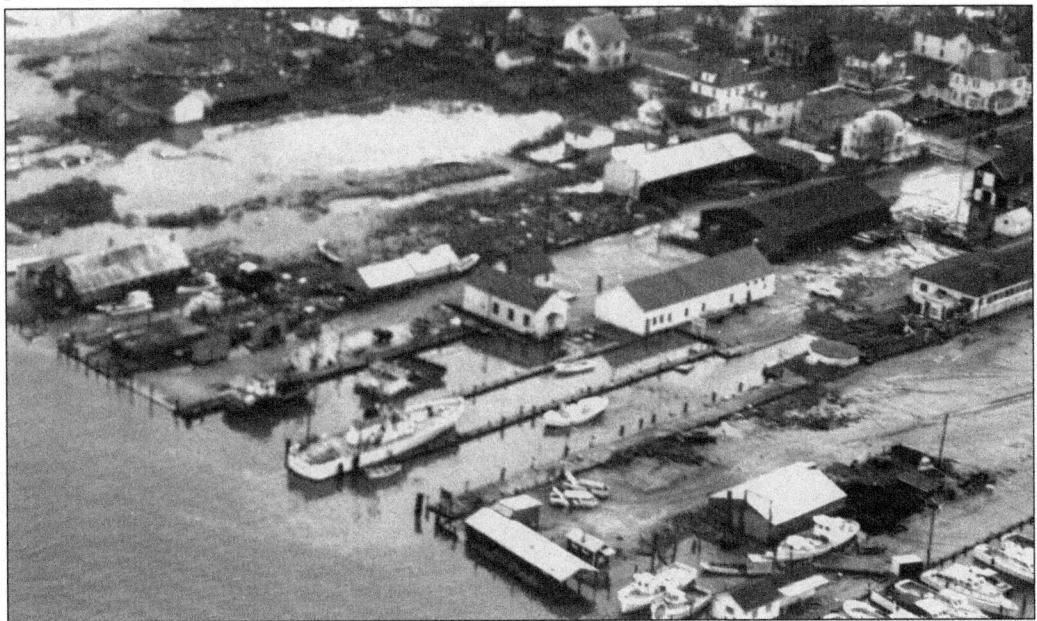

THE FLOODED COAST GUARD STATION. In comparing this aerial survey, titled "Storm Damage to the Mid-Atlantic Coast," to a similar one in Chapter Three, we can see how the 1962 storm deluged the base. Water has not only risen up to the docks, but it has also flooded the buildings. Yet this photo represents the period when the water was receding, so it is easy to imagine what it must have been like at the peak of the downpour and winds. (Courtesy of the United States Coast Guard, Division of Public Information.)

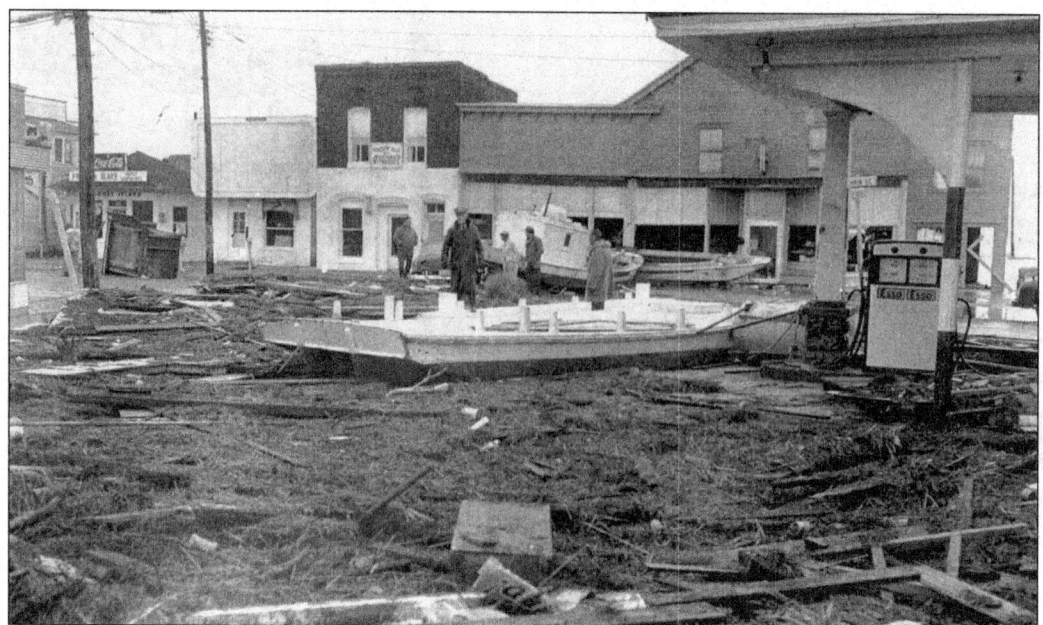

RUBBLE-STREWN STREETS. The severity of the storm is clear in this image. The Esso gas station at Mumford and Main Streets has been demolished, the pump nearly ripped off its foundation. A skiff rammed one of the pillars of the gas station, destroying itself in the process. Imagine the force of the wind and torrents needed to lift a boat and crush it into a cement pillar, causing extensive damage to both. Debris lies everywhere. The men in the street appear to be on cleanup duty while the police chief looks over the damage. (Courtesy of Robert Conklin.)

HURRICANE DENNIS. This September 1, 1999 photo shows the strength of Hurricane Dennis as it descends on Assateague. Andrew Alesbury, age eight, holds onto a post and protects his face from gusting sand particles. Note the mounting waves behind the child. Assateague takes the brunt of ocean storms since it is a barrier island and is the first land mass to be exposed, protecting Chincoteague in the process. Hurricane Dennis weakened as it traveled north from the Carolinas. (Courtesy of Stephen Cherry of the *Daily Times*, Salisbury, Maryland.)

Ten

Church and Cemetery
Altar Stones and Tombstones

The Virginia barrier islands have a colorful but somewhat ambiguous history when it comes to churches and burial grounds. Since America was founded on religious freedom, Chincoteague made sure it took advantage of that right. For nearly 215 years, various faiths and creeds have taken root on the island, some of which endured hardships only to grow and expand, while others closed or moved to the mainland. Whatever the causes, worship has a rich and lively—albeit confusing—history on Chincoteague and Assateague.

In 1786, Chincoteague Baptist Church was one of the first services to make its appearance and was located just outside of Chincoteague in New Church, VA. Then, in 1869, Pastors Joseph Kenney and J.M. McCarter, realizing that neither the Protestant nor Methodists denominations had high attendance records, set out to improve this by forming the Methodist Episcopal congregation, the forerunner of today's Christ United Methodist Church. Around this same period the Up the Island Church and the Good Will Church were established.

One interesting piece of Chincoteague's religious history involves the Christ Sanctified Holy Church, founded c. 1887 by Joseph Lynch, who was unhappy with Methodism because he felt it was too worldly and failed to place enough emphasis on being saved, or "sanctified via the Holy Spirit," in order to gain acceptance into heaven. Lynch and Sarah Collins managed to gather enough converts and established traveling ministries, which evangelized around the country. The sect endured through the years. Around the same time, in 1893, the Beulah Baptist Church was established but closed when influential member Captain Bunting died.

In 1895, the Union Baptist Church—the place where African-American Methodists worshiped from a segregated balcony—burned down and was rebuilt. The year 1919 witnessed the construction of the Assateague Baptist Chapel, which was abandoned in 1922 and floated across to Chincoteague. In 1924 the Jehovah Witnesses made their appearance. In 1930 the Methodist Protestant church closed; the building served as shelter for World War II soldiers, as a cafeteria for elementary schoolchildren, and in 1964 it became St. Andrew's Roman Catholic Church. In 1937 the Church of God was begun, after a successful tent revival.

Even today, churches on Chincoteague move and sway to a rhythm of their own. This is also true for the island's cemeteries, where a richness pervades the landscape, as seen in the tombstones of Captain Chandler or the surface-level caskets seen in most graveyards. Leaf through this section and learn about the history of life and death on the island.

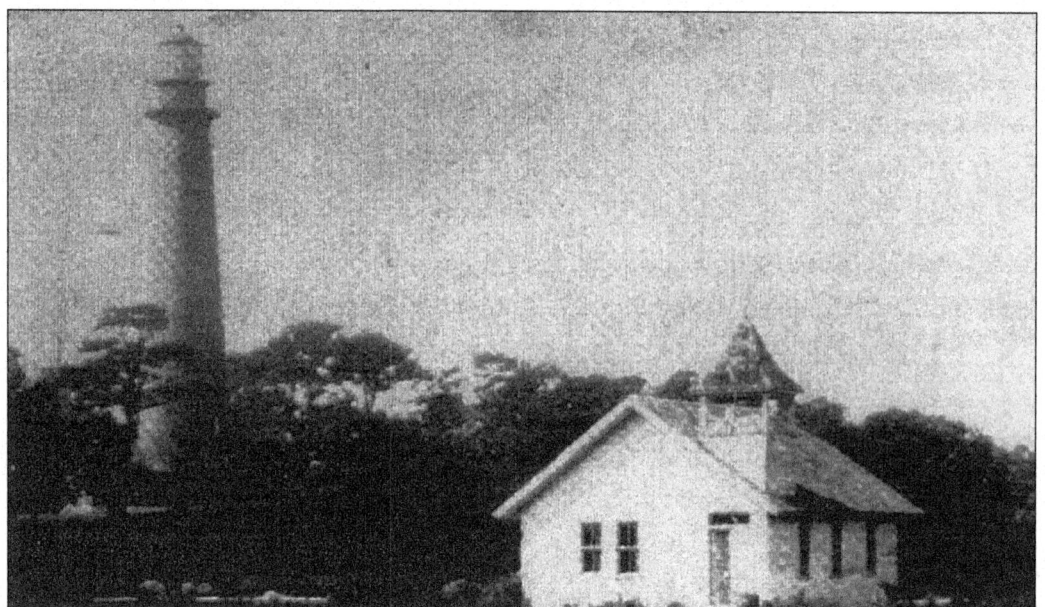

THE ASSATEAGUE BAPTIST CHURCH, 1919. These images are before and after shots, showing the Assateague Baptist Church in two different eras and with two different purposes. The above photo shows the church with the lighthouse in the background. The only formal religious institution on the island at the time, it was built in 1919 on the donations by both Assateague and Chincoteague denizens, and the Reverend Sawyer served as its first pastor. December 25, 1920, was the date of the first and only wedding in the church. The church was abandoned three years after it was built and was floated across the water to Chincoteague, where it was converted into a small house. The bottom photo shows the church remodeled into a home. (Above image courtesy of Curtis Badger.)

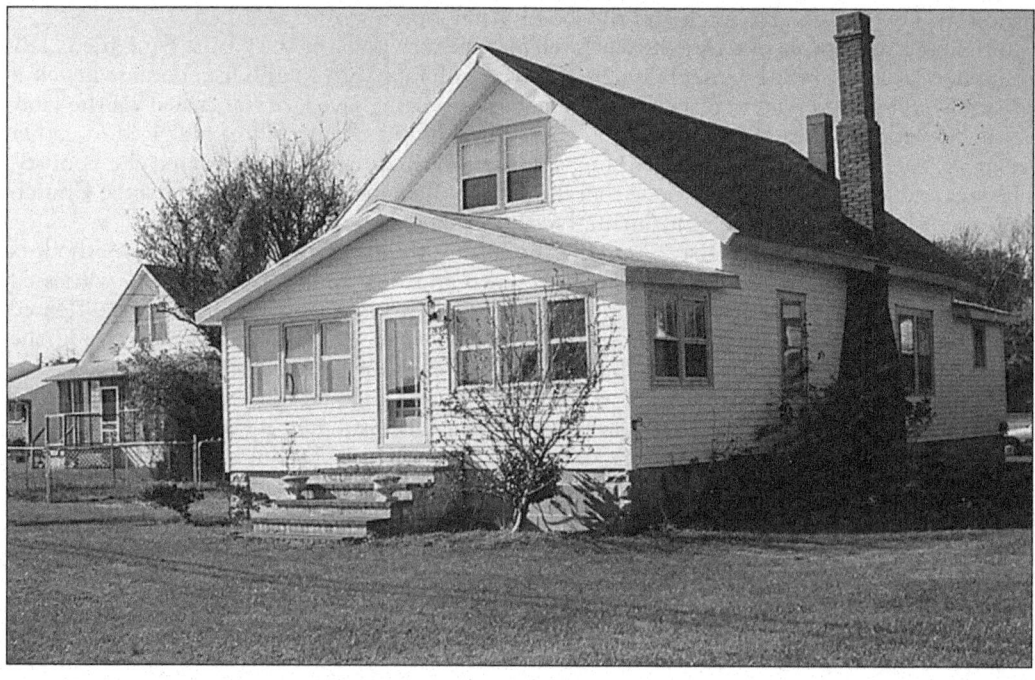

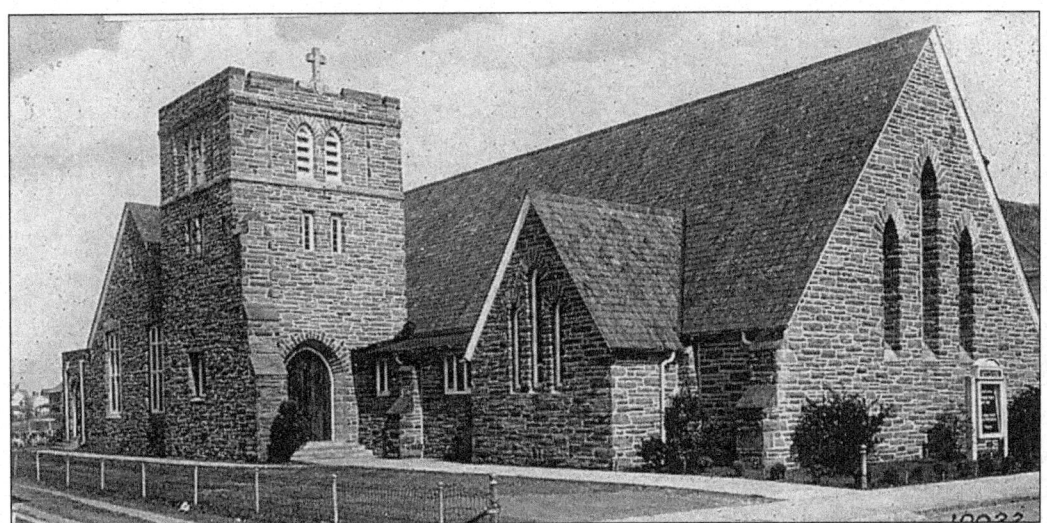

THE CHRIST UNITED METHODIST CHURCH, 1869. Started by two ministers who met in what is now St. Andrews Church, this Baptist and Methodist combination church, with just 50 original members, soon overtook the Methodist church and became the Methodist-Episcopal church. During its history, it split with members living on the north side of Main Street, when they established their own services, and with those on the south end, when they opened their own church. By 1922, the church grew so much that a new nearly $40,000 building was erected in the Gothic style. Later, the factions were reunited. (Collection of John E. Jacob.)

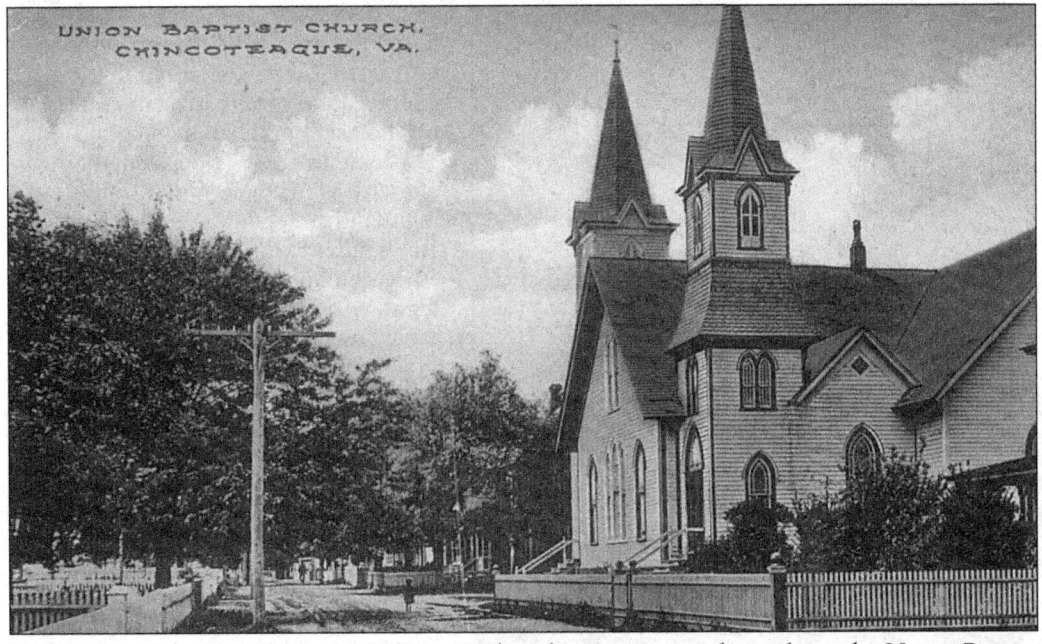

THE UNION BAPTIST CHURCH, 1800s. With only seven original members, the Union Baptist Church later grew enough to afford and complete building improvements, only to be destroyed by fire in 1895. The congregation moved near the carnival grounds and erected the first part of its new building. During the Ash Wednesday Storm of 1962, the church served as shelter for the Teaguers who remained on the island. This postcard is postmarked 1910 and was sent to Mattie Adkins in Delaware. (Courtesy of Louis Kaufman and Sons; collection of John E. Jacob.)

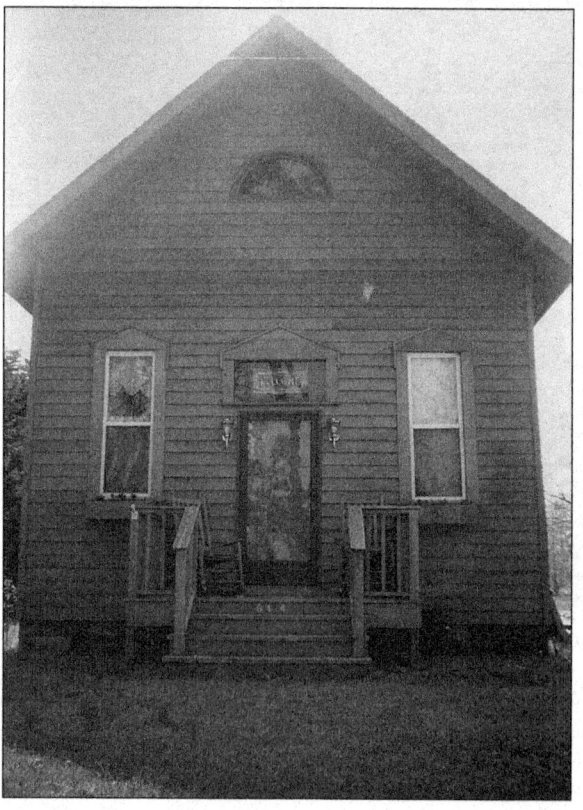

THE FREEWILL METHODIST EPISCOPAL CHURCH, 1879. The original congregation of this African-American Methodist church consisted of just 11 people in 1874. Though small, the church saw much activity through its mainland connections, and by the 1890s, it had grown to 42 members. A new building was erected in 1897 for about $50,000, while the old one served as a schoolhouse for children from 1936 to 1942. Ministers for the congregation drifted in from other areas, and by the early 1900s, church attendance started dwindling, and the church ceased operating. The building remains on Willow Street but has been remodeled into a small home (left) by Robby and Sherry Conklin.

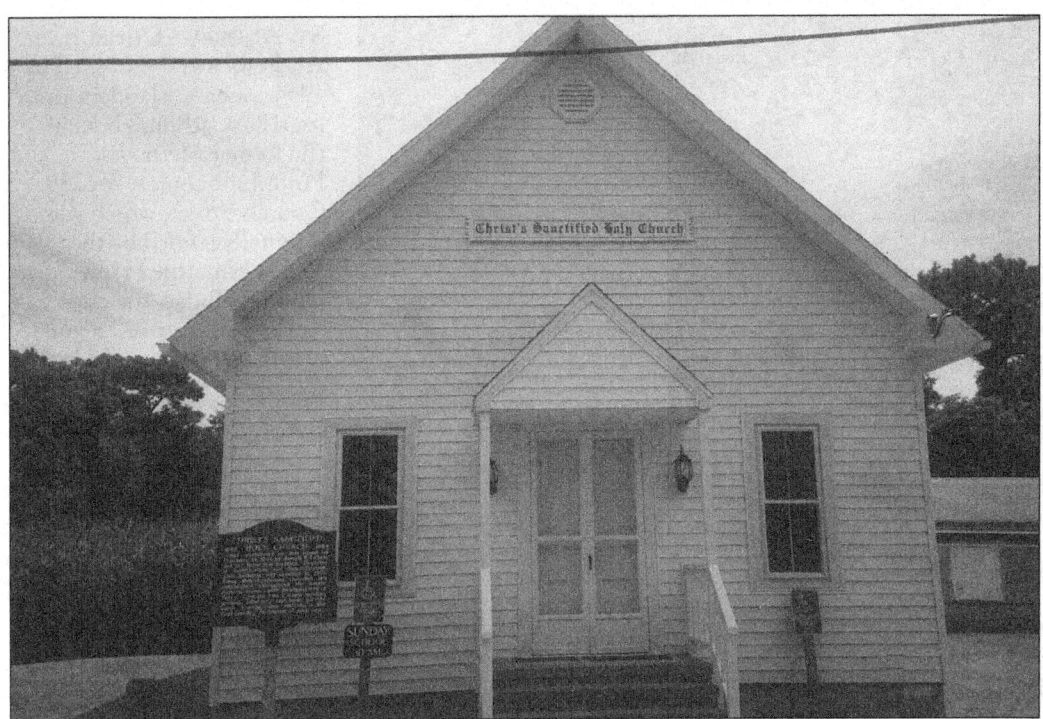

THE CHRIST SANCTIFIED CHURCH, 1892. In 1892, Joseph B. Lynch, who was a leader in the Methodist Episcopal church, founded his own religion because he did not believe his former church promoted holiness or bestowed on parishioners the blessing of sanctification—a work of grace. He, with Sarah E. Collins, organized Christ's Sanctified Holy Church with the goal of evangelizing islanders and spreading the word across the country. Many of the newly evangelized packed all their worldly goods onto floats and primitive houseboats and sailed around the country doing just this. The year 1917 brought a great reunion among all the members, and a massive revival was held in 1921. Services were characterized by singing, body and hand gestures, and shouting. By 1939, the group had stabilized, and today, they can be found in over 100 cities. The building sits on North Main Street.

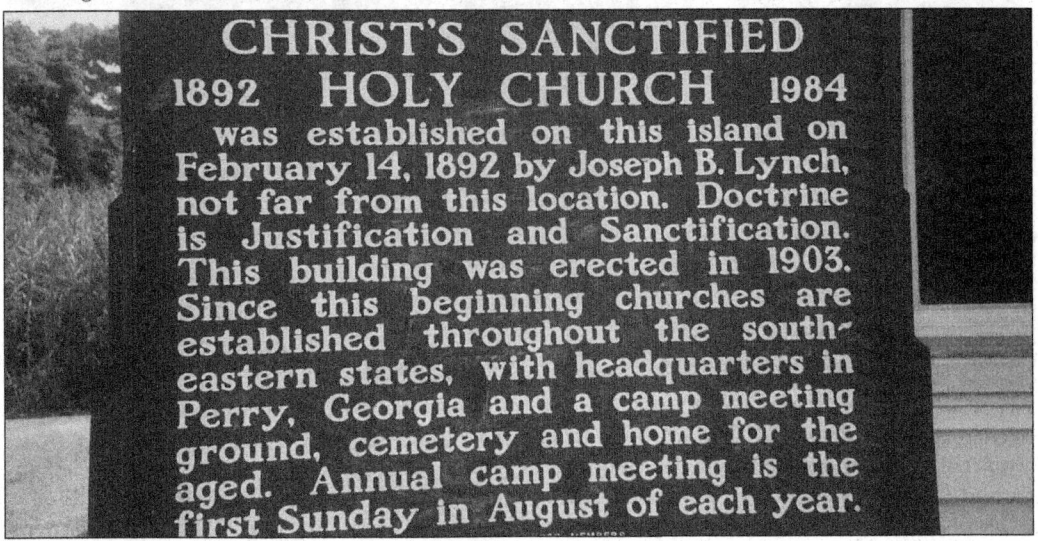

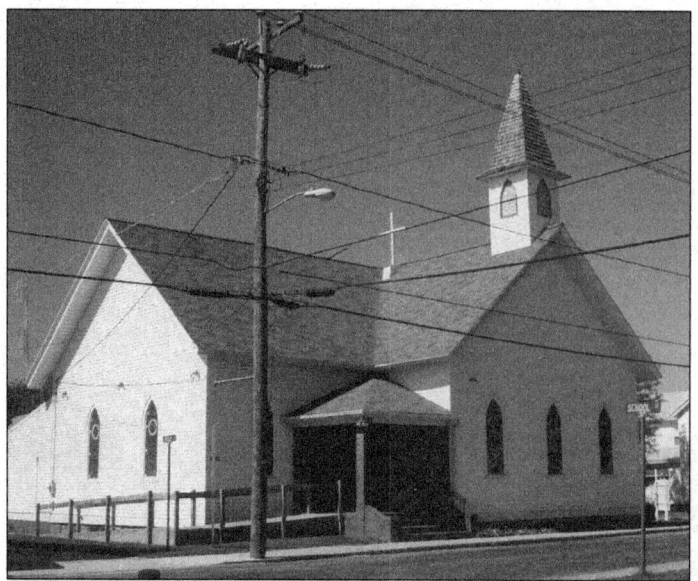

ST. ANDREWS CHURCH. St. Andrews was established in 1964 to serve islanders and tourists. Catholics bought the former Methodist Protestant church at 6288 Church Street, which was originally owned by the Christ Sanctified Holy Church. Today, the church serves well over 100 regular members and thousands during tourist season. (Courtesy of Effie Cox.)

AN AERIAL VIEW OF THE CEMETERY. This unique 1940s view shows the town of Chincoteague in the background and the Willow Street cemetery in the foreground, hidden among lofty trees. From this view, it appears that the majority of graves had headstones, although some above-ground vaults can also be seen. The houses are of interest, too, showing the relative sizes and styles of the time. (Courtesy of Donna Mason.)

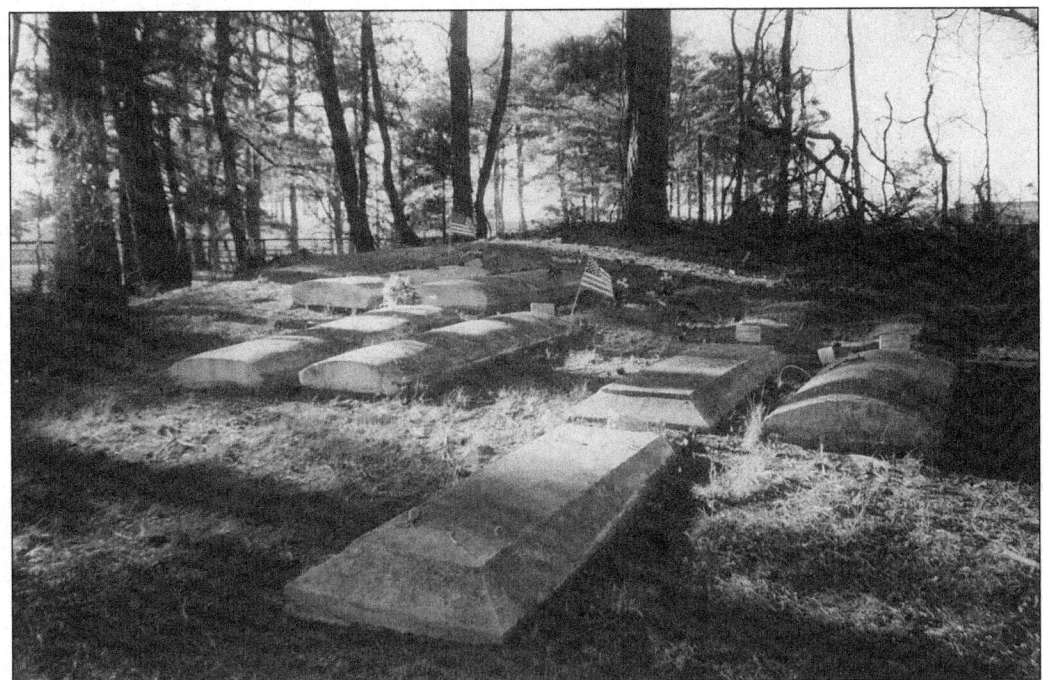

CEMETERY VAULTS. In this 1990s photo of Christ Union Baptist Cemetery, the cement slabs covering old caskets are visible at the ground level.

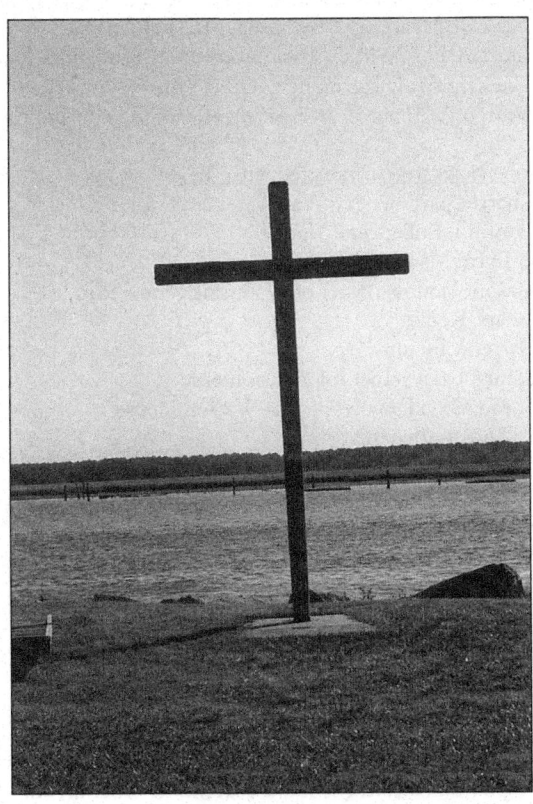

THE CROSS AND MARKER. This image of Memorial Park shows a wooden cross anchored by a concrete slab, on which is inscribed, "This cross dedicated Easter 2, April 1988 to the men of Chincoteague Island who lost their lives at sea." Lee Savage donated the property, and Reginald E. Stubbs erected the dedication. The monument stands in testimony of all the men who lost their lives in war—no matter what military branch—and to those who went to sea in the service of humanity.

BIBLIOGRAPHY

Assateague Island. Handbook 106. Washington, D.C.: Division of Publications, National Park Service, U.S. Department of the Interior, 1980.
Badger, Curtis, et al. *The Barrier Islands: A Photographic History of Life on Hogg, Cobb, Smith, Cedar, Parramore, Metompkin & Assateague.* Harrisburg, PA: Stackpole Books, 1989.
Barnes, Brooks, Miles; Truitt Barry R. *Seashore Chronicles: Three Centuries of the Virginia Barrier Islands.* n.p.: University Press of Virginia, 1997.
Chenery, Richard L., III. *Old Coast Guard Stations, Volume One: Virginia, Popes Island to False Cape.* Glen Allen, VA: Dietz Press, n.d.
Jack, Andrea, et al. *Assateague: Island of Wild Ponies.* n.p.: Sierra Press, 1977.
Krieger, Robert L. *The Chincoteague Toll Road and Bridge Company.* Wallops Island, VA: n.p., April 1980.
Mariner, Kirk. *Once Upon an Island: The History of Chincoteague.* New Church, VA: Miona Publications, 1996.
Mears, Robert. *The Watermen and Wild Ponies: A Chincoteague Waterman Remembers; Life of Chincoteague and Assateague,* 1994.
Points, Larry, et al. *Ribbons of Sand.* n.p.: Sierra Press, 1997.
Rew, Lillian Mears. *History Notes of Chincoteague.* Chincoteague, VA: Chamber of Commerce, n.d.
Ride with Me (script). Bethesda, MD: n.p., 1999.
Turman, Nora Miller. *The Eastern Shore of Virginia 1603-1964.* n.p.: The Eastern Shore News, Inc., 1964.
The Virginia Eastern Shore 17th Century
Wroten, William H. Jr. *Assateague.* Second edition. n.p.: Tidewater Publishers, 1972.

Interviews were conducted with the following:
Cherrix, Jay; owner of Tidewater Expeditions
Conklin, Robert and Nancy
Enright, Maury
Mason, Donna; owner of Waterside Motor Inn
Mears, Robert
Oyster Museum
Points, Larry; chief information officer
Snead, David; owner of The Watson House
Tolbert, Katherine
Whealton, Herman
Gehrm, Barbara; Chincoteague Chamber of Commerce
Watanabe, Todd
Assateague (VA) Visitors Center
Assateague (MD) Visitors Center

Other sources:
Ride with Me: Chincoteague and Assateague. Audio. Island of VA; MD: 1995.
Assateague Island National Seashore. Audio. Eastern National; CA: 1992.
Information packet. USCG; Scott T. Price; Portsmouth, VA.
"Tidbits about the Eastern Shore." www.esva.net/ghotes/shore.
Virginia's Chincoteague Island Adventure. brochure. n.p., 1999.

CPSIA information can be obtained
at www.ICGtesting.com
Printed in the USA
LVOW06*1359160717
541555LV00020B/173/P